THE
DIGITALSLR BIBLE

THE
DIGITAL SLR BIBLE

A COMPLETE GUIDE FOR THE 21ST-CENTURY PHOTOGRAPHER

NIGEL HICKS

David and Charles

A DAVID & CHARLES BOOK
Copyright © David & Charles Limited 2006

David & Charles is an F+W Publications Inc. company
4700 East Galbraith Road
Cincinnati, OH 45236

First published in the UK in 2006

Text copyright © Nigel Hicks 2006
Illustrations copyright © Nigel Hicks, Jon Hicks
and Bjorn Thomassen

A catalogue record for this book is available from the
British Library.

ISBN-13: 978-0-7153-2415-8 hardback
ISBN-10: 0-7153-2415-2 hardback

ISBN-13: 978-0-7153-2423-3 paperback (USA only)
ISBN-10: 0-7153-2423-3 paperback (USA only)

Printed in China by WKT Company Limited
for David & Charles
Brunel House Newton Abbot Devon

Commissioning Editor Neil Baber
Editor Ame Verso
Project Editor Nicola Hodgson
Head of Design Prudence Rogers
Art Editor Sue Cleave
Production Controller Beverley Richardson

Visit our website at www.davidandcharles.co.uk

David & Charles books are available from all good bookshops;
alternatively you can contact our Orderline on 0870 9908222
or write to us at FREEPOST EX2 110, D&C Direct, Newton Abbot,
TQ12 4ZZ (no stamp required UK only); US customers call
800-289-0963 and Canadian customers call 800-840-5220.

Opposite; top to bottom:
**A splash of summer;
saturated colours with a
sunflower against a deep
blue sky; Devon, UK.**

**A Blue-and-Yellow Macaw
stands out strongly
against the blurred
forest background; Rio
Negro, near Manaus,
Amazonas state, Brazil.**

**The bright orange of
calathea flowers provides
a stark contrast to the
sombre darkness of the
plants' leaves; Eden
Project, Cornwall, UK.**

**A close-up of a female
reindeer during the autumn
round-up; near Jokkmokk,
Lapland, Sweden.**

Contents

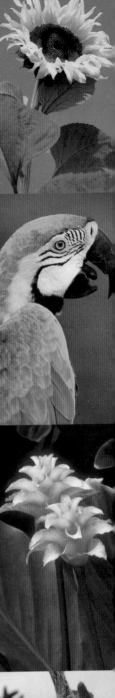

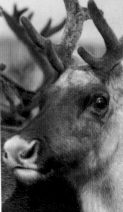

Introduction

The digital era is taking the world of photography by storm; pretty soon, it will have almost completely taken over from film. Photography is changing forever – not in the sense of a photographer's ability to perceive and create great images, but in the way the photographer captures those images, and what can be done with them after exposure.

Grasping those new digital techniques means facing a very steep, and at times quite daunting, learning curve. The aim of this book is to make that curve a little less steep, and altogether more climbable. The problem for many photographers new to digital photography is that, although the digital process initially seems to be a straight swap for film with the added benefit of easy post-photography alterations, they soon find that there are marked differences. The huge challenge of the film-to-digital switch starts to become apparent, and it is at this point that many photographers start to wonder whether they have made the right move, and hanker after the relative simplicity of film.

Many digital books on the market do not help: some get bogged down in the immense amount of science and technology involved; others turn into an excuse to show off a skill in advanced in-computer image manipulation. I hope this book avoids both pitfalls. Concentrating on the 35mm digital SLR (DSLR), and deliberately staying away from the niche area of medium-format DSLRs, *The Digital SLR Bible* aims to lead the reader through some of the most basic science to give a simple overview of how a DSLR works, before using some of that science in a summary of how to choose the right camera and lenses. This is followed by introductions to many of the main DSLR features, both those that are similar

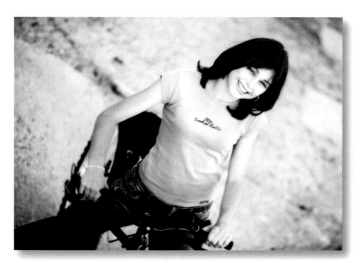

A modern, contemporary portrait, made dynamic by tilting the camera, and rendered monochromatic by desaturation of a colour image.
Canon EOS 1Ds, Canon 70–200mm lens, 1/500 sec at f/2.8, ISO 400. Image courtesy of Bjorn Thomassen.

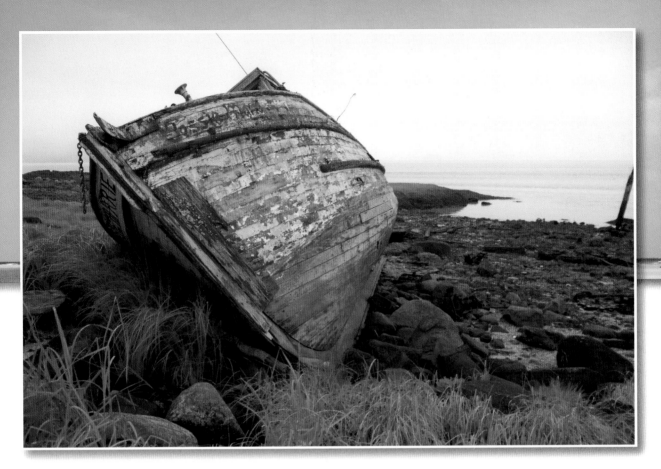

to and quite different from a film SLR, plus some of the problems unique to DSLRs. The main photographic techniques and specialisms are reviewed, particularly the ways in which digital photography makes their execution rather different from film. Finally, the vast arena of how to handle the resulting images on a computer is introduced, from downloading, through simple image optimization, to a little more advanced image manipulation.

The overall aim is to find a relatively straightforward way through the digital jungle, describing simple techniques that give encouragement to the photographer. This is particularly so in the final chapter, where the huge subject of in-computer image work has been stripped to the essentials. Image optimization and enhancement techniques have been restricted to the simplest and most important: for the most part, I describe only those techniques that I use regularly and that work for me.

My hope is that anyone new to digital SLR photography will be able to use this book to lead them from the very beginnings as a digital novice through to a competent level from which they will be able to move forward and continue to learn about the digital era by themselves.

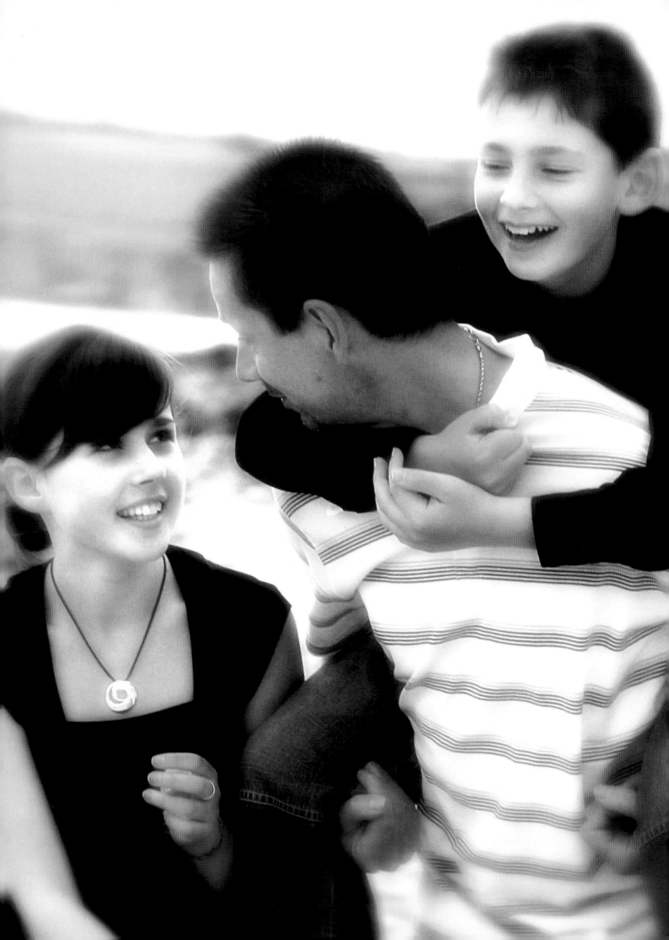

1

The Camera Revolution
From Film to Digital

It does not seem long since photographers such as myself were claiming that, although digital photography had many uses, it would be many years before it took over from film. This particularly appeared to be the case in areas of professional photography where image quality was more important than simply getting a photograph as quickly as possible. How times have changed, and how quickly, too!

A great outdoor portrait image, illustrating the creative power of a digital single-lens reflex (DSLR) camera coupled with in-computer image editing.
Image courtesy of Bjorn Thomassen.

The first digital single-lens reflex (DSLR) cameras were introduced in the early 1990s, but it is only since 2000 that they have become so hugely popular. In just a few years, DSLRs have moved from being used by a relatively small number of press and public relations photographers to the mainstream of both professional and amateur photography. This enormous leap has been enabled by massive improvements in sensor design and digital storage, and by intense competition among the main camera manufacturers, which has constantly improved camera specifications and driven down costs.

Until very recently, any photographer aspiring to make the switch from film to digital faced the problem of knowing the most cost-effective moment to make the change. With technology improving at breakneck speed, one week's top-of-the-range and highly costly camera was the following week's unsaleable dinosaur. Now, however, things have calmed down somewhat; improvements tend to be incremental rather than revolutionary, and prices slide downwards more slowly. The technology is maturing, allowing digital photography in all its forms – but especially the DSLR – to come of age.

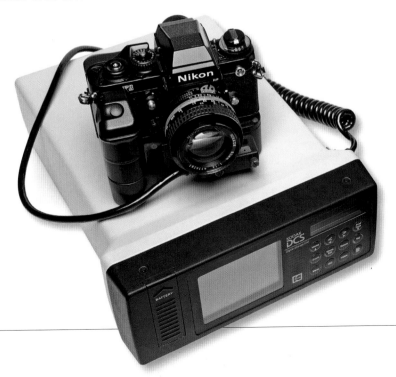

The world's first DSLR, the Kodak DCS100, along with its digital storage unit – the image storage system that today has been replaced by a tiny memory card.

History of the DSLR

	
1991	Kodak introduces the very first DSLR, the DCS100.
1992	Kodak follows up with the DCS200, the first camera with on-board image storage – a miniature hard drive.
1994– 1995	Kodak brings out the DCS420 and 460, with further major improvements to design.
1995	Kodak's first competition appears in the form of the Fujix DS-515, produced by a Nikon–Fuji collaboration, and the Minolta RD-175.
1998	Kodak introduces three more DCS cameras: the 520, 560 and 315. Up until now, all DCS cameras have been based on Nikon bodies, but the 520 and 560 are the first to use a Canon body.
1998	Press photography at the football World Cup, held in France, shows the growing dominance and advantage of digital photography.
1999	Kodak introduces the DCS620, based on a Nikon body.
1999	The Kodak–Nikon cooperation breaks down; Nikon produces its own DSLR, the Nikon D1, at a fraction of the price of Kodak's DCS cameras.
2000	The Sydney Olympics confirms the growing domination of the DSLR in sports and news photography.
2001	Canon introduces its first DSLR (the D30); Nikon expands its range; and Kodak introduces the DCS760.
2002	Kodak introduces the DCS Pro 14n, the first DSLR with a full-frame sensor. The camera flops when it fails to live up to its claimed specifications.
2001– 2005	A flurry of new DSLRs are released by the main camera manufacturers, with prices crashing and technology rapidly improving.
2005	Badly losing out to the competition, Kodak announces its withdrawal from the DSLR market.

The Digital Dawn

The digital era in photography began in the late 1980s, with the introduction of the first scanners, image-manipulation software and, of course, computers powerful enough to handle the workload. Photographs were still taken on film but were then digitized in a scanner. The computer equipment was extremely expensive (and by today's standards rather primitive), so initially almost the only takers were the world's newspapers. News publishers were perpetually fighting to get breaking news on to their front pages before their competitors, while at the same time struggling to modernize what had been an antiquated production system. They had already started computerizing their writing and design phases, so it was inevitable that they would computerize their photography too, whatever the cost.

Digital capture – in other words, photography with a digital camera – started up at about the same time. It was extremely clumsy initially. Early cameras were unable to process images and so had to be permanently tethered to a computer. Colour image capture required three separate exposures for each image – one each for the red, green and blue colours. This made it impossible to photograph moving subjects and meant that it was essential that the camera be fixed very securely to ensure absolutely no movement between exposures. These cameras' usefulness was severely limited, applicable only to studio still-life photography.

The DSLR Debut

The problems of the early days were overcome, initially with 'single pass' cameras, as they were called, allowing all three primary colours to be captured with one exposure. These were followed by models that no longer needed to be

related subjects Sensor types: (page 25). Choosing a camera: (page 35).

computer-linked. The arrival in 1991 of the very first DSLR signalled a major development. Produced by Kodak and named the DCS (later renamed the DCS100), this was the first truly portable digital camera system. Built around a Nikon F3 body and using standard Nikon lenses, it was essentially a 35mm camera with which photographers were already familiar, the film housing replaced with a digital sensor and associated electronics.

Inevitably, the system had numerous downsides. The camera was unable to store images; these had to be transferred via a cable to a cumbersome digital storage unit (DSU), worn as a backpack by the photographer. Furthermore, the sensor was smaller than a frame of 35mm film, making it impossible to capture the entire field of view of each lens, translating into a multiplication factor for their focal lengths (an issue that persists with many DSLRs today). Finally, image resolution and dynamic range (the ability to resolve information in shadow and highlight areas) were much poorer than was possible with film, a product of the sensor having just 1.3 million pixels (see page 21) – fewer than some of today's mobile phone cameras.

Over the next few years, Kodak brought out a stream of new digital SLRs that steadily improved on the DCS100. Most of them were built around Nikon camera bodies, but some were based on Canon. Technology slowly improved too, but prices remained astronomically high at GB £10,000–25,000 (US $17,000–42,500), depending on the model.

Once again, newspapers and news agencies led the way. With relatively poor image quality less of an issue than for glossy magazines, and speed of delivery vital, DCS cameras steadily replaced the slower, scanned-film route for producing photographs for newspapers. Once it became possible to email images back to editors' desks from laptop computers minutes after being shot, the DSLR reigned supreme in press photography.

Things started to move quickly in 1999, when Kodak and Nikon fell out. Nikon soon announced the development of its first DSLR, the D1, at a price considerably lower

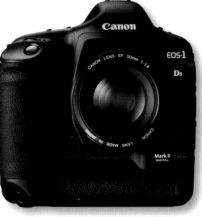

At the time of writing, what is arguably the world's leading 35mm DSLR, the Canon EOS 1Ds, with a 16.7-megapixel sensor.

than any of Kodak's cameras, followed shortly by Fujifilm with its Finepix S1 at an even lower price. Canon joined the fray with the D30 in 2001, and since then there has been a steady flow of DSLR models at rapidly falling prices and improving specifications. Coupled with the huge improvements since 2000 in the processing power and memory capabilities of the computers that are an essential extension of any DSLR, digital photography now represents a maturing and highly usable technology. Having been left behind in the race, Kodak, the great digital pioneer, withdrew from the DSLR market in 2005.

Embracing the Revolution

It is hard to imagine a world in which film has been completely replaced by electronic media, and yet this seems ever more likely – and perhaps much sooner than anyone has

Going digital: the advantages

1 The ability to see an image within seconds of the shutter being pressed, greatly increasing confidence and creativity.

2 An almost unlimited capacity to make alterations to exposure, colour and contrast following any photography session.

3 The option to remove distracting or ugly elements from an image, such as wires, cars and litter.

4 The facility to make digital montages of several images, to make stunning composites that would either take a long time to create in the studio or would be completely impossible.

5 No more film expenses to take into consideration – once sufficient memory capacity has been bought, it is possible to keep shooting as much as necessary, with every image essentially free of charge.

6 All of one's imaging can be done in a 'digital darkroom' in a home office, without the need to send material out to professional photography laboratories, or to be involved with one's own smelly and toxic chemical darkroom.

considered. It is conceivable that film will continue to have some specialist uses, but as digital cameras become ever better at image capture and computer software makes manipulation of those images ever simpler, so digital photography will develop to a point where it dominates almost all forms of photography – if it doesn't already.

But why make the switch? Film represents a well-developed, mature technology; the image quality is superb; it is reliable, and we are pretty confident in the long-term survival of images shot on most types of good-quality film, such as Kodak and Fuji. This cannot be said for many aspects of digital photography, particularly that of long-term storage. Furthermore, although digital running costs are low, the start-up investment can be quite formidable and the pitfalls numerous and expensive. The film-to-digital switch can be such a leap into the unknown that it is sometimes a wonder why anyone bothers. Yet the photographic world continues its headlong rush into the digital era, so there must be some irresistible force (other than clever marketing) behind it.

The full image that was displayed in the camera LCD screen: a 31-megabyte image of a red pepper, which could easily be reproduced in a magazine double-page spread.
Canon EOS1Ds, Sigma EX 28–70mm lens, 6 sec at f/22, ISO 100.

Perhaps the greatest single advantage of the DSLR over its film counterpart is the ability, via the LCD screen in the camera's back, to see an image within seconds of pressing the shutter.

related subjects

LCD screen menus: (page 48).
LCD screen displays: (page 49).

In-computer image exposure optimization: (page 64).

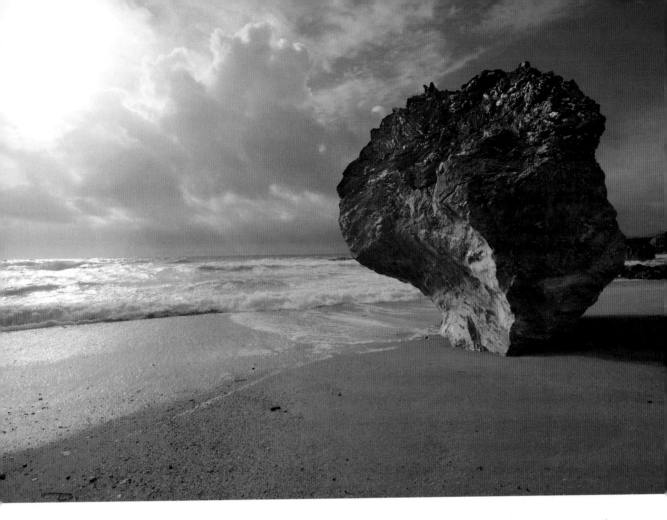

The power of digital photography lies in being able to make alterations long after the photography is finished. This is a landscape image before (right) and after (above) optimization in a computer. The image was deliberately underexposed during photography in order to capture as much detail as possible in the bright sky. Once on the computer, it was possible to lighten the main subject – the shoreline rock – to create a dramatic landscape view in which all the main elements are clearly visible. Canon EOS 1Ds, Sigma EX 17–35mm lens, 1/200 sec at f/10, ISO 100.

There are, of course, a number of factors. For both the amateur and professional photographer there is the glorious plus of being able to see an image within seconds of shooting it. Knowing that you have the image you want, correctly composed and exposed, is a massive boost to confidence. It is also potentially a great time- and cost-saver, reducing the need to take extra shots with slightly different exposures and compositions 'just in case', as one so often does with film. That LCD screen on the back of the digital camera might seem a small innovation, but for me it is probably the greatest single advantage that digital photography offers over film.

Linked with this is the creative stimulus that digital offers. Not being able to see the results of a film-based photo shoot for several hours or days, with costs that have mounted with each additional frame and roll of film used, can dampen the spirit of photographic experimentation and innovation. Contrast that with the immediacy of digital results and the fact that new frames can be shot endlessly without cost (provided one has sufficient memory available), and the creative advantage of digital is striking.

Moreover, the ease with which exposure errors can be corrected, and

Tip Make full use of the image data displayed in the LCD screen, especially the histogram, which is essential in determining whether the image has been correctly exposed.

the infinite alterations that can be made to digital images once downloaded from the camera to computer, is extraordinary. No longer is one stuck with whatever the film reproduces, captured at the moment the photographer pressed the shutter, or faced with an expensive laboratory session that may not even succeed in making the required alterations. Image-manipulation software allows a huge number of changes to be made in the computer, limited mainly by the photographer's level of skill at using the software.

And then there is the printing: there is no longer the need to go to a printing shop to have a set of dubious-quality prints made, or, in the case of the serious amateur or professional, the need for long hours in a dark and toxically smelly darkroom to generate a small number of prints. Instead, high-quality prints can be run straight off the personal computer in the comfort and clean air of one's own home or office.

Investment in a DSLR and associated computer equipment provides the opportunity for a high-quality and fully integrated digital photographic capture and output via a sophisticated 'digital darkroom': clean, bright,

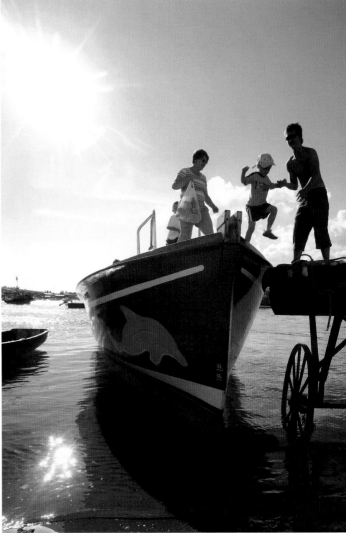

Photographing into the sun is always difficult due to the danger of flare. In this image, post-photography optimization on the computer has removed flare that was streaking across both the boat and the family. The result is a great image of a fun summer day at the seaside.
Canon EOS 1Ds, Sigma EX 17–35mm lens, 1/160 sec at f/9, ISO 100.

A simple studio shot of test tubes filled with coloured liquids illustrates just how easy it is to alter the appearance of a digital image with a few simple steps during post-photography computer manipulation.

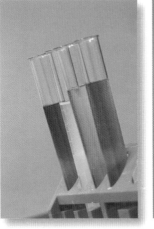

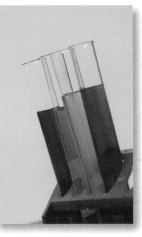

related subjects

Altering hue and saturation: (page 136).
Cleaning up an image: (page 138).

Printers: (page 154).

airy, non-toxic, and easily set up in just about any home or office.

For the professional photographer there is at least one more reason to take the plunge: the need to keep up with (or preferably one step ahead of) the competition and be able to supply what clients want. For news and sports photographers, that meant making the plunge very early on, in the 1990s. They were soon followed by public relations professionals, for whom getting an image to the end-user quickly was more important than image quality. These were followed in the early 2000s by people in the advertising world, for whom both image quality and the ability to drastically alter images were vital. Until recently, many glossy magazine and book publishers were resistant to switching from film to digital photography, since image quality is their primary concern. For many, until the past

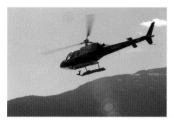

A silhouette of a helicopter, initially made unusable by the sun flare (top), and then with the flare removed during image optimization on the computer (bottom).
Canon EOS 1Ds, Sigma EX 70–200mm lens, 1/200 sec at f/16, ISO 100.

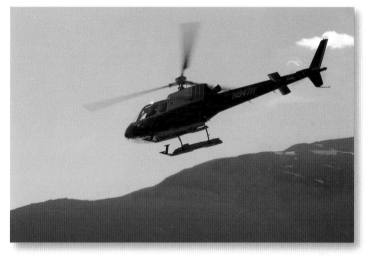

The ideal digital darkroom

1 **Computer central processing unit (CPU)** with a DVD-writer and DVD-ROM.

2 **Monitor.** Flicker-free and high resolution for good image editing.

3 **Standard keyboard.**

4 **A graphics tablet with optical mouse.** Although image editing is perfectly possible using a standard mouse, the pen, or stylus, of a graphics pad offers much finer control when highlighting specific image areas.

5 **Inkjet printer.** Although other types of printer are available, inkjet printers have become the standard. Depending on the model, they can produce very high-quality image prints.

6 **Dedicated film scanner.** Although flatbed scanners are standard computer accessories, they do not scan transparency or negative film to a very high quality, so a dedicated film scanner is needed.

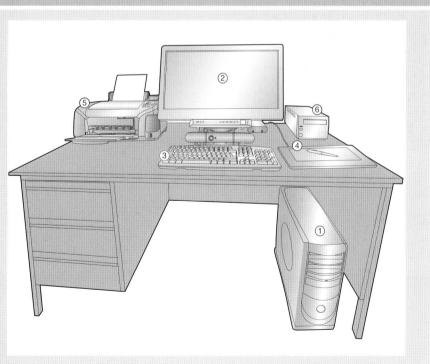

Tip When setting up a digital darkroom, choose a computer with plenty of memory and a monitor large enough to not cause eyestrain. The walls should not be a bright colour.

few years this premium quality could only be delivered by film – often medium-format film, as not even 35mm format was always acceptable. However, the advent of a few very high-specification DSLRs has brought about some rapid changes, leading editors to expect digital image submissions from their photographers.

The growth of online photo libraries has been a huge new area for professional DSLR users. Photographs are an ideal product for sale and distribution over the Internet, and this has been an area of

The first page of Nigel Hicks's image-management page within a well-known online library site.

rapid growth for professionals, especially as editors increasingly search for and buy images in this way. For the first few years, most online images had been photographed on film and then scanned, as DSLRs generally were unable to produce file sizes large enough to satisfy the demands of the online libraries' clients. However, the advent of very high-specification DSLRs, producing images with file sizes greater than 30 megabytes (MB), has changed all that, enabling these cameras to begin to dominate this market too.

The Digital Downside

Not everything is perfect with the digital world, and anyone embracing the DSLR needs to come to terms with its negative aspects. The first problem that any DSLR aspirant faces is the initial start-up cost; this is especially daunting for photographers who also need to invest in new computer equipment. Many other problems await the digital photographer, particularly when still new to the subject, although most become easier to manage with experience.

One problem that remains with the digital photographer indefinitely, and the one that is possibly the biggest single negative aspect of the DSLR, is the ease with which the sensor gets dirty. It is something that camera manufacturers have glossed over until recently. The sensors on all DSLRs will get dirty, and cleaning them without causing damage is quite a serious concern. This (and all the issues listed here) will be covered in greater detail in later chapters.

Finally, it is very difficult to adequately review large numbers of digital images quickly on a computer; you need to view each image individually rather than in batches. At the professional level, this is a backward step for editors who need to select large numbers of images for books and magazines in a short space of time. In the days of film, this simply involved taking a few minutes to look through a sheet of 20–24 transparencies laid out on a lightbox. This shortcoming was one of the major reasons for book publishers' resistance to working digitally, and I am not sure that an adequate solution has yet been found.

related subjects

Cleaning a dirty sensor: (page 108).
Image artefacts: (page 109).

Lenses in digital photography: (page 42).

Going digital: the disadvantages

1 Potentially considerable start-up cost, consisting not just of a new camera body, but also of spare batteries, memory cards and computer.

Professional digital camera equipment gathered together for work on the road – complete with laptop computer, which would be replaced by a desktop computer when at home.

2 Lenses optimized for use with film cameras do not always perform as well on a digital camera as might be hoped. Investment in new lenses may be needed.

3 Various colour and pattern artefacts (see page 109) can be introduced into images.

4 Difficulty in deciding what are the 'correct' colours for any image viewed on a computer monitor, leading to problems linking to an eventual output, such as inkjet print or publication in a magazine or book.

5 Initial difficulty in knowing how to distinguish between sharp and blurred images on a computer monitor.

6 The amount of in-computer processing needed to optimize an image can vary from one camera brand to another.

7 A DSLR's sensor will get dirty, and quite frequently. Cleaning it can be difficult and time-consuming.

8 It can be very difficult to accurately and quickly review large numbers of images.

A New Set of Ethics

One of the most interesting, and intractable, issues that digital photography raises stems from the ease with which images can be altered. The old adage that 'a photograph never lies' is simply not true any more, and a series of incidents in the early years of digital work has forced the world's news media to establish a code of ethics that strictly limits how much manipulation is acceptable.

All kinds of scenarios can be imagined in which heavily manipulated photos might be used to lie, to alter the 'truth', create a scandal or crisis, or simply to create news. Is that really smoke coming from the gun on the bow of that warship as it chases down a foreign fishing boat? Is that really footballer X kissing the wrong woman? Was that police officer really clubbing an unarmed and peaceful demonstrator?

These are all situations in which images could be manipulated – and indeed, in the past few years, more than one press photographer has been sacked for providing doctored images to their publications. It is not just individual photographers who

A fanciful digital composite image, showing CDs apparently 'flying' through the sky. This is obviously a digital creation, with no claim to represent anything in the real world.

Tip Do not be intimidated by digital photography's steep learning curve! Take it one step at a time, and concentrate on just enjoying this new form of imaging.

sometimes fall into the manipulation trap, but editors too. In the very early days of digital publishing, one very famous magazine altered an image of the Pyramids, moving two of them a little closer together to create a more pleasing composition. When discovered, this became a major story within the publishing industry, and proved to be a pivotal moment that led to the development of the code of ethics now in force.

For many photographers, whether amateur or professional, such issues may not be considered so seriously, but everyone needs to be aware of them. Of course, there are many images where in-computer manipulation deliberately aims to distort the truth, and this is usually obvious in the final photograph. The danger lies in images that subtly alter the truth and ultimately tell a lie that purports to be the truth. This can be a particular danger in nature photography, for example, where a photographer's ignorance of biology and ecology may inadvertently lead them to

The dangers of digital composites

The alteration of news by unscrupulous digital image manipulation is an obvious danger, but nature photography too can face serious problems, not necessarily out of malicious intent, but simply through ignorance of the finer details of the subject.

Although nature photographers might be able to shoot a broad range of subjects, it is almost impossible to have an equally broad, in-depth knowledge of every aspect of the biology behind it. As a result, the creation of digital composites can easily lead to the production of something that simply does not occur in nature. An example would be the creation of an image apparently showing a rare, elusive mammal in its wild environment. It may be virtually impossible to obtain such wild images. To overcome this, the animal may be
photographed in a zoo, excised from the obviously captive environment and pasted into an image of what is believed to be its wild habitat. The danger is that it could be easy to select the wrong kind of wild habitat. A Giant Panda, for example, pasted into an image of a rugged landscape forested with pine trees may look stunningly real, but is it appropriate, given that many of the coniferous forests of central and southwest China are actually spruce? Possibly only a panda expert could give a definitive answer.

So, does this matter? The answer is 'Yes', because such images – particularly if they become widespread – could in time create wide-ranging misunderstandings of our natural environment and wildlife, possibly quite damaging to efforts to protect them.

create something that simply does not occur in nature. It is each photographer's responsibility to decide what level of manipulation and distortion is acceptable for images claiming to be a true representation of the world.

For images representing places, events and people that are not that widely known, it might just be possible to get away with some considerable changes. Just don't try it with a view of something as well-known as the Pyramids!

related subjects Making digital composites: (page 146). Nature photography: (page 90).

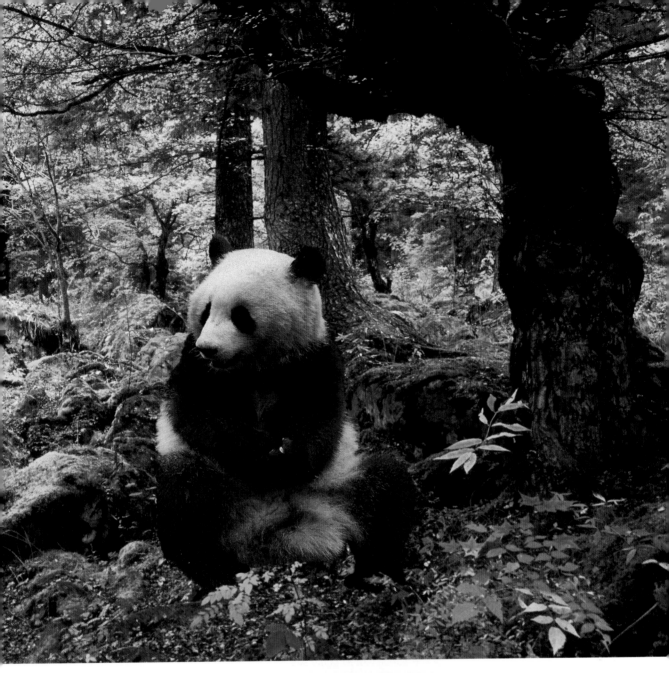

A wildlife image purporting to show a Giant Panda in its wild habitat, but actually created in a computer as a composite between a zoo-based panda and a forest scene in southwest China. As it happens, the correct type of forest has been chosen for this image, shot in a nature reserve that used to contain pandas. A real concern with this image, however, is that the panda may be a little large for the surrounding vegetation!

Tip When choosing image components to merge into a composite, take care to ensure they match, at least in the type and angle of light falling on them.

2 Catching the Light
From Digital Sensor to Memory Card

The scientific marvel of photography lies in the seemingly magical process of capturing light from a real three-dimensional view and reproducing it as a permanent two-dimensional image. For more than 100 years, the tried-and-tested method (hugely evolved and improved from its earliest days, of course) has been based on the chemical process of converting silver halides into metallic silver through exposure to light and chemicals, with the silver held in place in gelatin and mounted on a backing sheet or roll of acetate (or similar material). This process is better known to us as film – an amazing material taken for granted by anyone who has ever taken a photograph.

Abstract patterns formed by sedimentary rocks in a coastal cliff; Sandymouth, Cornwall, UK. Canon EOS 1Ds, Sigma EX 28–70mm lens, 1/125 sec at f/11, ISO 100.

It has taken just a few years for film to give way to the wholly different digital electronic route, where light is captured as an electrical voltage, and image data is stored digitally as a series of zeros and ones. Whereas film both captures and stores the image data, in digital photography the two processes are quite separate: image capture is the preserve of a light-sensitive sensor, and storage is handled by a removable memory card. Between the two lies a mass of electronic processing responsible for turning that light-initiated voltage into meaningful and high-quality image data.

Although a camera no longer needs space to house film and a film-winding mechanism, it needs instead to cram in a mass of electronic wizardry. It is a credit to the scientists, engineers and designers involved in developing the DSLR that they have managed it in almost exactly the same space originally occupied by film.

It is difficult to know exactly what goes on inside all that electronic circuitry, as the fiercely competing camera manufacturers keep much of it secret. That they all end up with high-quality images hides the fact that different camera makes probably reach the end result via quite different routes, making use of different mathematical algorithms and processing methods.

Nevertheless, image capture in all DSLRs follows one essentially similar path, as summarized in the flow chart on the page overleaf. The following pages detail each stage of the process from light capture through to image storage.

The Sensor

The sensor is the basis of all digital photography, capturing light and converting it into an electrical voltage. It is a rectangular silicon-based sheet of semiconductor material that sits in the camera where film used to go. It consists of an array of millions of light-sensitive sites. Each of these in turn consists of a photo-diode and associated electrical circuitry. Each light-sensitive site is equivalent to one pixel – the smallest unit, and hence finest resolving power, of any digital photograph. When camera manufacturers talk about a three-, five- or eight-megapixel (MP) camera, for example,

they are referring to the number of pixels, or light-sensitive sites, that make up the sensor – in this example, three, five and eight million.

The photo-diode in each pixel responds to light by producing an amount of electricity that is proportional to the intensity of the light. The pattern of high and low electrical signals emitted by the millions of pixels in the sensor in response to the light falling on each forms the basis of the image data. As described below, this electrical information is converted from the analogue, or wave form in which it was generated by the photo-diode, to a digital signal. This is then passed to the camera's image processor to produce the actual image.

Number prefixes

Some commonly used number prefixes:

Prefix	Meaning	Example
Kilo-	Thousand	Kilobyte
Mega-	Million	Megapixel
Giga-	Thousand million	Gigabyte
Tera-	Million million	Terabyte

Image processing (illustrated below)

1 Light from a view/subject
2 Focused by the camera lens on to the digital sensor
3 Photo-diodes in millions of pixels on the sensor convert the light falling on it into an electrical charge, the charge size proportional to the amount of light
4 The charge generated for each image is moved off the sensor into a buffer, temporary storage
5 Processing starts by conversion of the analogue signal to digital
6 The digital signal passes to the image processor(s), where colour interpolation occurs, followed by noise reduction, artefact removal and assembly of image data into a recognizable image
7 A thumbnail image is produced, along with data information, for display in the LCD screen
8 The image information is stored in the memory card

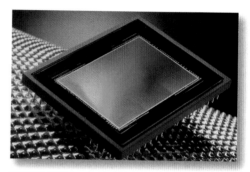

A Philips CCD sensor.

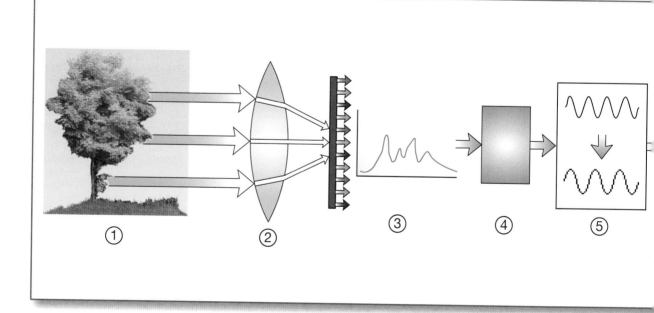

related subjects

Sensor dimensions and camera choice: (page 47).

Sensor noise: (page 109).

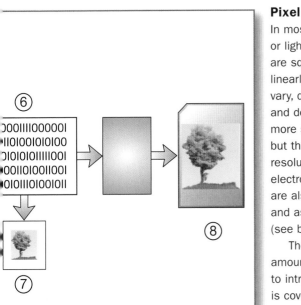

Pixel structure

In most sensors, the pixels, or light-sensitive sites, are square and arranged linearly. Their size can vary, depending on a number of factors and design compromises. Larger sites are more sensitive to light than smaller ones, but they tend to be less capable of high resolution and are more susceptible to electronic 'noise' (see below). However, they are also less susceptible to light saturation and as a result have a wider dynamic range (see below).

The photo-diodes respond only to the amount of light, not to its colour. Therefore, to introduce colour sensitivity, each pixel is covered with a coloured filter of one of the primary colours (red, green or blue), ensuring that each pixel responds to light only of that colour. Filters of all three

When a digital image is magnified several times, it breaks up into the individual square pixels that comprise the image. In principle, the smaller the squares and the more there are, the greater the detail that is possible. In this pair of images of a ferryman helming his boat through a marsh at Kvikkjokk, in Swedish Lapland, a magnified section that concentrates on the man himself clearly shows each pixel. Canon EOS 1Ds, Canon 16–35mm L lens, 1/100 sec at f/9, ISO 100.

The Bayer pattern of colour filters over a sensor's photo-diodes, showing the predominance of green. Each grouping of four pixels contains two green, one red and one blue filter.

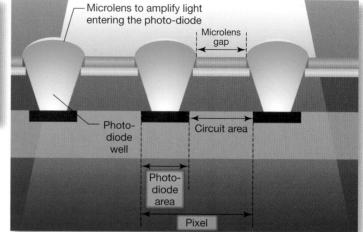

Microlens to amplify light entering the photo-diode

Microlens gap

Photo-diode well

Circuit area

Photo-diode area

Pixel

∧ A cross-section of a Canon full-frame sensor, showing two pixels. Each consists of a photo-diode and its well, a microlens over the well, and an area for circuitry.

A diagram of Fujifilm's ➤ super-CCD, showing the pixels arranged in an interleaved pattern instead of the more usual linear fashion. Each pixel consists of two photo-diodes, one large, the other small.

colours are distributed across the sensor, although, because the human eye is most sensitive to green-yellow light, this is mimicked by having twice as many green filters as red or blue. The filters are usually arranged in the Bayer pattern: each square of four pixels consists of two greens arranged across one diagonal, with a red and blue across the other diagonal.

With each pixel specialized to respond to just one colour, image resolution ought to be greatly reduced, but this is not the case. For each pixel, the 'missing' unrecorded two-colour data is interpolated in subsequent image processing using data from surrounding pixels that did respond to that colour, ensuring complete data on all three primary colours for every pixel. The fact that high-quality images, complete with accurate colour reproduction, are standard with digital images these days is testament to the accuracy of this interpolation process. In addition to the colour filter over each pixel, the entire sensor is covered by a low-pass filter. This helps to protect the sensor from the environment and, more importantly, filters out and reflects infrared light and organizes light waves as they pass through towards the sensor, greatly enhancing image quality, reducing image and colour artefacts.

CCD and CMOS sensors compared

Although **CCD** sensors have been the most widely used kind of sensor in high-quality DSLRs, the **CMOS** type is becoming increasingly common and may become the standard. Some comparisons are:

1 **CCD** sensors have a better inherent ability to produce high-quality images, but image processing overcomes many of the **CMOS** sensors' problems, such as noise.

2 **CMOS** sensors can be made more cheaply than **CCDs**.

3 Lower power consumption by **CMOS** sensors has a major implication for battery size, power and consumption in the DSLR.

4 Individual amplifiers on all pixels of a **CMOS** sensor, and simultaneous removal of the charge from across the whole sensor, gives **CMOS** sensors a major speed advantage over **CCDs**.

related subjects | Image histograms and clipping: (page 64). | Shooting to avoid burnout: (page 115).

Types of sensor

Two main types of sensors are used in DSLRs: CCD (charge-coupled device), and CMOS (complementary metal oxide semiconductor). Although CMOS sensors have been used for some time in digital compact cameras, until recently high-resolution DSLRs used mostly CCDs because of their ability to produce higher-resolution images with less noise. However, in the past few years, all of Canon's DSLRs have come on to the market using CMOS

Pixels will burn out if they receive too much light, such as when shooting into the sun. The main image shows a waterwheel silhouetted against the sun, with a white flare spreading across the image beyond the sun's position. Inset is an enlargement of part of the affected area, showing loss of saturation, contrast and burning out of many of the pixels. Morwelham Quay, near Plymouth, Devon, UK.
Canon EOS 1Ds, Sigma EX 28–70mm lens, 1/125 sec at f/16, ISO 100.

Dynamic range and burnout

The sensor's light-sensitive sites, or pixels, respond to light through the generation of an electrical charge in each pixel's photo-diode. This response is directly proportional to the amount of light received. However, when the light becomes particularly intense the photo-diode becomes saturated, and beyond this point the affected parts of the resulting image will reproduce as simply burned-out white areas, with all detail lost.

If the light intensity increases still further, the burning-out effect may start to spread across the sensor to adjacent photo-diodes that

otherwise would not be directly receiving excess light. This process is called 'blooming', and can cause serious burnout of areas of the final image.

The breadth of lighting intensity, from darkness to bright light, in which the photo-diodes can absorb light and record image detail is the sensor's dynamic range. Clearly, the wider this dynamic range is the better image quality is likely to be, so one of the main areas of work that has gone into sensor improvements is into broadening the photo-diodes' ability to react to bright light without burning out.

Tip When photographing in bright light, it is important to try to avoid burnout – a problem that can be monitored by looking for clipping of the image histogram.

sensors, generating some of the best image quality presently available, and Nikon too have started to use them.

In the past, CMOS sensors produced poorer images than CCD sensors largely due to their larger pixel size (a result of the way in which the electrical data is handled – see below) and greater inherent image noise. When Canon overcame these problems (by putting microscopic lenses over every light-sensitive site to amplify their sensitivity for the former, and through post-exposure image processing for the latter), the advantages of CMOS started to outweigh those of the CCD (see page 24). As a result, it is likely that CMOS sensors will be increasingly used in future DSLRs.

In addition to CMOS and CCD, two other sensor designs are presently in use. Fujifilm's super-CCD, used only in its own FinePix Pro range of cameras, consists of octagonal pixels arranged in an interleaved layout, lying at 45 degrees to each other. Each pixel contains not one but two photo-diodes, one much smaller and less sensitive to light than the larger main photo-diode. As a result, if the main photo-diode starts to approach saturation under intense light, the smaller, less sensitive, photo-diode starts to take over, capturing detail even in very brightly lit areas and thus preventing the image burnout that would otherwise result. Improved packing of the pixels, along with their interleaved layout, increases resolution in the horizontal and vertical axes of an image, which the eye is most sensitive to, and decreases resolution in the diagonal, to

The different angles of view possible with a wide-angle lens fitted to cameras with full-frame and small sensors. (Top) Shot with a full-frame camera, the Canon EOS 1Ds, using a 17–40mm lens set at 17mm; (centre) shot with a small-sensor camera, the Canon EOS 20D, using the same 17–40mm lens set at 17mm; (bottom) shot with a small-sensor camera, the Nikon D70, using an 18–70mm lens set at 18mm. Shaldon, Devon, UK.

related subjects

Lens choices for different DSLRs: (page 42).

The image circle: (page 43).
Full-frame versus small sensor: (page 47).

which the eye is apparently less sensitive. The interleaving also requires image interpolation during subsequent processing, something that leads Fujifilm to claim that image resolution is doubled, to 11MP from a 6MP sensor. This claim is, of course, disputed by Fujifilm's competitors.

The final sensor type is the Foveon, presently used only in Sigma's DSLRs. Taking advantage of silicon's transparency, this sensor consists of three layers of pixels, each layer responsible for capturing one of the primary colours. Mimicking the way colour film works, with its three layers of light-trapping chemicals, the Foveon removes the need for subsequent colour interpolation during image processing, and so should overcome many of the risks of colour errors in the final images.

Sensor size

For a digital sensor to be the same size as a frame on a roll of 35mm film it would have to be 24 x 36mm. However, the great majority are much smaller than this; only Canon presently uses a full-frame sensor, in its EOS 1Ds and 5D cameras. The smaller sensors were originally introduced for cost and image quality. Even though these issues are starting to ease, the smaller format seems to have become entrenched in most DSLR production. The main implication of this is the reduction in coverage achieved by the lenses – the smaller sensors are able to capture only a smaller area of the view covered by a lens than is possible with a full 35mm-sized frame. As will be described more fully in the next chapter, this results in a conversion factor for the focal length of all lenses when going from film to digital photography, usually of about 1.5. This means, for example, that a lens with a focal length of 20mm – when used with a film SLR – will have a focal length of 30mm when attached to a DSLR that has the smaller sensor. Although this helps to

Sensor dimensions, pixel count

Although two Canon cameras (EOS 1Ds and 5D) have full-frame sensors, most DSLRs (including several Canon models) use a smaller sensor, usually either 24 x 16mm or 23 x 15mm. The smaller sensor has implications for lens focal length; it also affects the final total number of pixels possible, their packing and size.

At least in theory, the larger sensor allows for pixels with greater sensitivity and dynamic range (see page 64), with the photo-diodes less prone to saturation, as well as providing higher resolution and general image quality than is possible with the smaller sensors. Canon's present top-of-the-line model, the EOS 1Ds Mark II, has 16.7 million pixels packed on to a 24 x 36mm sensor. The smaller sensors presently pack in about 6–8MP, although the Nikon D2x CMOS sensor has 12.4MP.

increase the apparent power of a telephoto lens, it decreases the effectiveness of wide-angle lenses, and has necessitated the production of a new generation of very wide-angle lenses.

Data Processing

Once light has been captured by the sensor and converted into an electrical signal, this then needs to be processed by the camera into data that can be assembled as a recognizable image.

Collecting the electrical charge

The first step in turning all those millions of electrical signals into an image is to move the electrical charges off the sensor. CCD and CMOS sensors do this in different ways. A CCD shunts the data one row of pixels at a time over to one side of the sensor, where circuitry removes each row's charges sequentially. CMOS sensors, on the other hand, have circuitry built into each pixel that removes the charge across the entire sensor simultaneously. The CMOS system, not surprisingly, has the major advantage over the CCD of speed,

Tip When choosing what DSLR to buy, do not base a choice on whether the camera has a CCD or CMOS sensor – the differences are not important to the photographer.

rapidly clearing the sensor after each image is captured and leaving it ready for the next shot.

From here, the image data moves to the memory buffer, a temporary storage site where the data is held until processing, with each image processed one at a time. The size of the buffer and the speed with which it can be continually cleared by the following processing steps are major determining factors in the capacity of a DSLR to shoot rapidly. A camera with a buffer that fills up quickly and takes a long time to clear is of no use to a sports or news photographer, who needs to shoot fast-moving action or rapidly changing situations.

Colour bit depth

One of the most crucial elements to high-quality image processing is the ability to generate all the colours, hues, shades and tones that could possibly come up in any image, and put together whatever sharp or gradual transitions that may be called for. Achieving this is largely down to the bit depth of the image-processing system. A bit refers to the data from a single pixel. In general, image colour processing consists of combining the data in blocks of eight bits to produce one byte of colour information. With each bit available in two forms (off or on, zero or one), each byte is able to generate 256 colours (two to the power eight; 2^8). These 256 colours are applied to each of the three primary colours, or colour channels, meaning that a complete RGB (red, green and blue) image can be composed of 16.7 million colours (256 x 256 x 256), which is far more than the human eye can discern.

Despite this huge number of colours, increasingly 12-bit and 16-bit processing is being used, resulting in a gargantuan number of colours that ensures extremely smooth gradations of colour tone and hue across areas such as expanses of sky.

The bit depth of an image is usually expressed as the number per channel; for example, 8 bits per channel or 16 bits per channel. However, occasionally the total bit number is given, such as 24-bit for an entire image (the same as 8 bits per channel).

Conversion to digital format

The electrical charge as collected from the sensor is in analogue, or wave form; this needs to be converted to a digital format before the image can be created. This is achieved in the analogue–digital converter (ADC). This is a critical step, the quality of which goes a long way to determining the quality of the final image. Wave-form data consists of an infinitely variable amount of information – in the case of an image, an almost limitless number of tones and colour shades. Digital data, on the other hand, can only consist of a set number of pieces of information, each discontinuous with the next. Represented as zeros and ones, each piece of information can only be one or the other – off or on. As a result, a smooth analogue curve becomes in digital a series of steps, which becomes smoother as more and more steps are built into the information to more closely approach the true smoothness of the analogue curve.

Achieving this smoothing of the digital stepped curve is partly down to maximizing the number of pixels on the sensor, but it is also a factor of how many pixels' data (known as bits) are used to build the data in each piece of information (known as bytes). For the past few years this bit depth, as it is called, per byte has normally been eight for each of the three primary colours. This set-up allows for 16.7 million colours and tones to be created in the final image – far more than the human eye can see. However, 12- and 16-bit per primary colour (or channel) processing is becoming increasingly common to generate incredibly smooth gradations of colour and tone in such aspects as sky.

Digital processing

After digital conversion, the image data goes through a number of steps, ultimately resulting in the final image. One of the most important processes is the colour interpolation required to create values

related
subjects

Sensor design: (page 24).

8-bit and 16-bit processing: (page 132).

for all three primary colours in the data coming from every pixel. As described on page 23, each pixel records the light from only one colour; data for the other two is built up from information supplied by surrounding pixels.

Processing requires several more steps, most associated with improving image resolution and sharpness. These include the removal of ghosting and colour artefacts, a risk mainly along high-contrast edges, and the smoothing of aliasing, or jagged edges, particularly visible along diagonal lines where the square pixels may become prominent.

Removal of noise is important. The product of random electrostatic discharges, noise is particularly problematic for images shot with CMOS sensors, long exposures and high ISO settings (i.e. high light sensitivity). Today's in-camera image processes have gone a long way to reducing this problem (see Chapter 6).

Another step is for user settings – those pieces of information input via the camera's menus – as well as exposure information automatically embedded, called metadata, to be included with the image data.

Shot in very poor light in a market in Belem, Brazil, the high ISO rating needed here resulted in an image showing a lot of noise, as can be seen in the magnified portion (right).
Canon EOS 1Ds, Sigma EX 28–70mm lens, 1/30 sec at f/4.5, ISO 800.

In-camera software

Usually known as firmware, in-camera software consists of the programs that control the camera's image-processing systems. As time goes by, camera manufacturers are able to improve these programs, and it is usually possible to obtain free upgrades to load onto your camera. It is worth checking your camera manufacturer's website from time to time to see if any updates are available for you to download. These can usually be copied from your computer onto your camera, though this sometimes needs to be done by a registered service centre.

Finally, all the image information is assembled to create the final image, which can then be converted into one of several standard image formats that can be stored on the removable memory card. A sub-step of this process is the production of a thumbnail image; this is displayed in the camera's LCD screen as a rough review of what has been captured.

Megapixels into megabytes

In going through all these processing steps, the electrical signals from the sensor change from being raw image data into a three-channel RGB (red, green, blue) digital image that can be viewed on a computer monitor, printed out or published in a magazine, book or brochure. What is meant by 'three-channel RGB' is that this is an image where every pixel has a complete set of data for all three primary colours; the data for each colour is known as a channel. Achieving this is largely the work of the colour interpolation process. The creation of these three colour channels results in the final image being roughly three times as large as the sensor, meaning that a 6MP sensor should generate 18MB images, an 8MP sensor 24MB files, and so on. However, since not every pixel ends up being used in an image, the final file size is usually a little

An image as displayed on the computer screen using Adobe Photoshop, showing tonal histograms for each of the red, green and blue channels, plus (at the top) the overall tonal histogram for the three colours combined.

related subjects

Colour bit depth: (page 28).
Introduction to Photoshop: (page 129).

Image size and end-use requirements: (page 37).

When saving an image to Jpeg format, a dialog box gives a range of options for the amount of compression, with 1 the maximum amount of compression and 12 the minimum. Choosing 12 ensures the smallest loss of data and so the least risk of degradation of image quality.

less than three times the sensor's size, the two examples given usually coming out at about 17 and 22MB respectively.

Image formats

The two main image (or file) formats that are of importance to photographers are known by the acronyms Jpeg (pronounced 'jay-peg') and Tiff, the former standing for Joint Photographic Experts Group and the latter Tagged Image File Format. Both these formats are universally recognized by all camera manufacturers and computers, whether Mac, PC or Unix.

All DSLRs are able to shoot in Jpeg format, but only some can use Tiff. Jpeg has for several years been the choice format for amateur photographers, largely because of its ability to compress image files down to a wide choice of sizes, as small as 1 per cent of the image's full size. This creates major savings in storage space both on the camera's memory card and in the computer. It also allows images to be emailed easily, opened on a computer

quickly and to be used on websites. However, there is a price to pay, and that is image quality. Jpeg's compression is a 'lossy' system: some image data is thrown away during the compression process. Each time the image is opened, that lost information has to be interpolated from the information still present, and so mistakes creep in, especially if the image is repeatedly opened and closed. This problem can be minimized by limiting the amount of compression each time the image is saved, but loss of image quality can never be completely overcome.

Jpeg 2000 is a newer version of Jpeg, developed to do away with the data loss associated with Jpeg compression. A lossless compression system in which no data is lost during image compression, Jpeg 2000 ought to have taken over as the Jpeg standard. It has failed to do so, however, largely due to manufacturers' fears over patents associated with the compression mathematics. Until those are resolved, Jpeg 2000 is likely to remain in the background.

Tip When saving images in Jpeg format, use only a minimum amount of compression in order to minimize the risk of loss of image quality.

In the quest to maintain digital image quality, Tiff has become the format of choice for most professionals. Compression in this format is possible, using the Lempel-Ziv-Welch (LZW) compression system, so named after its creators. Although it can reduce file size by only about half, LZW compression is lossless, thus removing the risk of loss of image quality. File sizes are inevitably large, especially with images shot on the top-end DSLRs, requiring the use of high-capacity memory cards. For emailing and use on websites, images usually need to be converted to Jpeg to reduce overall file size. However, for in-computer image manipulation, glossy high-quality image publishing and long-term storage, Tiff is very much the recognized standard for its ability to store images without loss of data (and hence potentially image quality) no matter how many times a file is opened and resaved.

To make the two formats easily identifiable when viewed on a computer, image names – at least on a PC – come with a three-letter suffix, usually .jpg and .tif, though these tags are often not visible when viewed on a Mac.

Raw formats

Not strictly speaking an image format, Raw files are created when the camera stores all the image data separately, with very little post-capture image processing. All the various bits can be assembled into an image format later on the computer by using either the camera manufacturer's own dedicated software or Adobe Photoshop's Raw Converter, which changes Raw images into Tiff- or Jpeg-format images. All DSLRs are able to shoot and store Raw files, and this is the recommended way to photograph. The advantage of shooting in Raw over Jpeg or Tiff is that any mistakes in exposure can subsequently be corrected on the computer without any loss of image quality; this is not possible if the image has already been 'locked' into a Jpeg or Tiff

The Raw files of some Canon cameras generate Tiff thumbnails, which, as a result, are viewable in Windows Explorer.

related subjects

Converting Raw images in the computer: (page 130).

Altering Raw image exposure settings: (page 131).

format. The downside is a little more time spent in front of the computer.

A serious problem with Raw formats is the lack of a standard. Since a Raw image's data can vary enormously depending on how the camera operates, the actual Raw structure varies not just from one camera manufacturer to another, but among the different models from the same manufacturer. This has made it very hard for third-party companies to produce software that can handle all the different Raw formats available. Adobe's Raw Converter, for example, has to be constantly updated to allow for new camera models. As a result, Adobe has developed what it calls the 'digital negative', a standard Raw format that works across all camera types. At present, it has yet to be universally adopted, but it is spreading steadily.

When it comes to the issue of storage space on the memory card, with Raw files having approximately the same number of megabytes as the sensor has megapixels (actually usually rather fewer), Raw files take up considerably more space than Jpeg images do, but only a third of the space that Tiff files use.

Raw file suffixes

Unlike Tiff and Jpeg, Raw format is not identical across all camera platforms. Since image capture is performed differently by each make or model of camera, the resulting Raw files are all somewhat different. To clearly identify these differences, three-letter suffixes are attached, as for Jpeg (.jpg) and Tiff (.tif). For Nikon Raw files this is .nef; for Canon .crw or .cr2; and for Fujifilm .raf. The new digital negative format has the tag .dng.

When viewed on a PC, Raw files shot on some Canon cameras have the .tif suffix attached. This is because these files generate a small Tiff-format thumbnail image, allowing them to be seen as thumbnails in Windows Explorer or on a Mac desktop before conversion to a Jpeg or Tiff. This is not possible with other Raw images, which need dedicated software to be viewable before conversion. It is this Tiff thumbnail that is seen in the file listings.

Most Canon Raw images have a .cr2 suffix, which, as a result, require Canon's own software to be viewable – in this instance, Canon Digital Photo Professional.

3
Digital Start-Up
The Equipment and What it Does

Anyone investing in a DSLR for the first time may find the initial steps daunting. With start-up costs high, it is important to choose the right camera for what you want to do. However, with new models always coming on to the market, standards steadily improving, and prices constantly falling, it can be hard to know what to choose. With so much of the camera manufacturers' digital-imaging processes shrouded in secrecy, it can be hard to compare the imaging qualities of different camera makes.

A replica of the Statue of Liberty, in front of the extraordinary architecture of the New York New York Hotel, Las Vegas, USA.
Canon EOS 1Ds, Sigma EX 28–70mm lens, polarizing filter, 1/90 sec at f/11, ISO 100.

It is all very well the makers claiming how many megapixels their cameras' sensors have, but as much of the image quality depends on in-camera image processing (see Chapter 2), the megapixel count is only part of the story.

Fortunately, the DSLR has come sufficiently far that image quality with all models is good, and in general you need not worry too much about the in-camera processing. Nevertheless, choosing the right camera for your budget and your style of photography requires some planning, so it is useful to follow a few simple steps.

Choosing a Camera

I used to encourage photographers with limited funds not to worry too much about the camera body they bought, suggesting that they concentrate on investing in the best lenses they could afford. After all, it was the lenses that focused the image and so – along with the film – were responsible for final image quality. The camera body was essentially just a black, light-tight box for holding, advancing and exposing the film, with a battery and a few useful gizmos thrown in such as a light meter. Everything else was just gimmicks.

Things have completely changed with digital. The camera body has developed

Priorities checklist

When deciding which DSLR to buy, make a checklist of your needs and likely uses for the camera:

1 Will the camera be used for amateur or professional photography?

2 Are you skilled in using a camera, moderately competent or a novice?

3 How will the images you take most likely be used – for example, in publishing, as prints for sale, or as prints simply for personal use?

4 What kinds of photography are you most likely to do, such as landscape, wildlife, portraiture, or sport?

5 Will you want to use lenses you already have with the new DSLR?

6 Do you want to get the latest model available, or will something slightly older be sufficient?

7 What is your budget?

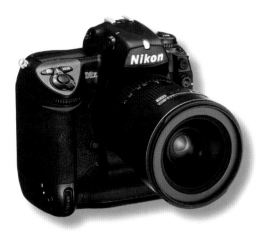

Three popular digital cameras on the market: (top) the Nikon D2x, a professional model; (centre) the Nikon D200, a 'prosumer' camera that bridges the gap between professional and amateur photographers; and (bottom) the Canon EOS 350D, aimed at amateur photographers.

from light-tight box to mini-computer, not only continuing with almost all the things that a film SLR does, but also incorporating all the elements of a 'digital film'. With film photography, choice of camera body and of film are quite separate issues, the latter often being chopped and changed long after the camera purchase according to changes in taste, quality and technology. With the DSLR, all the decisions one used to make about film become rolled into the choice of camera, so it is essential to make the right choice before spending a lot of money.

When deciding which camera models to consider, it is useful to make a checklist of priorities, as in the panel on the previous page.

Amateur or professional photography

Perhaps this is the most fundamental question to consider before committing to any decision, as it will determine a whole host of other priorities, such as budget, file sizes needed and the type(s) of photography that are ultimately to be undertaken.

Present level of skill

Someone taking their first tentative steps in SLR photography may find a top-end DSLR intimidating, as there are so many functions and options to work with. Such cameras are also rather expensive, so it may be better to invest initially in a cheaper camera in order to learn about the process of digital photography, and then upgrade later if necessary.

An experienced photographer, on the other hand, may require a more advanced DSLR to provide the quality and flexibility they need for the types of photography that they want to undertake.

End use of images

The end uses for your images will be a strong indicator of how large an image sensor you will need, and hence which camera model(s) to consider. Inevitably, the larger and higher the quality reproduction becomes, the larger the final images' file sizes must be, and hence the better and larger (in terms of the number of megapixels) the camera's sensor. Professional photographers need to think about how large their files need to be for use in advertising and publishing, the usual standard being the number of megabytes needed for a double-page spread in a glossy magazine. This is a minimum of 50 megabytes (MB), a file size that at present only one digital camera comes even close to (the Canon EOS 1Ds Mark II) without the need for file interpolation (see

related subjects | Changing image size in the computer: (page 140). | Sensor size and camera type: (page 27).

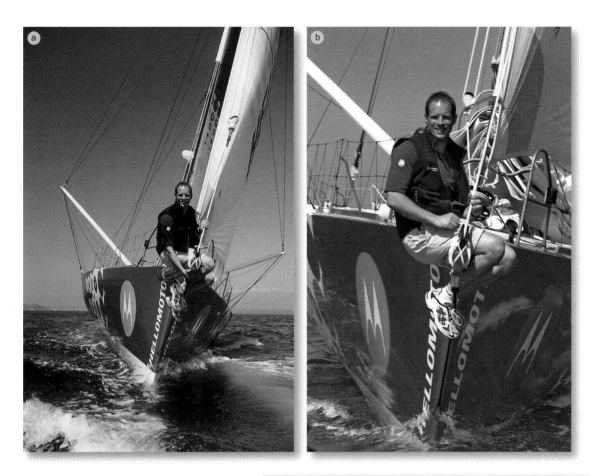

The days are long gone when the quality of digital images was inferior to those shot on film, as illustrated by these two images taken within seconds of each other. (a) was shot on Fujichrome transparency film, while (b) was shot digitally on a Canon EOS D30 camera.
Canon EOS 1Ds, Sigma EX 70–200mm lens plus 2x converter, tripod, 1/60 secat f/6.3, ISO 100.

page 140); i.e. increasing file size in the computer. Such photography requires the best cameras available.

Making prints, whether on a home inkjet printer or on more sophisticated laboratory-based machines, requires rather smaller files, though even here if intended print size starts to climb above A3 (11¾ x 16½in) then file size starts to become significant. However, for inkjet production of simple 6 x 4in snaps, file sizes of only about 6.5MB are needed – something that all DSLRs are easily capable of.

File sizes and image end-uses

One way to work out what size sensor you need on your DSLR is to work backwards from the file sizes needed for particular end uses. Using all files (except the one website example) at 300 pixels per inch (ppi), these are as follows:

Usage	Pixel dimensions	File size (MB = megabytes)
Magazine double-page spread	4950 x 3300 (approx)	49MB
Single page magazine	3300 x 2480 (approx)	25MB
Magazine cover	3300 x 2550 (approx)	25MB
A3 print (11¾ x 16½in)	4950 x 3525	52MB
A4 print (8¼ x 11¾in)	3525 x 2475	26MB
A5 print (5¾ x 8¼in)	2475 x 1770	13MB
10 x 8in print	3000 x 2400	7.2MB
6 x 4in print	1800 x 1200	6.5MB
6 x 4in image on a website at 72ppi	432 x 288	373.25KB

Tip Buy a camera that is capable of doing more than you think you need; once you get into digital photography you will probably want to push the boundaries.

Flowing water in a mountain stream, blurred in silky sheets by a long exposure. A difficult shot to pull off accurately, digital's ability to show me each resulting image within seconds of the shutter being pressed was hugely important in ensuring that I got the image just right. Resurrection Creek, Kenai Peninsula, Alaska, USA.

Canon EOS 1Ds, Sigma EX 70–200mm lens plus 2x converter, tripod, 1/5 sec at f/22, ISO 50.

Two pages of image portfolios from the author's website. Although the original images were all 70MB files, for use on the website separate low-resolution images were created that were each only about 40–80KB.

Images for use on the Internet need only be very small, from about 20 kilobytes (KB) to 3MB, depending on the intended viewing size. Only very small files are needed because the images will be seen only at the resolution of the computer monitor – usually either about 96 or 72 pixels per inch (ppi) (see page 37), which is much lower than is needed for either print production or publication. Just about any digital camera, DSLR or compact, can achieve the resolutions needed here.

Type of photography planned

No camera does everything perfectly, and as a result different models are optimized for different uses. The Canon EOS 1Ds, for example, aims at top image quality, at the expense of rapid, continuous shooting, whereas its cousin, the EOS 1Dn, is superb for rapid, continuous shooting, sacrificing a small amount of image quality to achieve this.

Sports and news photographers, who need to shoot fast-moving, rapidly changing

related subjects

Noise and the long exposure: (page 109).
Portrait photography (page 88).

Landscape photography: (page 94).
Nature photography: (page 90).

action, will need the latter kind of camera, looking carefully at such issues as a camera's maximum shooting rate and its burst rate. The former is the number of frames that can be exposed per second during rapid continuous shooting, while the latter is the number of frames that can be exposed in continuous shooting before the camera's buffer memory is full, causing it to stop shooting (even if you continue to press the shutter) until the images in the buffer have been processed and stored. In other words, a camera with a top shooting rate of five frames per second and a burst rate of 20 will keep shooting for four seconds before it is forced to stop shooting and process the backlog of images.

One of the best cameras presently available for photographers who need to catch fast-moving action is the Canon EOS 1Dn Mark II.

∧ **A sequence of action shots, catching the movements of a gull's wings, taken with the camera set to continuous, or predictive focusing, and continuous fast shooting.**
Canon EOS 1Ds, Canon 100–400mm L lens, 1/400 sec at f/8, ISO 100.

∨ **A second sequence of action shots, showing a football match being played by enthusiastic teenagers, again with the camera set to predictive focusing and continuous fast shooting.**
Canon EOS 1Ds, Canon 100–400mm L lens, 1/400 sec at f/5, ISO 200.

Landscape, travel and still-life photographers, concentrating on top image quality, will be more interested in sensor size and image-processing qualities than speed, and so should opt for cameras that provide that quality. Nature photographers might find themselves in a bit of a quandary, opting for the quality route if their photography concentrates on static subjects such as plants, but considering the fast-firing option if they photograph fast-moving mammals or birds.

Tip When shooting fast action, make sure the camera is set to both fast continuous shooting and predictive autofocus.

A view shot from a helicopter of marshland in the Rapa Valley, Sarek National Park, Lapland, Sweden. Shot on a DSLR using a lens optimized for use with film SLRs, this stunning image shows that these lenses usually work perfectly well with a DSLR.
Canon EOS 1Ds, Sigma EX 28–70mm lens, 1/800 sec at f/3.5, ISO 100.

Using existing lenses with a new camera

Lenses for digital photography are covered in more detail below, but the issue is included here as one of the priorities to include when choosing a new camera. Clearly, anyone making the switch from film to digital SLR will have a set of perfectly good lenses that will be usable with the new DSLR, and this may well determine which camera brand name they go for. Someone starting out afresh, however, will have the full range of brands and models of both cameras and lenses to consider, and choice of lenses (a guide to which is given below) may have a major influence on camera choice.

Even someone with an existing set of lenses may need to think about new lenses if they buy a camera with a sub-full-frame sensor (which, after all, is most DSLRs), and so need to improve their wide-angle photographic capability due to the focal length multiplication factor. It may also be necessary, after buying a DSLR and using it with the old lenses for a while, to invest in new lenses if any shortcomings in the existing set are shown up by the digital work.

Relative ages of available models

With the technology constantly improving, prices sliding, and new models coming on to the market, any decision on what camera to buy should include an assessment of how long a particular model has been on the market and how likely it is to be superseded in the near future. Anyone keen to obtain the latest technology might want to find out if any new models are imminent. However, manufacturers are sometimes coy about publicizing new developments in advance, presumably to ensure that the old models sell out before news of any more advanced replacement leaks out. Besides, when any new DSLR comes on to the market it generally has an initial

price premium, which falls away quite significantly after a couple of months. If you resist the temptation to snap up a new model as soon as it is available, waiting a little while can not only save money but will also mean that other photographers will discover the camera's technical glitches that need to be sorted out.

related subjects

The image circle: (page 43).
Lens aberrations: (page 45).

Film- and digital-optimized lenses: (page 44).

Available budget

This may well be the most important factor for many people buying a new DSLR, especially if they also need to buy new lenses and computer equipment. It can be a delicate balancing act between what you can afford and what you need to produce the desired photographic quality: the higher the requirements, the higher the budget needs to be.

In a scenario where technology is improving fast, it is generally better to buy the best and latest technology that you can afford, thereby maximizing the camera's lifespan before you feel the need to upgrade. However, if you are thinking about

investing in a camera whose specifications are already more than sufficient for what you need, one way to save money is to buy it secondhand once it has been superseded by an upgraded model. Many photographers feel they need the latest technology and therefore dump their old camera in favour of the new one quite quickly, generating a market of almost mint condition (since these cameras are probably no more than 18 months old) and competitively priced secondhand cameras.

Lenses for Digital Photography

In terms of film versus digital photography, there are presently three broad categories of lenses available:

1 Lenses optimized for use in film photography
2 Lenses optimized for digital photography
3 Lenses that can be used only on small-sensor DSLRs.

For someone switching from film to digital photography, the first choice in lens selection is likely to be to continue using the lenses they already have, which will certainly belong to the first category.

Someone buying a DSLR as their first SLR of any sort would do well to concentrate on lenses in the second and third categories. It is likely that anyone in this position, when considering which camera to buy, will be offered a package that includes the camera body and a 'standard' zoom lens, with a focal length of the order

A DSLR fitted with a 'standard' range zoom lens, 17–85mm, often offered by retailers as a package with the camera body.

The Canon 10–22mm lens, one of a new breed of very wide-angle lenses that can only be used on cameras with small sensors due to their small image area.

Focal length multiplication

For all SLR lenses, whether used for film or digital photography, the focal length is quoted for its use on either a film SLR or a full-frame DSLR. A 28mm lens, for example, will have a focal length of 28mm when used on either a film SLR or a full-frame DSLR. This measurement has become a common means of labelling a lens, to help identify it as wide-angle, standard or telephoto, and the relative position of each lens within their category. Thus, a 17mm lens is considered to be very wide-angle, but a 28mm lens only

moderately so; a 70mm lens a short telephoto, but a 400mm lens a powerful telephoto.

However, most DSLRs have a sensor that is smaller than the full frame, rendering this classification a bit awkward and necessitating a correction factor to be applied. Such sensors capture a smaller amount of the lens's image circle (see box, opposite) than is possible with the full-frame, giving any lens used with them a narrower field of view in the final images. The effect of this is to lengthen the lens's effective focal length by an amount

that is characteristic for the camera's sensor.

Most sensors vary between 23 x 15mm and 24 x 16mm, giving correction factors of between 1.3x and 1.6x, meaning that a 17–35mm lens applied to a camera whose sensor has a 1.6x multiplication factor actually has an effective focal length of 27–56mm. This is a crucial factor that must be remembered when any DSLR body and/or lenses are being bought as this is something that will significantly impact upon wide-angle photography.

related subjects

Sensor design: (page 24).
CCD and CMOS sensors: (page 25).

Full-frame versus small sensors: (page 47).

of 18–55mm. This will give a modest range of views from moderately wide-angle to short telephoto, passing through what is called the 'standard' focal length, generally at about 50mm and providing a view similar to that possible with the eye. These focal lengths – even when quoted for a lens optimized for use on a DSLR – apply to their use on either a film SLR or a DSLR with a full-frame sensor. Since most DSLRs use a smaller sensor, a conversion factor has to be applied, usually 1.3 to 1.6, depending on the camera model. When that 18–55mm lens is used on a camera that requires a 1.6x conversion, its digital equivalent focal length range becomes 29–88mm, meaning that it behaves as a 29–88mm lens would on a film SLR or full-frame DSLR.

A small range lens like this is useful for general work and for experimenting when new to SLR photography. However, to take full advantage of the huge potential of the DSLR, a much wider range of lenses should be included in the kit bag. The initial choice here is between zoom and primary (or fixed focal length) lenses. It used to be that the latter were optically superior to zooms, and were the lenses of choice for those in search of ultimate image quality. In recent years, however, zooms have improved enormously, and they are hard to beat for convenience and versatility. Today, almost all photographers prefer zooms over prime lenses, usually operating with three or four to cover all their likely needs.

Picking lenses depends very much on the kind of photography you are likely to want to do: powerful telephoto lenses will be important to sports and nature photographers; short telephoto lenses for many kinds of portrait photography; and a full range from wide-angle to telephoto will be needed for travel, landscape and architectural photographers. For someone shooting with a film SLR or a full-frame DSLR, a typical set of lenses would include 17–35mm, 28–70mm and 70–200mm lenses, plus perhaps a macro lens for close-up work.

When applied to a DSLR with a small sensor, a significant part of the wide-angle capability is lost due to the focal length multiplication, so it will become important to invest in a further very wide-angle lens, such as Canon's 10–22mm. When used on its 350D and 20D cameras, this lens has an equivalent focal length range of 16–35mm.

Many of the very wide-angle zoom lenses are quite new on the market, and have been introduced specifically to overcome the problem of lost wide-angle

The image circle

The image captured by a lens is actually circular (known as the image circle), not the rectangular shape we see in our final photographs – that is down to the image frame, whether film or digital sensor. With a film camera or full-frame DSLR, the rectangular area captured represents the maximum-sized rectangle that can be fitted into the image circle. The smaller DSLR sensors, however, capture a much smaller part of that circle, narrowing the lens's field of view and increasing its effective focal length.

Most lenses optimized for digital photography retain the same-sized image circle as those optimized for film. However, a few lenses – notably the very widest wide-angle lenses – have been designed to fit only on to those DSLRs with a small sensor. This is because they have been designed to produce a much smaller image circle – one that closely fits the small sensor's dimensions and is too small for the full-frame view. This has enabled the lenses to be much smaller, lighter and cheaper than would otherwise have been possible for such very wide-angle lenses.

The image circle. The circular area encompassed by a lens is inevitably much larger than the largest rectangular image frame that can fit into it. The larger of the two boxes shows the area captured by a full-frame 35mm sensor, while the smaller shows the area available to a camera with a small sensor. With a very wide-angle lens designed to work with small-sensor cameras, the image circle would be much smaller to match the sensor's smaller image rectangle.

Tip It is important to minimize the risk of lens distortions by choosing lenses that have only a relatively modest zoom range.

Film-optimized lenses with DSLRs: the downside

Lenses optimized for use on film SLRs do not always work as well on a DSLR as might be hoped, for the following reasons:

1 Vignetting or shading of the image corners may occur, particularly with wide-angle lenses and especially on cameras with full-frame sensors.

2 The images may not be as sharp as they might, largely due to the lens's resolving power not being as great as that of the latest sensor pixels.

3 Chromatic aberrations, particularly when using cheaper lenses, can result from inexact focusing of light of different wavelengths, resulting in colour banding that is more than one pixel wide, and that consequently can be recorded by the DSLR's sensor.

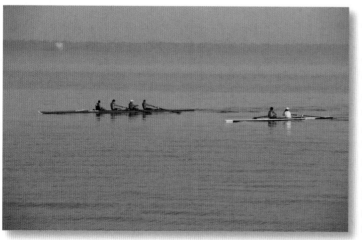

Vignetting can sometimes be a problem for film SLR-optimized lenses used on a DSLR, particularly – as here – when used on a full-frame DSLR.
Canon EOS 1Ds, Sigma EX 70–200mm lens, 1/160 sec at f/8, ISO 100.

capability when using a small sensor. Often they fit into the third category of lenses listed above, frequently being unusable not only on film SLRs but also on full-frame DSLRs. This is due to them having an image circle that is much smaller than normal, only just larger than the area covered by the sensor, and too small for the image circle needed to cover a full-frame sensor (see page 43).

Film-optimized lenses

While lenses optimized for use with film SLRs generally work well on a DSLR, there are a number of issues affecting image quality that need to be addressed. These are discussed below.

Vignetting in image corners

With lenses optimized for film photography, the light passing through is diffracted by the final lens element to cover the entire film frame or digital sensor in such a way that (depending on the lens design) it may reach the furthest corners of the frame at quite an acute angle. With film this generally does not matter – provided the film is exposed the light's incident angle is unimportant. With a digital sensor, however, it matters a great deal because each pixel is concave, the result of which is that the pixels' base is likely to be shaded by its sides. This will show up in the final image as shading or vignetting in the corners of the images.

Wide-angle lenses are most prone to this problem, though it can happen with telephoto lenses too. With numerous different lens designs in existence, it is difficult to say exactly which lenses will suffer this problem more than others. Vignetting is more likely to occur when using a DSLR with a full-frame sensor due to the larger image area included in the final image. The smaller image area created by cameras with a smaller sensor may crop off most, if not all, of the vignetting, reducing or even doing away with the issue. Carry out some tests with your lenses when you first set out with a new DSLR to see which of your lenses, if any, suffer from vignetting.

One of the steps involved in optimizing lenses for digital work is to alter the angle at which light leaves a lens's final element and thus at which it strikes the corners of the sensor, making that incident angle much less acute.

related subjects Removing image aberrations in Adobe's Raw converter: (page 131).

Focal length multiplication: (page 42). Sensor size: (page 47).

Image resolution

Recent improvements in sensor design have increased their resolution to the point where they now show up inadequacies in film SLR-optimized lenses. As a result, photographers shooting with such lenses may produce images that are not as sharp as they could be. Most such lenses have a resolution down to about 0.01mm (or 10 microns/10μm), whereas in the latest generations of sensors the highly packed pixels are often between 5 and 8 microns across. Thus, the resolving power of many film-optimized lenses no longer matches that of the sensors – an issue that the newest generation of digital-optimized lenses aims to address. A final critical issue concerns the resolution of images that are captured with a smaller sensor. To blow up an image to a given size, whether as an inkjet print or in a magazine reproduction, requires a greater magnification for an image captured on a small sensor than for one shot using a full-frame sensor. As a result, the small sensors put extra strain on the resolving power of the lenses, necessitating sharper focusing than might be necessary on full-frame sensors.

Chromatic aberrations

Linked to the issue of resolution is that of lens chromatic aberration, resulting in small amounts of colour banding. Most common in cheaper lenses, it is caused by the fact that glass refracts light of different

An architectural shot in which the lens has caused chromatic aberrations, particularly near the top of the building (see image left, and its inset). In the image on the right, the problem has been corrected in the computer using Adobe Photoshop. The Petronas Towers, Kuala Lumpur, Malaysia.
Canon EOS 1Ds, Canon 24mm tilt and shift lens, 1/80 sec at f/16, ISO 100. Image courtesy of Jon Hicks.

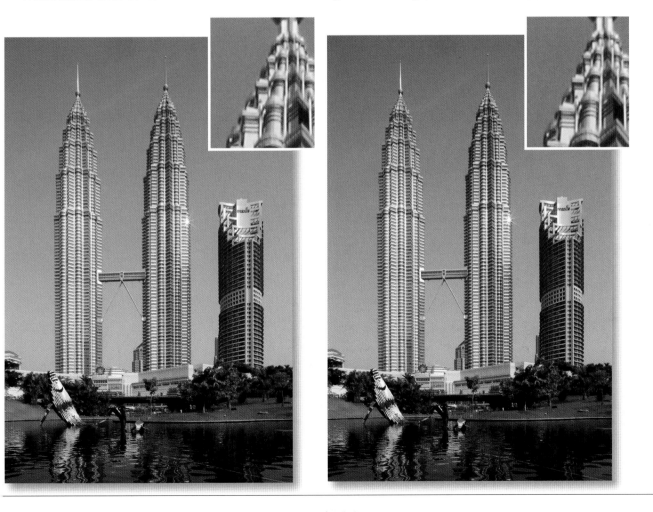

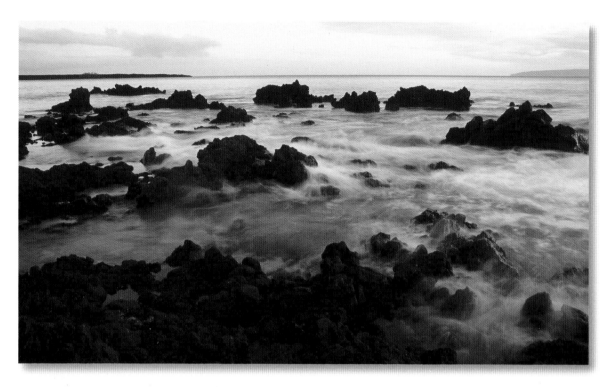

A rocky shoreline at Makena, Maui, Hawaii, photographed at dusk using a 17–35mm lens. The image shows a small amount of barrel distortion, as revealed by the slightly curving horizon.
Canon EOS D30, Sigma EX 17–35mm lens, tripod, 1 sec at f/22, ISO 100.

colours by different amounts, which, if not then refocused perfectly on the sensor, can result in narrow bands of colours where there should be a sharp point or line.

For this to be invisible in a digital image, that band would have to be less than one pixel wide and hence unrecordable on the sensor. However, it is often as much as two pixels wide, and so can become clearly visible in an image viewed on a computer screen when blown up to 100% zoom. In a typical inkjet print such an aberration may not be visible, but it can become an issue in a high-quality publication.

Other lens aberrations

While the new generation of digital-optimized lenses may be able to overcome the problems of vignetting, resolution and chromatic aberrations just described, the drive by lens manufacturers to produce ever-wider focal length ranges on their zoom lenses threatens to worsen another problem – image distortion. Wide-angle lenses tend to suffer from the issue of

barrel distortion, where parallel lines bulge outwards, whereas telephoto lenses are prone to pin-cushion distortion, in which parallel lines curve inwards. In a zoom lens with a range that goes from quite wide-angle through to moderately telephoto, it is possible for lens designers to correct the aberration at one end of the scale but not at the other, creating an argument for choosing lenses with only a limited zoom range (no more than about 3:1) and of only the best quality.

Digital SLR Features

When considering which DSLR to buy, it is useful to make a list of the features most important to you, and then run through the specifications of a variety of models to see how they measure up in those areas. Examine not just whether a camera has a particular feature, or what range of settings might be available for that feature, but also the ease with which that feature can be accessed and operated. For example, can

related subjects Megapixels to megabytes: (page 30). The image circle: (page 43).

the LCD screen viewing options be changed with a single press of a button using just one finger, or does it require a complex series of movements needing both hands? It may seem a small point in the warmth and relative comfort of a shop, but pressing multiple buttons in the dark, in freezing cold weather and with hands protected by gloves can become a major irritant!

To help in the selection process, the most important features are described here, concentrating on those that distinguish the DSLR from the film SLR.

The megapixel count and sensor size

There are two issues to look at here: the sensor's dimensions, and the total number of pixels crammed on to it. The former is a choice between full-frame and small sensor, and the decision here will be based on budget, required image file sizes, and the perceived impact on wide-angle photography that a smaller sensor would have. Cameras with full-frame sensors tend to be more expensive, but also give larger file sizes and generally higher image resolution, although the best small-sensor cameras seem to be catching up rapidly. The focal length multiplication factor needed for lenses used on small-sensor cameras is not going to go away, and anyone who dislikes this and the idea that they may have to invest in a new very wide-angle lens may prefer the full-frame sensor option.

As for the megapixel count, this is going up all the time as sensor technology improves and pixel size reduces. In general, the higher this number the better, though it is perfectly possible for the latest camera model with a modest megapixel count to give better images than an older model with a very high megapixel count. This is due to the former having better image processing. Bear this in mind when deciding whether to buy a brand new or an older model.

Most of the newest DSLRs, particularly those aimed at the consumer/amateur photographer market, presently have sensors with 6–8MP. These will generate RGB files of about 17–22MB, more than large enough for most printing and suitable for some forms of publishing. A professional photographer supplying photo libraries and advertising agencies will generally need a camera producing larger files than this.

The pros and cons of full-frame and small sensors

1 Full-frame sensors make it easier to produce cameras that generate large file sizes.

2 To blow an image up from its in-camera frame size to any given end use, such as an inkjet print or magazine publication, requires less magnification from an image captured on a full-frame than it does from a small sensor.

3 Full-frame sensors are more forgiving than small sensors of a lens's resolving power.

4 A full-frame sensor allows the use of larger pixels, which generally have a larger dynamic range than smaller pixels, allowing more detail to be captured in dark and highlight areas of an image.

5 No multiplication factor needs to be applied to lens focal lengths when used on cameras with a full-frame sensor.

6 Small sensors are much cheaper than full-frame sensors, making the DSLRs in which they are used much cheaper.

7 The smaller image circle of a small sensor opens up the possibility of development of a new generation of lenses that are much smaller, lighter and cheaper than many of those built for film and full-frame digital SLRs.

8 The smaller image circle of a small sensor reduces the risk of vignetting or corner shading occurring when using lenses optimized for use on film SLRs.

Tip Don't make your purchase until you have established the criteria for the camera you need and have identified which one(s) fulfil those criteria.

Camera LCD screen menus

The menus displayed on the LCD screen on the back of the camera are typically divided into sets that cover camera settings, image edit choices, and various tools. The most typical can be listed as follows.

Setting/tool	Explanation
Image quality	The format images are shot in; e.g. Jpeg (different qualities), Tiff or Raw
White balance*	The white balance control settings
Color temp	The exact colour temperature the camera is programmed to balance images against (only in those cameras with the facility to enter exact colour temperatures)
AF mode*	Selection of the different autofocus modes
Metering mode*	Metering mode selection
ISO speed*	ISO speed selection
Colour space	The choice of colour-management system; usually sRGB or Adobe RGB
AEB*	Automatic exposure bracketing
WB shift or bracket*	Shifting or bracketing exposures around the white balance
Review	Review of images in the LCD screen switched off or on, and for how many seconds displayed
Highlight alert	Burned-out areas of image shown in the LCD screen are lassoed and flashing
Display AF points	For cameras with multi-point autofocus, the points used to focus the camera for any image are shown over the image displayed in the LCD screen
Protect	Protection of images to make accidental deletion impossible
Auto power off	Time after which camera power is automatically shut off if it is not used
LCD brightness	Option to alter the brightness of the LCD screen
Date/time	Setting the date and time stored in the camera
File numbering	Choices for the way in which images are numbered
Language	Language choices to be used in LCD screen text displays
Firmware	The firmware being used by the camera and means to update it
Sensor cleaning	Holds the mirror up and shutter open (as long as the camera remains switched on) to allow cleaning of the sensor

* On some camera models these are controlled by separate buttons or dials, and so are not displayed in the LCD screen.

The LCD screen: menus

Not just for reviewing images, the LCD screen is also used to display a series of menus, each listing a host of possible settings. It may seem intimidating at first, until you realize that most will never be touched, several more will only be used when the camera is first set up, a number will only be called upon from time to time, and just a handful will be in regular use.

The menus vary from one camera model to another, but the most important and most used options include the shooting mode, focusing mode, ISO setting, metering mode, colour balance and management settings and exposure bracketing, plus a host of options for the way the camera operates (see box left).

Typical menus readable in the LCD screen on the back of a DSLR, in this case a Canon EOS 20D.

The LCD screen: image review settings

Immediately after pressing the shutter, the image taken will be displayed for a few seconds in the LCD screen (the exact length of time alterable in one of the LCD menus). In addition to this, any image stored in the memory card can be reviewed in the screen, and there are a number of options for exactly what will be displayed.

related subjects

Assessing exposure with the histogram: (page 63).

Histogram clipping: (page 64).
Image formats: (page 31).

LCD screen image review options

Images can be displayed in the LCD screen in a number of ways. The exact choice varies from one camera model to another, but generally consist of the following:

Multi-image

Can display several images simultaneously, sometimes with two settings – typically for display of four or nine images. Useful for comparing similar shots in a series for composition and relative exposure.

Full screen

The image is displayed across the whole of the LCD screen. Useful for checking overall composition.

Magnify

There is usually an option to blow up the full screen image to review limited parts of it. Useful to check focusing and to review composition details (e.g. has a subject got their eyes open or closed?).

Info

a) displays a small image in one corner of the LCD screen, with the rest occupied by the image histogram and a variety of image information (e.g. shutter speed, aperture, ISO setting, metering mode, white balance, file number, date and time); or

b) displays a full-screen image with the data laid over it. In this case data and histogram usually have to be scrolled, each being displayed too large to all fit in the screen together. Of all the data, the histogram is the most important; it is essential to check for correct exposure.

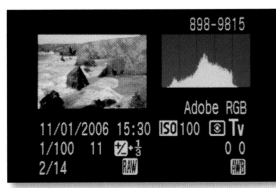

The info option as displayed on a Canon camera, showing thumbnail, histogram and metadata together.

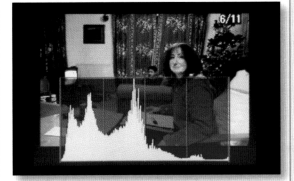

The info option as displayed on a Nikon camera, showing the histogram overlaid over a full-screen image. The histogram can be replaced with metadata by scrolling through options.

Tip Make full use of the LCD screen's data, particularly the histogram, which is essential in establishing whether an image is correctly exposed.

The principles of colour temperature

The colour temperature scale is a convenient way of comparing some of the properties of visible light of different wavelengths. It is derived from the ability of an incandescent metallic light source to emit light of different colours when heated to different temperatures, starting with orange and red at the lower temperatures, passing through white in the middle, and rising to blue at the top of the scale.

The temperatures at which these colours are emitted, known as the colour temperature, are measured in Kelvin (K), in which zero is equal to –273 °C, the temperature at which hydrogen freezes. The chart shows where common light sources come on this scale; for example, the candle at 1900K, tungsten light sources at 2800–3400K, the red light of sunset and sunrise at about 3400–4000K, normal daylight at 5500K, and the blue sky of a sunny day right up at the top at 11,000K.

Fluorescent lighting is generally not included in the colour temperature scale since it emits a discharge of light, but is not an incandescent light source. Fluorescent tubes, for example, emit light from a coating of phosphor that glows when an electric current is passed through mercury vapour.

What these options are and how they can be selected will vary from one camera model to another, but in general they consist of those shown in the box on page 49. Each has its own uses, and for many photographers arguably provide the most crucial advantage of digital photography over film: instant access to images as soon as they have been shot.

Colour temperature control

Balancing the colour temperature of the images with that of the available lighting is critical to good photography – particularly when shooting indoors under artificial light – and yet it is traditionally one of the least understood aspects of photography. As explained in the box below, every light source, whether it be the sun or a tungsten light bulb, has its own colour temperature; if photographic images are to reproduce colours accurately, they must be balanced with that light source's colour temperature. Failure to do so generally results in an odd colour cast to the images – for example, an orange glow in images shot under tungsten

The colour temperature scale

Candle flame 1,800–2,000K	Torch bulb 2,500K	Domestic tungsten bulb 2,800K	Sunrise/ sunset 3,000K	Early morning/ late afternoon 3,500K	Average noon daylight 5,500K	Under cloudy sky 7,000K	Shade under blue sky 7,500K

Electronic flash 5,500K

Tungsten photoflood lights 3,400K

Studio quartz bulbs 3,200–3,400K

Clear blue sky 10,000–15,000K

2,000K 3,000K 4,000K 5,000K 6,000K 7,000K 8,000K 9,000K 10,000K 11,000K 12,000K 13,000K 14,000K 15,000K 16,000K

The colour temperature table, showing the range of colour temperatures and colours, plus where the different light sources fit on the scale.

related subjects — Altering image colour temperature in the computer: (page 125).

ISO setting and the effect on digital noise: (page 109).

lighting, or an awful green cast in those taken under fluorescent tubes.

The ease with which colour temperature balance can be achieved by a DSLR compared with film photography represents one of digital's great leaps forward. With film there is simply the choice of standard daylight-balanced film (balanced for 5500K) or tungsten film (balanced for 3400K). Any refinements to colour temperatures beyond these two require the sometimes complex use of filters. With the DSLR, all this can be done automatically by the camera. All DSLRs come with a set of options, usually known as white balance settings, for balancing colour temperature automatically (AWB), in sunlight, in shade, under cloudy conditions, under tungsten lighting, under fluorescent lighting, and with a custom white balance setting (see box and Chapter 4).

Options for choosing different white balance settings, displayed in the LCD screen of a Canon EOS 350D camera.

Many professional DSLRs also allow the photographer to enter specific colour temperatures to which the camera should balance the images. This allows some very fine control for specific and perhaps unusual lighting circumstances. It also makes it possible to shoot with very fine control if you deliberately want to use the 'wrong' colour temperature to put a specific colour cast across the images, such as a warming reddish cast to suggest a cosy or romantic atmosphere, or to enhance the red light of sunset or sunrise.

Camera white balance settings

DSLRs typically have the following white balance settings:

Setting	Explanation
AWB	Automatic white balance; effective across the colour temperature range of about 3000–7000K, this detects the colour temperature of the ambient lighting and automatically sets the white balance accordingly.
Sunny daylight	The camera is balanced to 5500K, the colour temperature of sunny daylight in the middle of the day.
Bright cloudy conditions	The camera's white balance is set for colour temperature conditions in bright cloudy weather, usually about 6000K.
Shade on sunny day	The white balance is set to the colour temperature of light in shade on a sunny day, about 7000K.
Tungsten	The white balance is set to balance with the colour temperature of tungsten lighting, usually about 3400K.
Fluorescent	The white balance is set to balance with fluorescent lighting. Some cameras have three different fluorescent lighting settings in order to balance with different types of fluorescent tubes.
Flash	The white balance is set to the colour temperature of the flashgun used, which is usually about 5500K, or a little above.
Custom	The photographer can set up a white balance for unusual, specific colour temperature conditions.

ISO setting
Equivalent to film speed, this measure of sensitivity to light uses exactly the same scale as film speed settings, namely from about 25 up to 3200 ASA, rising from low to high sensitivity, and with 50–100 ASA being the usual settings required for most types of everyday photography.

The huge advantage of digital over film photography is that, with the former, the ISO setting can be altered for every image, whereas with film it is set for each roll – changing ISO involves removing the present film from the camera and inserting a new one with a higher or lower ISO setting.

Tip The most convenient white balance setting is automatic (AWB), which can control image white balance under a wide variety of colour temperature conditions.

ISO selection, as displayed in the LCD screen of a Canon EOS 350D camera.

O1	
Quality	
Red-eye On/Off	
Beep	▶100
AF mode	200
Metering mode	400
ISO speed	800
	1600

A fast-moving sport such as powerboat racing requires a camera that can shoot continuously for a prolonged period, loaded with a fast-writing memory card capable of keeping pace with the rapid production of new images.

All current DSLRs have a range of ISO settings from 100 or 200 to 1600; some also include 50 and 3200. How one sets the options varies from camera to camera, but in all of them it is a quick and simple process. As with film, image quality

deteriorates at higher light sensitivity settings – for film, due to increasing film grain size; for digital, due to electrostatic 'noise'. This problem will be described in more detail in Chapter 6.

Shooting speed and burst rate

This is important to sports and news photographers who need to shoot fast-moving action. Information on shooting speeds and burst rates can normally be found in the camera's specifications. While the latter cannot be altered by any of the camera's controls, shooting speed can be adjusted, with a couple of options, usually single shot plus fast and slow continuous shooting speeds.

Image formats: (page 31).
Cameras for fast action: (page 38).

Image buffer sizes and processing speed: (page 39).

Image format(s) and qualities

All DSLRs can shoot in Jpeg and Raw formats (some can simultaneously save images as both), whereas only a few can save images as Tiff files. A standard feature is to offer a series of Jpeg image qualities, normally defined simply as large or fine, medium and small. The large/fine quality makes use of all the pixels on the sensor, while the other two use steadily fewer, generating lower-quality images.

Photographers for whom image storage space is at a premium and who are interested mainly in shooting family snaps to be printed out on an inkjet printer may be happy using one of the lower-quality Jpeg formats. However, those for

whom image quality is the overriding goal are likely to use mostly Raw format, despite its greatly increased memory requirements.

Memory cards and image storage

All images need to be saved on the in-camera removable memory card, so the larger the files the fewer images it is possible to store on one card. With camera sensors and hence file sizes constantly increasing, this could have become a problem were it not for the fact that memory card capacity has also increased hugely over the past two to three years.

All DSLRs take at least two types of memory card: CompactFlash and Microdrive. An increasing number also take a third type, the secure digital card, or SD card. The first is a solid-state semiconductor, consisting of two types (I and II) with slightly different thicknesses, but both fit into any DSLR. The Microdrive consists of a minute spinning hard drive, an almost exact miniature of a computer hard drive disk. The SD card is similar in appearance to a CompactFlash card, but is thinner.

Until a few years ago, the Microdrive offered the best solution to photographers needing high storage capacity, but CompactFlash storage has come along so fast that that advantage has disappeared. Both Microdrives and CompactFlash cards are now available with several gigabytes (GB) of capacity. Furthermore, since CompactFlash cards, unlike Microdrives, have no moving parts they are less susceptible to breakage and so should have a much longer lifespan. Although remarkably robust, beware that they are not built for rough handling. Until recently, the storage capacity of SD cards was too small for them to be of much use in a DSLR. However, like CompactFlash, their capacity has grown, with top-end SD cards now having memories

Different kinds of memory card that can be used in a DSLR: CompactFlash (top), Microdrive (above), and SD card (below).

> A brilliantly sunlit view, not in Paris, but outside the Paris Las Vegas Hotel, in Las Vegas, USA. Shooting digitally enables the photographer to be sure that precious holiday memories or vital professional shots have been exposed and captured accurately, something that was not possible with film. However, as with the camera used to shoot this image, large files demand the use of high-capacity, fast-writing memory cards.
> Canon EOS 1Ds, Sigma EX 17–35mm lens, 1/125 sec at f/16, ISO 100.

ᐱ
Sandy cliffs lit up by golden evening sunlight. West Bay, Dorset, UK. The great advantage of digital over film is that as the light evolves with the sinking sun you can keep on shooting without extra cost: you don't have to worry about wasting money with each additional, and possibly wasteful, frame shot on film.
Canon EOS 1Ds, Canon 17–40mm L lens, 1/200 sec at f/10, ISO 100.

of about 1GB. This is quite adequate for DSLRs with smaller sensors.

Many new DSLRs are supplied with a memory card, but they are usually too small to be of much use, except perhaps for shooting low-quality Jpegs. The need to invest in additional cards can come as an unwelcome and expensive surprise for those new to a DSLR. Expressed as cost per megabyte, memory cards are probably the most expensive form of digital storage. So although it is important to buy enough cards to cover storage needs for any photographic outing; they should not be used for long-term image storage. Images should be downloaded from the cards on to some form of hard drive as frequently as possible, freeing up the expensive memory cards for the next photographic session.

When considering what cards to buy, the first consideration is storage capacity. If you intend to use Raw format frequently, it is no good buying cards that are so small a new one will have to be inserted every five minutes. Instead it may be tempting to simply invest in one huge card that will always have sufficient capacity for any

photo shoot without the need to swap cards. However, then there is a vulnerability – damage to or loss of that one card could see the destruction of a lot of images and leave you with no image storage at all. A safer balance is to have two or three medium-size cards that offer both a large amount of storage and back-up safety.

A further issue to consider when buying cards is write speed – the speed with which image files can be written to the card. High-speed cards are considerably more expensive than slower ones. Slower cards may be fine if your image sizes are quite small (either through having been shot with a small camera sensor or in a low-quality Jpeg format). However, if shooting in Raw format and/or with a large sensor, the relatively large file sizes may make the slower-writing cards almost unbearably slow. They are likely to have a significant impact on the camera's ability to shoot rapidly, greatly increasing any downtime during which the camera is unable to shoot due to its buffer being full. If this is likely to be an issue, the more expensive, fast-writing cards are essential.

4

Film and DSLRs Compared
Functions and Settings

Photographic techniques are very similar whether you use a digital or a film camera. All the laws of composition, lighting, focusing and exposure still apply, and many of the functions on a DSLR are identical to those of a film SLR. This is one of the main reasons why many photographers find the transition from a film SLR to a DSLR relatively painless.

The main camera manufacturers have largely managed to retain the look, feel and control processes of their film SLRs in their DSLRs. This helps photographers to adapt quickly to their new machines, so they can start taking pictures with them in more or less the same way that they did with their film cameras.

Digital cameras have come a long way in a short time. The digital SLR used for this image of wild lupins managed to capture all the subtle tones, lit by dull, rain-filled light, as beautifully as any film camera could have.
Canon EOS 1Ds, Sigma EX 70–200mm lens, 1/50 sec at f/11, tripod, ISO 100.

Appearances can be deceptive, however. It is possible to feel sufficiently comfortable with a DSLR that has many controls familiar from a film camera to be able to start shooting digitally straight away. Nevertheless, there are also quite a few differences that need to be learned, enabling the photographer to slowly adjust to the process of digital capture, and make the most of what the DSLR has to offer. We look at the similarities between the film and digital cameras, then move on to examine the differences.

Digital and Film Similarities

Camera manufacturers have made the most of the designs and technology already available in the world of film, transferring a host of functions directly from film cameras to the new DSLRs. This helps ensure the sense of familiarity that most experienced photographers feel the first time they pick up a DSLR. The most important of the functions that have gone straight from film cameras into DSLRs are listed in the box on the right, and are described in more detail here.

The identical functions of film and digital SLRs

To ease the transition from film to digital photography, digital SLR manufacturers have designed their cameras to behave in as similar a manner to film SLRs as possible. Consequently, many of the functions have been transferred over directly. The most important of these for the photographer are:

- Light metering

- Exposure controls for shutter speed and lens aperture settings

- Exposure compensation mechanisms for under- and overexposure

- Choice of lenses

- Lens focusing

- Flashgun controls

Light metering

The usual through-the-lens (TTL) light metering systems common to film SLRs are an integral part of all DSLRs. They measure the light reflected from a view visible in the camera's viewfinder to come up with suggested shutter speed and lens aperture settings for a 'correct' exposure.

Metering methods usually come with four choices: spot-metering, partial, centre-weighted, and evaluative. With the first, only a single, small part of a view is metered – normally just a zone in the centre of the view covered by a cone just a couple of degrees wide. Partial metering is similar to spot-metering, except that it meters on a rather larger area in the centre of the view. Centre-weighted metering measures the reflected light from right across the area visible in the viewfinder, but with greater emphasis given to readings from a broad central area. Evaluative metering, often also called matrix or multi-pattern metering, takes readings from many points around the viewfinder and then compares the resulting data with stored information on many thousands of possible lighting situations to come up with exposure settings.

Each metering method has its own uses. The spot meter is important either for accurate exposure of just

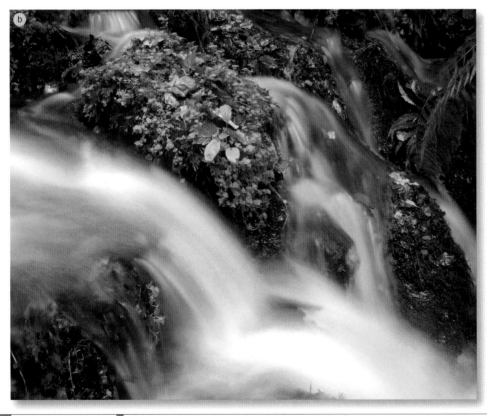

Film and digital SLRs are now equally able to generate stunning images: the choice comes down to personal preference and perception of convenience. Image (a), shot on film, shows a man of China's Naxi minority playing a two-stringed violin at a concert, resplendent in traditional costume. Image (b), shot digitally, shows a detail of a fast-flowing woodland stream in soft, shaded light.

related subjects | Lighting as one of the main pillars of good photography: (page 80). | Using the histogram to judge exposure: (page 64).

one small part of the view, or for multiple spot readings at different points around the view. Partial metering has a similar role, for subjects that occupy a rather larger area in the centre of the view. For gaining an accurate exposure of the entire image, centre-weighted metering used to be the method of choice before evaluative metering was developed. These days, however, the latter is increasingly taking over, and is now universal in DSLRs.

Exposure controls

In all cameras, the amount of light reaching either film or sensor while the shutter is open – namely, the exposure – is controlled by a combination of shutter speed and lens aperture. DSLRs have the same exposure controls familiar on film cameras, commonly consisting of such choices as those listed in the box on the right.

In addition, some DSLRs have automated exposure settings for different kinds of photography, such as portrait, landscape, close-ups and nature. For each setting, the camera is programmed to automatically select what it regards as the best types of shutter and aperture settings for each kind of photography (such as a narrow aperture to maximize depth of field, and hence slow shutter speed, for landscape photography).

Exposure compensation

There are many occasions when it is necessary to give an exposure more or less light than the meter reading indicates. This is often to compensate for the effect of a large dark area within the view, which may cause the light meter to try to overexpose the image, or for the effect of a large light area, which will cause the meter to try to underexpose. Exposure compensation can be carried out by setting the camera's exposure mechanism to manual and choosing alternative aperture and/or shutter settings to those recommended

Film and DSLR exposure settings

Abbreviation	Name	Description
P	Program	The camera has fully automatic control of both lens aperture and shutter speed.
Tv	Shutter priority	The photographer chooses the shutter speed, and the camera automatically sets the appropriate lens aperture.
Av	Aperture priority	The photographer chooses the lens aperture, and the camera automatically sets the appropriate shutter speed.
DEP	Depth of field exposure	The camera automatically sets the lens aperture needed for a given required depth of field.
B	Bulb	The shutter remains open for as long as the shutter button is pressed, allowing for very long exposures.
M	Manual	Fully manual control, in which the photographer sets both the lens aperture and shutter speed.

by the meter. However, if the camera is already in an automatic mode, it is usually simpler to keep it so, using the automatic exposure compensation facility. This can be used to over- or underexpose the image on a given exposure setting by increments of one-third or half stops, in most cameras up to a maximum of two or three stops above and below what the meter believes to be the 'correct' exposure. Accessing the exposure compensation facility varies from one make of camera to another. In Canons, for example, this can be set by turning the large camera-back dial while the camera-top LCD is displaying the meter's suggested aperture and shutter settings. In addition, many film and digital cameras offer a facility to automatically shoot three bracketed shots, each with an exposure differing by an amount that is preset by the photographer.

Lenses and focusing

The major piece of hardware that can be carried over from film to digital photography is the lenses. As described in Chapter 3, the degree to which lenses optimized for

Exposure selections on many SLRs, both film and digital, include not only the standard Program, Aperture and Shutter priority, and manual options, but also settings considered most appropriate for different kinds of photography, such as landscape, nature or portraiture, each illustrated by relevant icons. Selecting one of these, the camera will automatically select aperture and shutter speed settings typically used in that type of photography; for example, fast shutter speed and wide aperture for sport.

Exposure bracketing is a commonly used feature in both digital and film SLRs, with (a) shot at the exposure determined by the camera's light meter; (b) exposed at half a stop over the camera meter's setting; and (c) shot half a stop under the meter setting.

film photography are actually compatible with a DSLR can vary.

Questions of image quality apart, the lenses function in exactly the same way on a DSLR as they do on a film SLR, with identical on-camera controls. Autofocus

Under- and overexposure

The through-the-lens (TTL) light meter of any camera is designed to measure light that is reflected from the subject and to calculate the lens aperture and shutter speed settings that will yield an image of midtones. Of course, in the real world, there are few subjects that are ever composed wholly of midtones, and often either dark or light tones predominate. These can fool the meter into giving an inappropriate reading: a subject that is dominated by dark colours tends to cause the meter to overexpose the final image, whereas an abundance of light colours tends to lead to underexposure. Examples of the former are dark green

vegetation and black clothing, and of the latter sunlit sand or white walls.

Evaluative metering goes some way to overcome this problem, although even this is not entirely foolproof. Care should always be taken to ensure correct tonal rendition in the final images.

Finally, there is also a frequent need to deliberately underexpose an image in order to ensure that the image's tonal histogram shows no clipping at the highlight end, so that all image data is captured at the moment the shutter is pressed. Accurate tonal rendition in the final image can then be sorted out on the computer.

usually comes with two options: single shot or predictive autofocus. With the camera set to the former, the lens must be focused before each image is taken otherwise the shutter will not fire, and so is useful for individual shots of stationary or slowly moving subjects.

The photography of fast-moving subjects requires predictive autofocus. A camera set to predictive autofocus and with the shutter button partially pressed to activate the light meter will continuously refocus the lens as the subject moves closer or further away. If the shutter button is pressed all the way down, the predictive autofocus function also allows the shutter to keep firing (provided that the continuous shooting drive mode has been selected – see below) without necessarily refocusing fully between each frame. This process sometimes causes a few of the images in a sequence to be out of focus, although the majority will be perfectly sharp. This function is a must for sports and wildlife photographers, where it may be the only way to capture fast-moving action.

Drive modes

These settings, on both film and digital SLRs, determine whether a single press of the shutter button will fire the shutter just once or will allow continuous shooting as long as the button remains pressed. Thus,

related subjects | Exposure compensation for dark and light areas in a view: (page 68). | Choosing a camera according to its burst rate: (page 39).

Film and digital SLRs start to diverge at this point. When set on continuous shooting, a film SLR will keep on taking photographs as long as it has film and there is power in its battery. A DSLR, however, will keep going as long as there is temporary storage space in its memory buffer, that 'area' in the camera where image data is held prior to processing into images that can then be transferred and stored in the memory card. Once that buffer is full, the camera will seize up, refusing to take any more images until the backlog has been processed and stored. How quickly that happens varies hugely from one camera model to another, depending on such factors as the size of image files being created and the power of the camera's processor, but it has to be said that only the most powerful DSLRs are now starting to approach the capabilities of film SLRs. As outlined in Chapter 3, how much continuous shooting you are likely to do, and how fast a continuous shooting speed you may need, should be important considerations when deciding which DSLR to buy.

every camera comes with a single shot setting (the shutter will fire only once each time the shutter button is pressed) and one or two continuous shooting modes. These are basically either fast or slow continuous shooting speeds that can vary anywhere between three and eight frames per second. The drive modes also usually come with one or two self-timer settings, typically allowing either two- or ten-second delays on the shutter once the shutter button is pressed.

Predictive autofocus, available on both film and digital SLRs, allows the camera to track and retain focus on fast-moving subjects, such as in this image of an Amazonian tern in flight. This feature makes feasible some types of photography, particularly nature and sport, that otherwise would be extremely difficult.
Canon EOS 1Ds, Sigma EX 70–200mm lens with 2x converter, 1/320 sec at f/5.6, ISO 100.

Tip With digital, it is not usually necessary to bracket exposures around the meter's reading provided a successful exposure is judged according to the image histogram.

The Digital SLR Comes into its Own

When it comes to the process of image capture, then film and digital SLRs go their separate ways. From here onwards, the power of the DSLR starts to come into its own, particularly once some of the subtle differences from film photography have been mastered. This section outlines some of the most important features of the DSLR that make it stand apart from the film SLR.

A variable ISO rating for every image

One of the greatest constraints of film photography was being tied to a particular film speed, or ISO rating, for the length of an entire film; you could change it only when it was time to put a new film in. Of course, photographers adapted to this restriction, but there were often occasions when I would have loved to have been able to change the film speed to match rapidly changing lighting situations. Armed with a DSLR, I am now free to do so. From time to time I increase the ISO setting from my habitual 100 to something higher to cope with poor lighting conditions. Sometimes I drop it to 50 to decrease the sensor's sensitivity and so make it easier, for example, to blur flowing water even in sunlight, when it is often difficult to obtain a sufficiently slow shutter speed.

The choice of ISO settings varies from one camera model to another. They typically range from 100 up to 1600, with some models including 50 and 3200. These settings are supposed to coincide with those of conventional film, so that digital and film SLRs set up side by side, with identical lenses, pointing at the same subject and set to the same ISO rating should have identical exposures. In fact, DSLRs are generally more sensitive than film, and often expose with a higher shutter speed or narrower aperture than is possible with a film camera under identical conditions.

The higher ISO settings of a DSLR camera usually perform better than the higher film speeds. Film photographers (particularly when they are using slide film) generally frown at the thought of using 400, 800 and certainly 1600 ISO-rated film, because as the speed/sensitivity increases so does the size of the film's grain, thereby reducing resolution, contrast and colour saturation. With DSLRs, however, image quality remains high through much of the ISO scale, although it does start to deteriorate at the highest settings. This deterioration is not due to grain, of course, because there is none, but because of the digital 'noise' that starts to creep in.

The LCD screen and an instant result

If there is one single factor that has persuaded photographers to switch from film to digital, it is that little liquid crystal display (LCD) screen on the back of every digital camera. To see the results within seconds of pressing the shutter is an enormous boost to confidence and creativity, and one that had me bursting with excitement the first few times that I used a DSLR.

However, it is one thing to be able to see an image in the LCD screen, and it is quite another to be able to interpret what is shown sufficiently well to be sure that the image has been successfully captured. The screen is very small, and visibility is not always very clear, especially when viewed outdoors in sunshine. As displayed on the screen, that little image is very

Being able to alter a digital camera's ISO setting (in other words, a sensor's light sensitivity) for every image can be hugely important in a range of lighting conditions. For this brightly lit image of a waterfall in Sweden, I had to turn the ISO setting down to its minimum – ISO 50 – to obtain a sufficiently slow shutter speed to blur the falling water. Juolme Falls, Stora Sjöfallet National Park, Sweden.
Canon EOS 1Ds, Sigma EX 70–200mm lens, 2 sec at f/32, ISO 50.

related subjects The ISO number and noise: (page 109). LCD screen settings: (page 48).

These images show the importance of controlling an image's tonal histogram. The strongly backlit coastline image, despite being very dark, has a histogram that is well within the limits, meaning that all the image data has been captured. The sunlit garden image, however, has such a wide contrast range, with many shadow and highlight areas, that the histogram stretches across the full extent of the graph's axes, with clipping at the highlight end – the image is burned-out. Both images were taken using a Canon EOS 1Ds camera. The histograms shown are as seen on a DSLR's LCD screen.

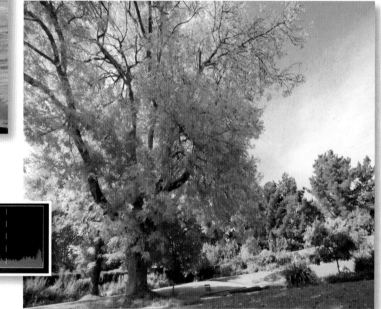

useful to check for good composition and any serious blunders, and using the enlarge facility that is found on most DSLRs is helpful (although not foolproof) in checking for accurate focusing.

To check for accurate exposure, it is essential to call up the histogram, or bar chart, that is embedded with each image and that gives an accurate view of the tonal ranges (but not colours) found throughout the image. It is only by using and understanding this chart that you can be sure the image has been caught accurately.

Understanding the histogram

The histogram shows an image's tonal values ranging from totally black on the far left to totally white on the far right, for an 8-bit-per-channel image corresponding to the 256 colour tones, with 0 on the far left and 255 on the far right. The height the graph reaches at any point along the horizontal axis represents the numbers of pixels having that particular tonal value.

Although there is no 'ideal' type of histogram to aim for – different kinds of images generate radically different

Tip Always shoot with a low ISO setting – between 50 and 200 – in order to minimize image noise.

histograms – you should always aim for the histogram to fall to 0 pixels at either end of the tonal range before the ends of the histogram's scales are reached. If the histogram abuts right up to either end of the scales without falling to 0 then the histogram is said to be 'clipped', and image data will have been lost.

What this means for an image that has a histogram clipped at the shadow end of the scale is that parts of the image are completely lost in darkness, resulting in areas of black. In those with a histogram clipped at the highlight end, parts of the image will be burned out, with no detail visible in bright white highlights. Generally speaking, the former is considered to be less serious than the latter, at least in part because the eye tends to take less notice of dark patches than it does of bright areas. For this reason, it is important to go to great pains to keep the histogram within the limits of the scale at the highlight end.

Although all kinds of problems can be rectified in image-manipulation software on the computer, the digital photographer needs to be aware that image data that has been lost as a result of a clipped histogram can never be retrieved. Once that data is lost, it is impossible to bring details back into burned-out highlight or deep shadow areas. A histogram that shows clipping, particularly at the highlight end, indicates that the image must be shot again with an exposure that hopefully will eradicate the clipping problem.

For the experienced photographer, looking at both the histogram and image thumbnail in the LCD, it is usually possible to pinpoint exactly which part of the image is causing the problem. This will help you decide how serious the problem is and how to solve it. In order to help identify exactly which part(s) of the image is in trouble, most DSLRs come with a 'highlight alert' feature, which spots, lassoes and flashes up the burned-out area(s).

Controlling exposure to overcome histogram clipping

With film photography, the aim is always to obtain images that are 'correctly' exposed – 'correctly' being defined as whatever the photographer decides portrays the subject in the best way. When working digitally, however, the aim is to obtain an image whose histogram shows no clipping, particularly at the highlight end. The film

Film versus digital light sensitivity

Throughout most of the range of normal light intensities, both film and digital sensor react in a linear way: the amount of light 'captured' as silver or an electric charge is directly proportional to the amount of light received.

Digital sensors maintain this linear relationship through the entire light range, from complete darkness through to brilliant white light. Film's response tapers off at both the shadow and highlight ends, *creating something of an S-shape to its light-response graph. This means that while film is able to retain some details in both very dark and very bright areas of an image, digital can quickly lose all detail here: digital's dynamic range can be limited.*

This is particularly a problem for digital in bright highlights, where loss of detail and hence burn-out can be particularly noticeable and damaging to overall picture quality.

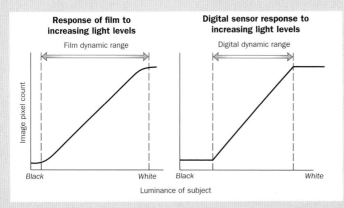

These graphs comparing film and digital sensitivity to light show that film has a potentially broader dynamic range due to the trailing off of its sensitivity in dim and bright light, compared to digital's continued directly proportional response.

related subjects

Clipping at a histogram's shadow end: (page 68).

Twin exposures to compensate for excessive contrast range: (page 68).

A still life lit from just the right (a) shows a high contrast range, with deep shadows on the left and excessive brightness on the right. At f/16, as exposed here, the image histogram remains within limits at the shadow end, but shows extensive clipping at the highlight end. Stopping the aperture down to f/22 might have brought the highlight clipping into the graph's limits but would have resulted in clipping at the shadow end. In (b), the still life is lit from both sides, enabling the image to be exposed at f/22 and generating a histogram that is within limits at both ends.

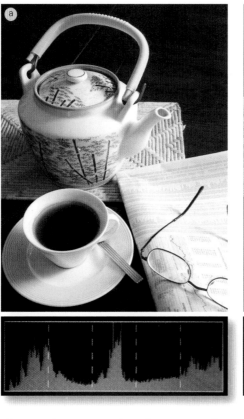

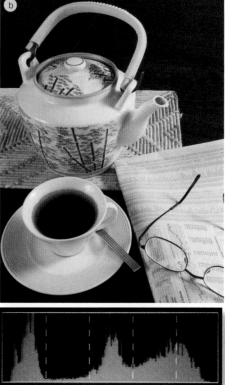

photographer, too, needs to be concerned about contrast range – an image filled with black holes and burned-out white spots is not likely to be a great one, whether it is on film or digital – but because film is less sensitive to high and low light levels than a digital sensor, contrast is less of a problem (see box opposite).

If photographing a subject lit by artificial lighting (such as in indoor portraiture or still life), any clipping observed in initial test shots may be removable by decreasing the contrast range of that lighting. This can be achieved by providing more fill-in lighting through additional lights or reflectors, which will light up shadow areas. This should make it possible to use either a faster shutter speed or narrower lens aperture, moving the whole histogram to the left and so decreasing clipping at the highlight end.

If photographing a moveable subject outdoors, especially in sunlight, the problem

of clipping at the highlight end can be overcome by moving the subject to an area with less bright light – somewhere in the shade, under a tree or beside a shaded wall, for example. This will reduce the contrast range of the lighting, probably allowing images with no histogram clipping to be produced.

Problems are likely to occur when photographing something immobile outdoors in natural light, such as a landscape view. Clipping can occur under almost any lighting conditions, but is most likely when the tones in the view's colours cause the camera's TTL meter to under- or overexpose the image, or in bright sunlight when there is simply too much contrast range in the light for the camera to handle. Meter-induced overexposure is common, even when using evaluative metering, in landscape photography when large amounts of dark green vegetation are

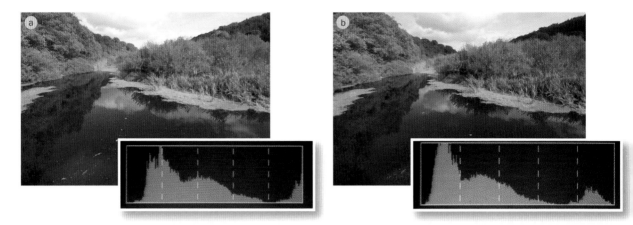

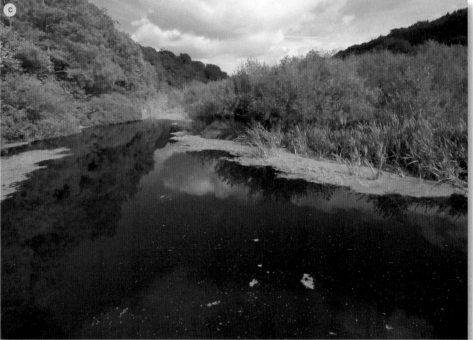

In this view of a calm river lined by vegetation, the darkness of the water has fooled the camera's light meter into overexposing the image (a), resulting in clipping at the highlight end of the image histogram. Underexposing the image by 1.3 stops has brought the histogram within limits, but has resulted in an image that is rather too dark (b). Manipulation of this image in the computer has resulted in a final image (c) that is both correctly exposed and has a histogram showing no clipping.

present. The meter wants the camera to reproduce that dark tone in a more neutral way (i.e., to make it lighter), causing the camera to overexpose the image and resulting in clipping at the highlight end of the histogram. This is easily overcome by underexposing the image – usually by half to one stop, occasionally more – bringing the greens to a more natural darker tone and allowing the bright end of the histogram to fall within the upper limit. In doing this, the entire histogram will probably move a little to the left, but usually without causing the shadow end to start clipping. This scenario is possible in just about any photographic situation (such as with dark backgrounds in portrait photography), and is usually overcome by utilizing the simple underexposure technique.

There are also many occasions when, even though the LCD image and the histogram indicate that the main or most part(s) of an image are correctly exposed, a certain portion is burned-out

related subjects

Lightening a dark image on the computer: (page 132).

Specular highlights: (page 116).

and showing clipping at the highlight end. Underexposing a subsequent image to bring that burned-out part into the histogram will almost certainly render most of the image underexposed, but this is not a problem so long as there is still no clipping at the shadow end of the histogram. The important thing is that all the image data has been caught between the two ends of the histogram, and the best exposure for that particular image can be worked on later on the computer.

Ending up with an image that is too dark is completely alien to an experienced film photographer when they first start shooting digitally. This is a major difference between film and digital photography: the film photographer needs to expose film to obtain images that are correctly exposed at the time the shutter is pressed. The digital photographer must aim, at the time they press the shutter, to get all the image data within the confines of the histogram. Getting the overall image 'correctly' exposed at this point is secondary, and provided all the data has been captured the overall exposure can be corrected on the computer. It should be noted that a very dark image when lightened on the computer is likely to contain some noise; care should be taken while trying to overcome highlight clipping not to end up with a noisy image instead.

Correct exposure for digital versus film

1 Photography with film demands that each image be shot to give the main subject the 'best' exposure, depending on the intended end result. This may require bracketing of exposures and later choice of the most appropriate image.

2 Photography with digital demands that clipping of the tonal histogram be avoided, particularly at the highlight end of the graph. It may be necessary to underexpose an image to ensure this. General underexposure can be corrected later on the computer.

3 Post-photography manipulation of images is relatively difficult with film – almost impossible with transparencies – and so in high-contrast images there may be no alternative to having some burned-out highlights provided most of the image is well-exposed. However, due to film's S-shaped light-response graph, it is likely that most highlights will retain some detail.

4 Due to the huge amount of post-photography manipulation possible with digital images, there should be little reason to suffer burned-out highlights (other than specular highlights, such as sunlight glinting off water). High-contrast views, for example, can be dealt with by combining two or more images with different exposures.

As with this image, a garden with plenty of shady trees and shot under a high bright sun is almost certain to generate an image showing far too great a contrast range, its histogram showing clipping at both the shadow and highlight ends.
Canon EOS 1Ds, Sigma EX 28–70mm lens, polarizing filter, 1/100 sec at f/9, ISO 100.

Tip Images shot with an excessive contrast range can be less effective than those taken under less contrasty conditions.

Coping with excessive contrast range

Photography in bright sunlight is likely to result in histogram clipping at both ends: the contrast range between the highlight and shadow areas is simply too great and no amount of under- or overexposure will squeeze the histogram within the scale's limits.

The simplest way to deal with this problem is to make a judgment as to how serious the clipping is in terms of its overall effect on the photograph. Do the black and burned-out areas take up a significant part of the image or only relatively unimportant, small or discrete parts? If the overall effect is relatively minor, the photographer might decide that it is better simply to minimize the burned-out parts of the image (i.e. clipping at the highlight end of the histogram) without significantly increasing the shadow-end clipping.

If the problem is significant (such as with an overexposed sky above an underexposed landscape), a solution is required. The first possible step is to reshoot with graduated neutral density filters over the lens in order to darken the sky. A second possible method is to apply such a filter digitally in the computer after the photography – although this will not really help if image data has been lost due to clipping at the time the image was taken. A third approach is to shoot the view twice, first with an exposure ideal for the darker parts of the image, and then with an exposure balanced for the lighter areas. The two images can then be combined in the computer to make a single correctly exposed final image (see Chapter 8).

Clipping at the shadow end

Much of what has been said about overcoming histogram clipping has been aimed at the highlight end of the graph, in order to remove burned-out highlights. Little has been said up to this point about

Twin exposures of high-contrast views

When a view has such a high-contrast range that it is impossible to photograph without resulting in significant clipping at both ends of the tonal histogram, one solution is to photograph the scene twice – the first time correctly exposed for the shadow areas, the second for the highlight sections. The two images can then be combined later in the computer to produce a correctly exposed image whose histogram lies fully within the graph's 1–255 range.

First, meter for the view's dark areas and take a shot that correctly exposes for these. In the resulting image, although the dark areas should be correctly exposed, the highlight areas will be burned-out: the histogram should show no clipping at the dark (left) end of the scale, but a large amount of clipping at the light (right) end. Then re-meter for the view's light areas and take a shot that correctly exposes these. This time, the image will be quite dark, with a lot of clipping at the left end of the histogram and no clipping on the right.

In doing this, it is better if the camera is secured on a tripod or other camera support in order to ensure good registration of the two images. If you are shooting quickly, however, it can be managed handheld, although you need to take care in lining up the image components in the computer, and some cropping of the final image will almost certainly be necessary. Even if the camera is secured on a tripod, the fact that you may need to move the camera between exposures in order to meter on different parts of the view means that exact registration may be difficult to manage.

Once the images are on the computer, the correctly exposed parts of the two images are merged – the over- and underexposed sections being discarded – to create the final image. Exactly how this process is achieved is described fully in Chapter 8.

related subjects | Comparison of digital and film sensitivity to light: (page 64). | LCD screen views: (page 49).

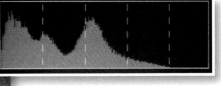

In this image of standing stones in a shaded garden, the background has gone into excessively deep shadow, resulting in clipping at the dark end of the image histogram. This could probably be overcome by increasing the exposure, but then the stones would probably be overexposed.
Canon EOS 1Ds, Sigma EX 28–70mm lens, 1/50 sec at f/5.0, ISO 100.

> Night-time views, such as this one of the Strip in Las Vegas, inevitably contain large black areas that are likely to produce dark clipping in the histogram.
Canon EOS 1Ds, Sigma EX 17–35mm lens, 4 sec at f/16, tripod, ISO 100.

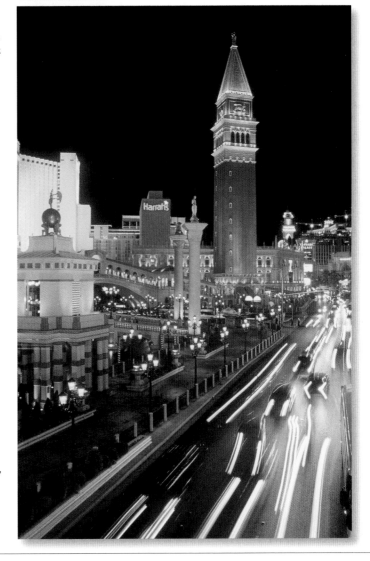

the shadow end. This is because, as already briefly mentioned, this is generally considered to be less serious than highlight-end clipping. Of course, if shadow clipping starts to occur across a significant part of the image, such as in a dark landscape, steps need to be taken to correct that, otherwise some important image details will be lost. The solution will consist mainly of overexposing the image a little, although great care must be taken to ensure that this does not move the histogram so far to the right that it results in clipping of the highlights. If the problem cannot be solved without causing highlight burn-out, then the twin-exposure technique that has been described above may be necessary.

There will be occasions when large dark areas – rendered in the histogram as shadow clipping – may be quite appropriate, particularly in night-time photography. Urban skyline shots, for example, are likely to include significant amounts of quite featureless black skies, even allowing for

light pollution, and nothing needs to be done to alter the resulting histogram – at least not its shadow end. Bright city lights might cause highlight burn-out at the other end of the scale, and that should be solved if possible.

Colour Balance

Controlling colour balance is a constant worry for the film photographer. It can be very difficult to manage, involving the right choice of film and an array of filters, as described in Chapter 3. For the DSLR photographer, however, fine control of colour balance is a simple matter of choosing the appropriate options on the camera – settings that can be changed quickly for each image.

The basic principles of colour, how it affects photography, and how these are translated into a series of camera options are described in Chapter 3. Their practical application is covered here.

The most practical of all the colour temperature settings is automatic white balance (AWB), in which the camera automatically balances the colour temperature of the exposure with that of the ambient light. This is usually a highly effective method, although its accuracy varies from one camera model to another, and every photographer should do some

tests on their camera's AWB before putting all their faith in it.

Another limitation of the AWB setting is that in most cameras it is effective only for a colour temperature range of about 3000–8000K. This covers most everyday situations, from indoor halogen lighting to bright cloudy weather. However, it may not correct the orange hues of low-power tungsten lamps or candles (which have colour temperatures of 1500–3000K), or sometimes the strong blues found in shady areas on bright sunny days (about 8000K). The latter is overcome by using the

^

Colour balance in a DSLR is shown in this image of a candle, one of the lowest energy light sources available. Using the AWB setting (a), the flame is quite white, though with a little orange glow, indicating reasonable colour balance, though not perfectly accurate. Image (b) was taken with the camera balanced to a colour temperature of 5500K, identical to the white balance of daylight film. There is a strong orange glow, indicating that white balance is poor, with the flame's colour temperature well below that for which the camera is balanced. In image (c), the camera is balanced to 9000K, resulting in an even stronger orange glow – the gap between the flame's colour temperature and that to which the camera is balanced is even greater than it was in image (b). In image (d) the camera is balanced to 2800K, the lowest colour temperature at which this camera's Kelvin scale could be set. The candle and flame are quite white, indicating an accurate white balance – more so than under the AWB setting.
Canon EOS 1Ds, Sigma EX 28–70mm lens, 1/15 sec at f/9, tripod, ISO 100, for all images.

Creating a custom white balance

If shooting under unusual colour temperature conditions, for which perhaps your camera has no exact setting, it is possible to create your own custom white balance. Follow these steps:

1 Select the custom white balance setting on the camera.

2 Take a photograph of a white or neutral grey piece of card, with the card filling the view, under the lighting in question.

3 Save the resulting image information to the camera's custom white balance file. This tells the camera what colour temperature to use for all subsequent images shot under this lighting.

4 Take the photographs you need, with the camera set to the custom white balance setting containing the information you have just entered.

related subjects

Principles of colour temperature: (page 50).

DSLR white balance settings: (page 51). Image composition: (page 77).

In this dusk view of the Teatro Amazonas, the opera house in Manaus, Brazil, the white balance selected has been varied to generate different atmospheric effects. In (a), the AWB setting has been used, resulting in an image that, though well exposed, lacks the attractive red glow typical of this time of day. In (b) the white balance point has been set at 8000K, well above the colour temperature of the ambient light. This results in an excessive reddish balance to the light, much greater than is ever seen in images shot at this time of day on film. In (c) the white balance has been switched to the cloudy daylight setting (about 6500K), giving softer and more realistic reddish hues typical of images shot on film.

Canon EOS 1Ds, Canon 24mm tilt and shift lens, 0.3 sec at f/3, tripod, ISO 100, for all images.

Tip When photographing evening views, try to shoot when there is still some light in the sky as this usually adds greater visual impact to an image.

camera's 'sunny weather shade' option. The former can be tackled in many DSLRs by entering an exact colour temperature with which the exposure should balance, though this may require several guesses to get right. Alternatively, a custom white balance can be set up (as detailed in the box on page 70).

There will be occasions when you may not want to balance the colour temperature accurately, and will prefer, for example, to allow a soft orange glow to creep into images. This will occur when the ambient colour temperature is lower than that for which the camera is balanced. This is particularly common for landscape and travel images taken shortly after sunrise or before sunset, and under artificial lighting when trying to create a romantic mood.

To set it up, simply take the camera's white balance setting off automatic and choose one of those – or enter a specific colour temperature – that you know will balance the camera for a colour temperature higher than that of the ambient light. Conversely, if you want to add a blue hue to an image, choose a setting or colour

temperature that is well below that of the ambient lighting.

For situations where it is not clear which colour temperature will produce the best results, it is possible with many DSLRs to take a series of images bracketed for colour temperature, in a manner that is analogous to the well-established exposure bracketing technique.

Flash photography and colour balance

Achieving accurate colour balance when using a flashgun can be very simple or quite problematic. The great majority produce a light balanced for the 5500K of daylight, which means it balances well with the surrounding ambient light if it too is 5500K daylight. Keeping the camera on the AWB setting will ensure good all-round colour balance. The camera's 'flash' colour balance setting should provide an even more accurate balance, but in fact in many models the overall result is a little too warm; i.e., the image comes out a bit red.

Problems may arise if the ambient light is not 5500K daylight, particularly with indoor tungsten lighting, where the colour temperature will be a rather red 3000K. If the camera's white balance is set to tungsten, to balance with the ambient light, even if the exposures for the flash and ambient lighting are balanced, the colour temperatures will not be, the image coming out with an overall blue hue. If this happens, the solution is to put an orange 85c colour-conversion filter gel over the flashgun's head to make its colour temperature similar to that of the ambient lighting. With the camera set to tungsten white balance, the entire scene will then be subject to an even colour balance.

With fluorescent ambient lighting, on the other hand, ensuring a colour balance across both the background and the flashgun-exposed subject can be managed by putting a green colour-correction gel across the flash's head. This will give the

Colour temperature bracketing

Relatively small changes in the colour temperature of an image can have an important effect, whether technical or aesthetic. If it is not clear that the camera's single colour temperature setting will deliver the best results, it is usually possible to set it to shoot a series of three images with bracketed colour temperatures, differing from one another by set increments.

How to set this up varies from one camera model to another. It usually consists of

either a simple +/– scale similar to the exposure bracketing system, or of a grid in which the three exposures can be moved around to alter relative amounts of cyan, magenta and yellow filtration (the complementary colours to the red, green, blue primaries).

As a standard rule, the incremental changes in colour temperature occurring among the three bracketed images are measured in mired shift units, a standard measure of colour temperature change.

related subjects

Use of flash in portrait photography: (page 89).

Flash in animal photography: (page 92).
Interiors photography: (page 100).

flash the same colour as the ambient fluorescent lighting, enabling the camera's fluorescent white balance setting to give an even colour correction across the whole image. Alternatively, a few top-end flashguns can vary the colour temperature of their output, making it possible to electronically achieve flash–background colour balance.

Filters in Digital Photography

Although filters are an essential part of film photography, they are much less important in the digital world as so much of what they do can now be done by the camera.

One of the most commonly used set of filters, the pink 81 series, so essential in film photography to remove the blue hues typical of bright cloudy days, has been rendered redundant by the AWB and 'cloudy' settings of a digital camera.

Similarly, the colour correction and compensation filters once commonly used for colour balancing under artificial light, mainly tungsten and fluorescent, are no longer needed due to the DSLR's whole range of colour temperature choices. This saves a lot of time and mental calculations.

Apart from the filters occasionally used on flashguns as described above, the only filters now needed, largely by the landscape and travel photographer, are polarizers and graduated neutral density filters.

As described earlier in this chapter (see page 68), the latter are useful in decreasing the contrast range across an image – for example, when photographing a view containing a bright sky and a relatively dark landscape. This makes it easier to bring the two ends of the image histogram within the scale's limits.

Polarizing filters remain useful for their ability to increase saturation, to help overcome the effects of haze, and to remove reflections from shiny surfaces,

The importance of balancing flash colour with ambient light and the camera's white balance. In photographing a room whose ambient lighting came only from tungsten bulbs, the camera's white balance was set to tungsten, and flash was used to fill in some of the shadow areas. In the first image (a), the flash was fired with its daylight-balanced light unaltered, giving an overall blue wash to the room (since the colour temperature of daylight-balanced flash is much higher than the tungsten white balance setting on the camera). In the second image (b), an orange filter (an 85B colour-conversion gel) was placed over the flash head to balance its output colour temperature with that of the tungsten lighting and hence the camera's tungsten white balance. The resulting image is reproduced with white light, in which the tungsten light, too, comes out white.

such as vegetation, windows or water. For this reason, they are still an essential part of the outdoor photographer's kit. However, they can also increase contrast, so when using one it is important to ensure that the image histogram does not become clipped as a result. If the polarizer is being used only to increase saturation and it is impossible to achieve this without introducing clipping into the histogram, then remove the filter and concentrate on getting the histogram right. Saturation can always be improved later, on the computer.

Tip When shooting interiors, try to ensure that all lighting sources and the camera are as closely balanced for colour temperature as possible.

5 Photographic Skills the Digital Way

Whether you shoot on film or digitally, the skills of photography are still much the same as ever – at least when it comes to such concepts as the visualization of potentially great images well before the shutter is pressed; the creation of superb compositions; the use and abuse of natural and artificial lighting; and the best use of focusing. What has changed is some of the technical steps needed in capturing those images. Photographers who take up digital photography must ensure that they continue using all the traditional skills of photography, applying them in the digital world and making whatever adjustments are needed to make the best use of the new technology.

As this backlit shot of a yacht racing under spinnaker shows, the key to great photography, whether shot on film or digitally, is composition and lighting.

It does not matter how well adapted a photographer becomes to the digital technology if they do not have a firm grasp of basic photographic skills. Poorly created images will look bad whether shot on film or on pixel, and no amount of post-photography cleaning up and image optimization on the computer can change that. Ensuring that the traditional skills – especially the psychological and aesthetic senses that a photographer needs if they are to create great images – can be successfully merged with the digital technology is the subject of this chapter.

General Photographic Skills

The camera does not take a picture: the photographer does. The photographer sees – or if in the studio or working with models, creates – a view with three-dimensional components that they perceive can be brought together into a striking two-dimensional image. The camera is used to distil that image from the three-dimensional world, the technology assisting in the photographer's manipulation of composition, lighting and focusing. The

degree of success can be measured in at least two ways: first, how close the final image comes to matching the image that the photographer pre-visualized before pressing the shutter; second, the impact the final image has on other people. The two are not necessarily the same.

Success depends on the photographer's skill, both technical and psychological, and the degree to which the camera's technology helps or hinders the photographer's creativity. The latter depends on the camera manufacturers' ability to produce cameras that work in the real world and live up to the claims made of them, as well as on the photographer's ability to choose the right camera for the kind of photography they want to do.

The photographer's creative skills rely on a combination of natural talent, study and practice. The photographer must work hard to be able to reliably create the best photography they can. Even a novice photographer is likely to produce a stunning image occasionally, but they may not know how they achieved the result, and will only be able to reproduce it sporadically and with large helpings of luck. Luck will continue to play a part for even the most

The pillars of good photography

Composition

- **Keep it simple, with just one clear and dominant subject.**

- **Usually the main subject should be off-centre.**

- **Use the law of unequal thirds to balance the image aesthetically.**

- **Make use of angles and lines to help create mood.**

Composition, lighting and focus have all come together here to create a great image of two macaws. Good composition has captured a moment of affection between the two birds; lighting is flat, ensuring no harsh shadows; and focusing has put both birds sharply in focus, with the background blurred.
Canon EOS 1Ds, Sigma EX 70–200mm lens, 1/320 sec at f/4.5, ISO 100.

Lighting

- **Keep the lighting appropriate for the subject.**

- **Minimize shadows to soften an outline; increase shadows to emphasize form, outline and texture.**

- **Use the colour of light to affect atmosphere; e.g. red for warmth and 'comfort'.**

- **Try not to use light of too high a contrast that will cause dense shadows and burned-out highlights.**

Focus

- **The main subject must almost always be sharp for the image to be of use.**

- **Careful use of selective focusing can help to further emphasize the main subject against the background.**

- **Keep the focusing appropriate for the kind of subject: wide-angle landscape views may need a great depth of field; telephoto portrait shots may require a shallow depth of field.**

experienced and skilled photographer, but it is not reliable as a means of generating great photography to order again and again. Study and practice, hopefully combined with natural talent, inspiration and imagination, are the usual keys to producing consistently good results.

The two major pillars of successful photography are composition and lighting: no image can be truly great unless both elements come together simultaneously. A secondary, but nevertheless crucial, element is focusing. It may sound obvious to say that generally – unless the image is being deliberately blurred – an image's main subject must be sharp. The problem comes with deciding where in the image it is acceptable, or indeed essential, for the

Exposure bracketed multiple images: (page 115).

Differentially focused multiple images: (page 116).

This image of a woman, quietly reading in an apple orchard in spring, conveys a sense of calm relaxation, making the viewer want to stretch out on that bench too.
Canon EOS 1Ds, Sigma EX 70–200mm lens, 1/250 sec at f/5.0, ISO 100.

In this architectural image, shot with a wide-angle lens, depth of field has been maximized to put the entire image in focus. Remarkably soft lighting – bearing in mind the strong sunlight – has been created by the huge reflector that is the white canopy roof.
Canon EOS 1Ds, Sigma EX 17–35mm lens, 1/45 sec at f/13, ISO 100.

sharpness to fall off. How to successfully assemble these three components into an image is often subjective, but it can also be critical, with a thin line separating a great image from mediocrity. Understanding the concepts of composition, lighting and focusing helps you to consistently put your images on the right side of that line. The subjective elements are often those developed with practice once the basic skills have been mastered and that define personal style.

Creating the composition
Less is more
The greatest images are usually those containing a single strong subject that grabs and holds the viewer's attention. That single subject competes with nothing else

in the frame, takes control, instantly sets up a communication with the viewer and tells them just about everything they need to know about the image.

At the other end of the scale are images containing an array of potential main subjects, each competing for attention, resulting in a picture that is confusing and lacking in impact. Such images can be difficult to look at: they are agitated, may cause the viewer's eyes to skip almost randomly around the frame from one point of interest to another, and, if they communicate with the viewer at all, it is usually with very mixed messages.

In other words, to create a great image, keep it simple. More often than not, less is more. Giving the viewer less to look at in the end communicates more to them,

Tip When framing the subject in the camera viewfinder, almost always arrange it a little off-centre; this is generally more aesthetically pleasing than if centrally placed.

Less is more: the simplest compositions often have the greatest visual impact, as illustrated by these two images of the Taj Mahal at dusk, and of Mount Fuji at sunrise. Note in both images that the main subject is off-centre, with the overall image composition conforming to the law of unequal thirds.

creating strong feelings of empathy with the image. Do not shoot an image of the entire crowd at a soccer match: home in on just a few faces with all the excitement and emotion of the match written across them. The beauty of a waterfall might be better portrayed in the detail of water splashing off one rock near its base than in a view of the entire waterfall.

Framing the subject

One of the fundamental rules of composition is that usually the main subject should not be right in the middle of the image, but a little to one side: this is often known as the law of unequal thirds. Without realizing it, and certainly without knowing why, most people find the resulting

related subjects

Colour temperature at the ends of the day: (page 50).

Using the white balance settings to alter colour balance: (page 70).

asymmetry aesthetically pleasing – much more so than the symmetry that results from a centrally placed subject.

The psychology of angles and lines

Linked to the above is the psychological impact that different angles and lines can have on image mood. Diagonal lines, for example, generate dynamism, energy and movement. The effect can be quite powerful provided the image is not crowded with too many diagonals and so long as they do not run in conflicting directions. The latter can result in an image that conveys a sense of confused agitation. An image containing parallel horizontal lines, on the other hand, puts over a sense of calm and peace, provided the lines are quite widely spaced. Parallel vertical lines, meanwhile, generate a feeling of strength and solidity, such as you might see in a cliff or building – again, provided the lines are widely spaced. Lines that are close together make an image appear too busy, and may lead to a sense of restlessness.

Camera orientation can have a dramatic impact. Holding the camera vertically, or in portrait orientation, can

The law of unequal thirds

According to this rule, a subject should be framed in such a way that it divides the image into three parts of different sizes. This can be especially effective if some of the background components also contain lines that naturally divide the image into segments – such as clouds, a river bank, or buildings – with the main subject sitting at a point where these lines meet. This sometimes occurs by chance, but a photographer should always be on the lookout for elements that can be brought together into such a composition.

The law of unequal thirds. In this idealized landscape, the most prominent edges of some of the landscape elements, namely the mountain slopes and the river bank, divide the image into unequal thirds, while the main subject – the snow-capped mountain – sits at the intersection of the lines, away from the centre of the image.

emphasize the effect of vertical lines in a view. Holding it horizontally, or in landscape orientation, can enhance the impact of horizontal lines. Either orientation can have an effect on diagonal lines if the image frame intersects those lines to create

A static desert view is turned into something quite dynamic through the inclusion of strong diagonals, accentuated by a very wide-angle lens. A narrow aperture has kept the entire image in focus, an essential part of this image's success.
Canon EOS 1Ds, Sigma EX17–35mm lens, polarizing filter, tripod, 1/15 sec at f/22, ISO 100.

Tip Not every subject will lend itself to the law of unequal thirds, but keep a lookout for ones that do – they will often lead to the strongest compositions.

strongly acute angles. Tipping the camera to an angle that converts horizontal or vertical lines within a view into diagonal lines can also be effective, although it seems to work best when the subject itself is less important than the atmosphere or message conveyed.

Composition and the choice of lens

Choosing the right lens for the subject and the mood you want to convey is crucial to a successful image. Although wide-angle lenses make it possible to fit much more of a particularly large subject into the image frame, they have other effects that need to be considered. For example, they will exaggerate the impact of diagonal lines; this is fine if the aim is to create a dynamic, energetic image, but useless if the aim is a calm one. Similarly, all image components, including the main subject (unless it is really huge anyway), will become quite small,

making it necessary to have the camera close to the subject to maintain its overall dominance and impact in the image. One of the biggest mistakes made in this area is a failure to ensure the subject is sufficiently dominant. A desire to show as much of the surroundings as possible results in an image where the subject is too small, as a result of which the entire image lacks impact. Maintaining an effective size for the subject in the image frame means moving in close if a wide-angle lens is to be used, but stepping back some way if a telephoto lens is chosen.

Getting the lighting right

One of the critical differences between location and studio photographers is that, while the former have to make the best use of whatever light nature provides, the latter can create and completely control their own lighting. What unites them,

Background and lens focal length

It should be borne in mind that, because of its wide view, a wide-angle lens will include far more of the background than a standard or telephoto lens, even though it will probably be used much closer to the subject. This really matters: the background is not simply space-filler, but can and usually does have an important (though sometimes subtle) impact on the mood and composition of an image. It may also contain distracting elements, so the more there is of it visible in the image the more likely this is to be a problem.

The telephoto lens's narrow angle of view (a) will ensure that only a very limited amount of background is visible.

The wider view of the wide-angle lens (b), on the other hand, will include large amounts of background. Moreover, due to the greater depth of field of the wide-angle lens, much of the background is likely to be in focus, decreasing the subject's visible separation from it. The telephoto lens's narrow depth of field, on the other hand, will probably blur what little background there is, ensuring that the subject remains clearly visible, appearing to 'pop out' of the image.

>

The effect of lens focal length on background inclusion. An image shot with a wide-angle lens will be very different from one taken with a telephoto, even if the camera-to-subject distance is altered to ensure that the size of the main subject remains the same in each.

related subjects

Focal length multiplication in DSLRs: (page 42).

however, is that they must have a firm grasp of exactly how to use their light in order to create great images.

Choosing your light quality

What constitutes great light depends largely on what you are trying to photograph. Landscape photographers become almost poetic about the low, red sunlight shortly after sunrise and before sunset, loving the warm glow that it imparts to many landscape views. Portrait photographers, on the other hand, are more likely to be happy with soft lighting, such as occurs on bright overcast days, when the sun is high but diffused by a veil of thin cloud or mist. Under these conditions, skin tones can be reproduced well, with few hard shadows along jaws, around eyes and under noses.

Taken on a bright overcast day, the soft light has kept shadows across the faces of these two girls to a minimum, while the bright colours have instilled a sense of vitality. Image courtesy of Bjorn Thomassen.

The beautiful red light of this sunrise has created a stunning silhouette of Stonehenge. This is the classic light that landscape photographers dream of!

Dull, flat lighting can be useful when photographing plants, as the problems of complex shadow and highlight patterns, typical of images taken in sunlight, are overcome. This early summer view of the Heian Shrine Garden, in Kyoto, Japan, has really benefited from being taken in such light.

Landscape photographers have to wait for the right weather conditions and times of day to get their golden light, but portrait photographers have the option of doing it all indoors, where they can mimic that soft, diffused light with the careful use of flash lights, diffusers and reflectors – skills that will be covered later (see pages 88–89).

Completely flat or dull light can still be quite attractive to portrait photographers, provided they can use reflectors to bounce light back into their subjects' faces. Other photographers can use this kind of light only with certain subjects, such as those for which high-contrast sunlight would produce confusing images. Such subjects include many kinds of plants,

photography of which in sunlight can result in an indecipherable mass of highlight and shadow areas. Flowing water and rocks are often also best photographed in dull light, the former to allow the use of slow shutter speeds that enhance the feeling of flow, and the latter to enhance the visibility of details and patterns in the rock surface.

Choosing your lighting angle

In addition to light quality, lighting angle is a crucial consideration. The most basic option here is frontal lighting, where the subject receives light from directly behind the photographer. The resulting image tends to be quite flat, with visible shadows at a minimum, greatly reducing any sense of

Colour temperature and its effect on colour reproduction: (page 51).

Flat frontal lighting is useful in minimizing shadows and skin blemishes, and so is frequently used in fashion and glamour photography, as shown in this image of a young model.
Canon EOS 1Ds, Canon 24–105mm lens, 1/100 sec at f/2.8, ISO 400. Image courtesy of Bjorn Thomassen.

the subject's three-dimensional shape. How desirable this is depends heavily on the kind of photography. Portrait photographers, particularly when photographing women, regularly use this lighting angle as – provided the light is also heavily diffused – it minimizes skin blemishes. Other photographers, particularly those shooting landscapes, will generally be less impressed, as frontal lighting is poor when it comes to creating mood – although it is useful for images that simply create a record of a time and place, the images being clear and straightforward.

Side lighting is highly effective to create mood and generate a sense of a subject's three-dimensional shape. With this lighting angle, shadows can be quite strong, picking out contours, shape and surface texture.

Unfortunately, it can also result in a large contrast range, with deep dark shadow areas and brightly lit highlights – perfect for producing images with clipped histograms! This is a particular risk with strong lighting, but is generally manageable provided the light is well diffused. This is easily controlled by those using artificial lighting, but more problematic for those dependent on the sun and the presence of any airborne dust or water vapour that might diffuse the light.

Back lighting is particularly effective in situations when a photographer wishes to generate moody images. In this case, the light shines from behind and (usually) above the subject towards the camera, often generating a glowing halo around the subject, especially around hair, fur or

Tip It is easy to become stuck in using only lighting conditions that you feel comfortable with. Do not allow this to happen: always experiment and push the boundaries.

Creating a starburst effect

In any images where the sun is visible, the way it appears can be radically altered by changing the lens aperture. A wide-open aperture will cause the sun to appear simply as a large diffuse white ball – a significant part of the image around it burns out. Decreasing the aperture size steadily reduces the size of this ball. Using an aperture of about f/16 and above creates a tight starburst that can be stunning if its intensity is reduced by partially hiding it behind an object, such as a small cloud or the corner of a building.

In this landscape image of Snowdonia National Park, Wales, a low sun side-on to the view has resulted in large shadow areas that highlight the mountains' contours and create a three-dimensional feel to the forest and foreground scrub.

plants. Details in the subject will be greatly muted (although usually visible): portrait photographers often use a reflector to bounce light back into their subject's face, thus ensuring that all the facial details remain clear. A lens hood should be used when shooting a backlit subject to reduce the risk of flare creeping into the lens – something that can make this lighting angle rather tricky to pull off successfully.

related subjects Landscape photography: (page 94). Architectural photography: (page 98). Travel photography: (page 102).

An extreme example of back lighting is the silhouette, where the lighting is very low, or sometimes immediately behind the subject. The risk of flare getting into the lens is quite high in this situation, unless the low light, whether sun or flash lighting, is at least partially hidden from view, such as behind the subject, a cloud or a tree branch. The results can be stunning, with the subject's details completely lost (unless reflectors or strong secondary lights are used to push light back at it), and the shape of its outline becomes the whole purpose of the image.

Light and colour temperature

As described in Chapters 3 and 4, an understanding of colour temperature is important in producing well-exposed and atmospheric images. Under most circumstances, it is possible to leave a digital camera's white balance setting on automatic (AWB) and expect it to produce images that have a quite accurate colour balance. However, there are times when you may want to control the colour balance yourself, such as to enhance the welcoming, warm red glow present at sunrise and sunset, or to generate a homely atmosphere in an interior or still-life image.

Increasing the blue balance is also possible, though usually less desirable, since this can create an image with a cold, sterile and unwelcoming feeling. This kind of light would be appropriate for a threatening polar or alpine wilderness photographed in the light of early dawn.

Keeping it in focus

With very few exceptions, for an image to be of much use, let alone classed as great, it must be sharply focused. No matter how well composed and lit an image is, if the focusing is poor it will not be worth keeping. This is something that needs emphasizing, because it is remarkable how frequently people attempt to proclaim the virtues of an image that is poorly focused.

Many photographers switching from film to digital find they have to learn all over again how to assess an image for sharpness. Viewing a magnified digital image on a computer screen is not as straightforward as examining a piece of film

◄

Outline is everything in making great silhouette images, as illustrated by this view of the replica Statue of Liberty in Las Vegas, with the sun hidden behind the statue.
Canon EOS 1Ds, Sigma EX 70–200mm lens, 1/200 sec at f/11, ISO 100.

In many landscape images, particularly wide views, it is important to have the entire picture in focus. In this view of mangroves along a beach in the mouth of the River Amazon, this was achieved using a wide-angle lens and a very narrow aperture. Despite the strong sunlight, the narrow aperture necessitated a slow shutter speed and hence the use of a tripod.
Canon EOS 1Ds, Canon 17–40mm L lens, polarizing filter, tripod, 1/25 sec at f/22, ISO 50.

Tip **Always take care over focusing: no matter how well composed and exposed an image is, if it is not sharp it will almost certainly be of no use to you.**

> **Telephoto lenses are useful in portrait photography, as their narrow depth of field ensures that a correctly focused subject will stand out strongly against a blurred background, as in this image of a young model.** Canon EOS 1Ds, Canon 24–105mm lens, 1/125 sec at f/8, ISO 400. Image courtesy of Bjorn Thomassen.

with a lupe on a lightbox. The skill comes with practice, however, and it is essential that all photographers can decide whether their digital images are sharp or not.

While it is critical that an image's main subject be sharp, this need not be the case for the background or any other elements in the image. Whether to have the non-subject components of an image in focus or blurred may be a crucial consideration in deciding how to compose and shoot the view.

Focus and lens choice

Wide-angle lenses normally have a naturally large depth of field, frequently ensuring that it is possible to get much of the image in focus in addition to the main subject. This is particularly important for landscape, architectural and interior design photography, where it is often necessary to have an entire view in sharp focus.

Telephoto lenses, on the other hand, have a much narrower depth of field,

meaning that correct focusing is critical. It will often be possible to get only the main subject and a relatively narrow band in front of and behind the main subject in focus, leaving most of the background and foreground to go into an indistinct blur. While this may be a problem for depth-of-field-hungry landscape, architectural and interior design photography, it can be highly effective in portrait, nature and sports photography, where a blurred background can help the subject to 'pop out' of the image, with no distracting elements to draw the eye away.

When to use a tripod

The exact amount of depth of field available is determined by lens aperture: the narrower the aperture, the greater the depth of field. Narrow apertures also mean slow shutter speeds, so a quest to maximize depth of field will almost certainly necessitate the use of a tripod. Do not be tempted to shy away from this simply because tripods are a nuisance.

Depth of field

Depth of field is the distance through an image view that can be photographed in focus, as measured between the nearest and furthest sharp points from the camera.

The maximum achievable depth of field decreases with both increasing focal length and increasing aperture size (i.e. decreasing f/number). Therefore, in a view that is to be photographed using a wide-angle lens stopped down to f/22, the depth of field will be enormous – quite possibly the entire view from the nearest visible point to the distant horizon. A wildlife image that is taken with a 400mm lens at f/5.6, on the other hand, will

have a minimal depth of field, perhaps only of a metre or so, therefore making accurate focusing critical, but ensuring that the subject will stand out clearly and distinctly from a blurred background.

Depth of field also decreases dramatically in close-up photography, so that even at an aperture of f/22 it may be only a few centimetres or even less.

When a lens is focused on the subject, it is a general rule that the depth of field extends further behind that subject than it does in front of it: this factor can be used to good effect when you are deliberately using selective focusing.

related subjects Predictive autofocus: (page 60). Continuous shooting: (page 60). Merging foregrounds and backgrounds in the computer: (page 148).

Abandoning the narrow aperture to allow you to handhold the camera will inevitably result in the depth of field being too narrow, and so will generate an image that is inaccurately focused. Conversely, pushing ahead with the narrow aperture and slow shutter speed, but insisting on handholding the camera will only result in an image that is blurred due to camera shake. Either way, the resulting images will be useless. Do what you know is right: take your time, use a tripod, set the aperture you need to get the right depth of field and hence appropriate focusing, use as slow a shutter speed as necessary and finish up with brilliantly sharp images!

This is particularly important when light levels are low, or when the lens aperture needs to be stopped right down in order to truly maximize depth of field, such as in many kinds of landscape views, or when photographing plants or interior layouts.

Fast-moving subjects

When trying to freeze fast-moving action, a fast shutter speed is paramount, resulting in wide-open apertures and narrow depths of field. The danger then is inaccurate focusing on the subject, but combining the effectiveness of predictive focusing, fast continuous shooting and a willingness to keep on firing until a few images are in focus (in digital photography at absolutely no extra expense) will almost always result in some useful images.

Deliberate blur

Deliberately blurring a fast-moving subject by using a slow shutter speed is a commonly used technique to enhance the dynamism and energy of an image. Completely freezing motion with a fast shutter speed can result in images that look rather static and dull. Blur the motion and suddenly the image comes alive, especially if combined with flash lighting,

capturing the energy and vitality of the event. Such blur should not be confused with inaccurate focusing or camera shake. The latter can sometimes be deliberately used, with slow shutter speeds, again often combined with flash and also with blurred movement, to enhance the energy of a scene, especially in situations such as bars and nightclubs where a tripod is impractical but where it is important for the ambient light and background scenes to be visible.

Motion blur introduced into an image by a slow shutter speed, as in this image of a group of musicians, can greatly increase the feeling of movement within the image, enhancing its dynamism and sense of energy.

Handheld photography: the reciprocal shutter speed rule

If handholding the camera, how slow a shutter speed can you use and still produce sharp images? This depends on the focal length of the lens used. A rough rule is to use a shutter speed no slower than the reciprocal of the selected focal length. So, if a lens is being used at 30mm, the slowest shutter speed at which you can handhold is 1/30 sec. At 300mm, the slowest speed

possible is 1/300 sec. The advent of image-stabilizer lenses has changed all this, at least at the telephoto end. Lens manufacturers claim that this facility allows handheld photography at three stops of light less than is possible with a fixed lens. In that case, a 300mm image stabilizer lens can be handheld down to a shutter speed as low as 1/40 sec – a huge improvement.

Tip Not only does blurred motion help to add a sense of dynamism to an image, but it is also useful when you want to include people who remain anonymous and unidentifiable.

Photographic Subjects
Portraits

Indoor portrait photography is superb for producing carefully formalized studies of a subject, allowing total control of both lighting and background. Image courtesy of Bjorn Thomassen.

Outdoor portrait photography is most often reserved for spontaneous shots of people having fun, surrounded by their 'natural environment'.

The photography of people ranges from spontaneous, informal snaps on the beach through to highly formal, staged shots in a studio. The styles are hugely different, the resulting images apparently showing little in common. Yet they all share much the same kind of goal: to capture and freeze a moment in time and to extract something of the essence of the person or people in the image.

Indoor and outdoor photography
Portrait photography is one of the few forms of photography that can be carried on both indoors and outside, and the constraints and opportunities of the different kinds of lighting available have a big impact on the kinds of portraiture possible. Although formal portraiture is possible outdoors, the space and ready-made light of the open air lends itself to spontaneous informal portraits, the snapshot reportage style of photography that requires the photographer to be mobile, using on-camera flash as fill-in lighting, rapidly shooting moments as they arise with little or no posing of the subjects. The resulting images often depict fun times, may well be frivolous and most likely will capture the feeling of the event rather than the subjects' personalities.

Indoor photography, on the other hand, with its need to generate artificial sunlight in the form of flash lighting, or at least reflectors, is inevitably more fixed and formal. If well composed and lit, this style is likely to generate truly attractive, and often thoughtful, portraits of a single individual or at most a small group – images that distil something of their personality and that become lasting memories of those people.

Soft versus hard lighting
Soft lighting is a must for flattering portraits. Hard lighting, such as bright sunlight, will result in deep shadows and excessively bright highlight areas, enhancing jaw and nose outlines, emphasizing heavy brows, reflecting strongly off shiny skin and showing up every wrinkle. This is especially so for a high, side-lighting sun, but it is also true for strong, undiffused studio lighting set at an acute angle to the subject. Although such lighting might be used in studio portraits of men for whom it is more important to portray strength of character than any physical beauty, for most situations an attractive physical appearance is the hoped-for outcome. In order to achieve this, diffused lighting, usually delivered frontally, is the ideal, as it minimizes shadows and softens features

related subjects

White balance settings for photography in artificial lighting: (page 50).

Merging several portrait images in the computer: (page 124).

and skin texture. In the studio, this effect can be achieved through the controlled use of flash lighting (see attached box, right), while outdoors much depends on the weather conditions. A bright overcast day will be ideal, as the veil of cloud acts as a huge diffuser. The use of a single reflector arranged in front of and below the subject will deflect light into their face, eliminating any shadows. In sunny weather, the subject should be photographed in the shade, under a tree or in the shade of a wall, again using reflectors to deflect light into the subject's face.

Throughout, white balance can usually be controlled well with the AWB setting, though the sunny, cloudy and shade settings can be chosen if preferred.

In this portrait shot outdoors on a sunny day, the light falling on the subject was softened by placing her in the shade of a tree. A white reflector was used to bounce light back into her face, to ensure even, shadow-free lighting.
Canon EOS 1Ds, Canon 28–70mm lens, 1/125 sec at f/4, ISO 100. Image courtesy of Bjorn Thomassen.

Lighting a studio portrait
The typical lighting method for a high-key studio portrait is as follows:

1 Use two lights and a reflector with a large white background.
> The main light should be fitted with a large diffuser, such as a softbox or umbrella.

2 Set up the main light to the left of the camera.
> It should be pointing almost straight at the subject but a little to one side, illuminating mainly their right side.

3 Set up the reflector on the subject's opposite side, quite close in but out of camera view.

4 The second light should be beside the subject, pointing at the background.

5 With only the main light active, set this up with enough flash output to give a lens aperture of about f/16 to maximize depth of field.

A modern high-key portrait, with the background a plain pure white and the subject lit frontally.
Canon EOS 1Ds, Canon 28–70mm lens, 1/125 sec at f/8, ISO 100. Image courtesy of Bjorn Thomassen.

> Test this with a light meter, measuring incident light immediately in front of the subject.

6 Set up the reflector so that light bounced back into the subject's shadow side is one to two stops below that of the main light.
> Check this with the light meter, again using incident light, coming from the reflector towards the subject.

7 Set up the background light to give the same output as the main light onto the background.
> Again check this using the light meter, reading incident light shining onto the background.

8 With all the lighting set up and checked in this way, arrange the subject and take the first images.
> Check the results in the LCD screen, being careful to look for clipped histograms and strong shadows on and around the face. If necessary, make adjustments to the lighting and reshoot. Once the lighting is right, shoot whatever images are needed.

Tip Always try to keep your subjects relaxed: tense subjects will usually look stiff and unnatural in the final images.

Photographic Subjects

Nature

An Amazonian manatee, photographed in an aquarium in Manaus, Brazil. This species is extremely difficult to find and even harder to photograph in the Amazon's murky waters; this image of a captive manatee conveys the beauty of the animal and speaks for the importance of protecting its wild cousins.
Canon EOS 1Ds, Canon 17–40mm lens, 1/125 sec at f/4.5, ISO 200.

The simplest wild animals to photograph are those that have become habituated to human presence. This young spider monkey, living free inside a forested urban park in Manaus, a vast city in the middle of Amazonian Brazil, was quite unfazed, although rather curious, by my presence.
Canon EOS 1Ds, Sigma EX 70–200mm lens, 1/250 sec at f/2.8, ISO 200.

The living world is an endless source of beauty and, for the photographer, subject matter. From tiny insects to plants to the largest mammals and birds, the variety available for the nature photographer is enormous, the huge diversity requiring a large range of skills that can be only touched on here.

Wild and captive animals

Interest in nature photography tends to concentrate on the large popular mammals; the big cats, great apes, giraffes, elephants and pandas beloved of television documentaries. This is understandable, as these are the animals we most closely associate with the characteristics we tend to admire: ferocity, strength, an independent spirit and intelligence.

Even among just the mammals, nature photography should consist of much more than these few iconic species – which is just as well, as most people, most of the time, will have to concentrate on photographing wildlife close to home. Relatively few people will ever have the opportunity to photograph the world's big cats and great apes, at least in the wild.

Regardless of the location, photographic techniques for mammals, and larger birds too, are pretty much the same. There is one crucial problem: how to get close enough. Even an apparently powerful telephoto lens can seem woefully inadequate out in an open grassland with the target species a couple of hundred metres away. The DSLR can be a major blessing here, especially for photographers using a DSLR with a small sensor, as the focal length multiplication factor greatly increases apparent lens power. A 400mm lens fitted to a camera with a sensor that has a 1.5x multiplication factor, for example, will suddenly become a 600mm lens.

Even with this help, distance can still be a problem. For those with plenty of

related subjects

Minimum shutter speeds for handheld photography: (page 87).

Merging subjects and backgrounds in the computer: (page 149).

time, construction of hides and/or slowly allowing wild animals to become used to your presence over several days or even weeks can pay dividends. Time is a luxury few of us have, so the most common solution is to find locations where the wildlife is habituated to human presence. Gardens and urban parks can be useful in this regard, and even in some national parks the wildlife has become used to the presence of four-wheel-drive vehicles.

The most human-habituated animals are, of course, those in zoos and wildlife parks. Although many nature photographers frown on the idea of photographing captive animals, it does have an important role, allowing not only close-up portraits that would be difficult with any wild animal, but also photography of species that would be almost impossible to photograph in the wild. The captive animals serve as an important representative of their wild cousins, and anything that promotes the cause of a species and its conservation should be considered of value.

V **Many plant images require a large depth of field to get everything in focus, often shot in quite dim woodland light. This view of ferns and horsetails in woodland near Haines, Alaska, photographed on a cloudy day, was no exception. Fortunately, there was no wind, so when coupled with a tripod a slow shutter speed was perfectly usable.**
Canon EOS 1Ds, Sigma EX 70–200mm lens, tripod, 1/6 sec at f/22, ISO 100.

The beauty of plants

Fortunately, plants do not run or fly away, but successful plant photography poses its own challenges. The frequently large, spreading shape of plants often requires a big depth of field to bring the entire plant in focus, while the tendency of plants to wave around in the slightest breeze demands a fast shutter speed. These two needs are in conflict with one another. If a sharp image is essential, the usual solution is to concentrate on maximizing depth of field and wait patiently for a windless moment before pressing the shutter. In digital photography it is possible to use a double-exposure technique, using a fast shutter speed to freeze movement, and then later in the computer combining the sharp parts of differently focused images. In excessively windy conditions, consider giving up the idea of sharp images altogether, and incorporate blurred leaf movements into the composition.

Lighting is another important issue. Whether shooting tiny forest-floor plants or gigantic trees, it can be tempting to shoot in sunlight simply to maximize the amount of light available. However, the result is often images with a confusing mishmash of shadows and highlights that do not adequately portray the plant subject. It is usually better to shoot

∧
When photographing in woodland, it can be tempting to want to shoot in sunlight simply to maximize the amount of light available. However, the result can be a confusing mass of shadow and highlight areas (a). A far more meaningful image can be obtained under cloudy conditions, when the flatter light reveals the vegetation more clearly (b). Muddus National Park, Lapland, Sweden.

<
When high wind makes a slow shutter speed impossible, go with the flow and make blurred movement a part of the image, as with this close-up of a rice field in southern China.
Canon EOS 1Ds, Sigma EX 70–200mm lens, 1/4 sec at f/16, ISO 100.

Tip **Remember that the rules of good composition still apply even to photography of species where just getting any kind of image is a major challenge.**

Close-up photography of small flowers, such as these wood anemones in a forest in southwest England, is usually much better in overcast light. Photography in sunlight would result in harsh shadows around the leaves, while the white flowers would probably burn out.
Canon EOS 1Ds, Sigma Ex 28–70mm lens with extension tube, tripod, 0.4 sec at f/22, ISO 100.

in overcast conditions when the lighting is flat and shadows reduced to a minimum. The blueness of such light should be corrected by the camera's AWB white balance setting, but you can set the camera to its 'cloudy' or 'shady' settings.

Insects and other tiny species

The photography of truly small species, whether plant or animal, requires a unique skill. Photography of an animal or plant less than a couple of centimetres across is difficult with a normal set of lenses, as getting the subject large enough within the image frame usually means setting the camera up closer than the lens's minimum focusing distance. Overcoming this requires the use of a macro lens or of a normal lens fitted with either an extension tube or a close-up lens.

Depth of field is extremely narrow in close-up photography, so ensuring sharp focusing over the whole of a subject often requires a narrow aperture (at least f/11, and usually more). For photography of a plant, such as a lichen or moss, this is not a problem, as the camera can be set up on a tripod and a slow shutter speed used. However, for a mobile animal, particularly one that flies, this can create real problems.

The usual solution is to handhold the camera with a flashgun attached. The flash allows a much slower shutter speed to be used, freezing both the insect's movement and any camera shake. It is essential that the flashgun be capable of quenching its output power down to the very low levels needed to accurately illuminate a subject that is likely to be only a few centimetres from the lens, something not always possible

with the most powerful flashguns. It must also be possible to mount the flashgun on the camera in such a way that there is no danger of it casting a shadow of the lens across the subject.

Close-up photography of moving insects, such as butterflies, can be difficult and time-consuming. When shooting with film, a major problem has always been that a lot of frames can be wasted with inaccurate flash exposure or focusing, with the results not visible until some time later. With a digital camera, having an instantly visible result points out where mistakes are being made, allowing immediate changes and so increasing the chances of success.

Handheld flash photography is often the best way to capture images of tiny invertebrate animals, as with this unusual image of a spider catching and killing a bee, in Kenting National Park, Taiwan. With this technique, the flash not only helps to illuminate the subject against the background, but also eliminates camera shake, resulting in clear, sharp images.

Exposure and green vegetation

The dark green colour of most vegetation can affect the accuracy of in-camera light meters. Plant greens are usually darker than a neutral tone and so tend to cause a light meter that is reading reflected light to overexpose the resulting images. Even evaluative metering can fall victim to this, especially if the view also contains significant shadow areas. To overcome this, it is frequently necessary to underexpose images relative to the exposures suggested by the in-camera light meter.

related subjects | **Flash in digital photography: (page 72).** | **Flash and white balance control: (page 72).**

This close-up of forest-floor lichens in Muddus National Park, Swedish Lapland, was taken without special close-up equipment. The extremely short minimum focusing distance of some of the best wide-angle zoom lenses makes it possible to do some close-up photography without specialist kit. Furthermore, being a wide-angle lens, even when set on its longest focal length there is still quite a reasonable depth of field, keeping plenty of the lichens in focus.
Canon EOS 1Ds, Canon 16–35mm L lens, 1/50 sec at f/9, ISO 100.

The choice of close-up equipment

The following equipment can be used for close-up photography:

Equipment	Name	Advantages	Disadvantages
Macro lens	Lens designed to allow very close-up focusing.	Highly flexible, high-quality optics, can usually give magnification up to life-size, and can also be used for standard photography.	Relatively expensive; yet another lens to have to carry around.
Extension tube	Fits between camera and a telephoto lens to enable close focusing. Tubes of various sizes allow different amounts of magnification.	Very small and light to carry, cheap, can sometimes give up to life-size magnification.	Not very flexible, unless an adjustable tube can be bought. Exposure increased by up to two stops.
Close-up lens	Just like a screw-on filter, fits onto the front of the lens to allow close focusing.	Very small, light and cheap. Different lenses available for different magnifications. Lighting, and hence lens aperture, unaffected.	Image quality may not be high unless the very best lenses are bought. Magnification rate rather low. Not very flexible; different lenses needed for different magnification.
Bellows	Extendable tube running on a rail, fitting between the camera and lens. A complex glorified extension tube.	Flexible magnification possible, up to several times above life-size, producing high-quality images.	Heavy, bulky, expensive, difficult to use. Large amounts of light lost for exposure.

Photographic Subjects
Landscapes

All the rules of landscape photography that apply to film hold true for digital capture, at least in terms of such issues as time of day, quality of lighting and composition. However, there are some crucial differences in the way the digital photographer must go about capturing the images.

A sunrise view across the marshy grasslands of the Somerset Levels, Somerset, UK.
(a) With the camera's white balance mechanism set to automatic (AWB), the image's colour balance came out more or less as the eye saw it, with just a little splash of red close to the horizon. (b) When seconds later the image was reshot with the white balance mechanism set to 'sunny daylight' to mimic the 5500K balance of film, the image came out much warmer, with strong red tones.
Canon EOS 1Ds, Sigma EX 28–70mm lens, tripod, 1/15 sec at f/11, ISO 100.

The ends of the day

If shooting at dawn/sunrise or sunset/dusk, when the light is rich in reddish colours, the film-user will be used to the final images coming out even redder than the view appeared to the eye. The reason for this is that, while colour film is balanced for use under 'average' daylight conditions, with a colour temperature of 5500K (see Chapter 3), at either end of the day the light has a temperature of only about 4000K, a rather reddish light. While the human eye and brain are able to partially compensate for this increased red content, film cannot, resulting in images with a strong red tendency. This is usually very beneficial to the atmosphere of an image, and something that most landscape photographers are only too pleased to allow to happen.

Things are rather different when shooting with a digital camera, however. If shooting with the camera's white balance mechanism set to automatic (AWB), the camera will sense the lower colour temperature at either end of the day, and will compensate, producing images very similar in colour rendition to what the eye sees. The result? Total loss of the much-loved warm atmosphere generated by those enhanced reds so typical of film images.

The solution is to switch the camera's white balance mechanism to 'sunny daylight' (5500K) or even 'cloudy daylight' (6500–7000K) settings, to mimic or even exaggerate the effect of film. Be careful, however, if aiming to exaggerate the reddish hue by setting the camera to a higher colour temperature balance (such as is achieved on a 'cloudy daylight' setting) than has ever been normal with daylight film. The gap between the camera's balanced colour temperature setting and the actual

∧

A landscape of rugged Alaskan mountains on a gloomy day has come out as a striking image thanks to the camera's white balance mechanism, which – set to 'cloudy' – gave a more accurate colour balance than might have been possible had the image been shot on film.
Canon EOS 1Ds, Sigma EX 70–200mm lens, 1/160 sec at f/16, ISO 100.

related subjects The colour temperature scale: (page 50). Changing colour balance with different white balance settings: (page 70).

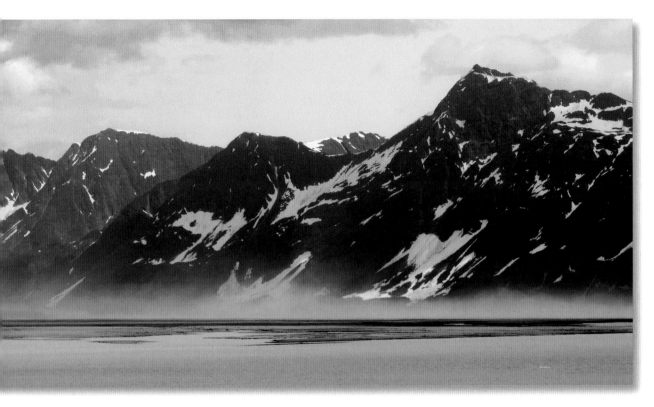

colour temperature of the light could be huge, resulting in an enormous red shift in the images. It is possible to have too much of a good thing, bathing the images in just too much red and orange colour. Exercise discretion, and always check your images in the LCD screen after shooting.

Cloud cover and bluish light

Unlike the reddish light at the ends of a clear day, in cloudy weather throughout the day the light is generally quite blue, with a colour temperature of 6500–7000K – considerably higher (and hence bluer) than the 5500K of white light on a sunny day. In these conditions, landscape images shot on film will have an unpleasant blue cast unless a pink 81A or B filter is fitted across the lens to compensate. Digital photographers can achieve this correction automatically by setting the camera's white balance to either automatic (AWB) or to 'cloudy'. Alternatively, with some cameras it is possible to enter a specific

colour temperature for which the images should be balanced. Doing this requires the photographer either to have a colour temperature meter or to be extremely good at guessing the necessary setting!

These adjustments will overcome the blue cast, but will do nothing to fix the dull

Photography in poor light

When the clouds roll in, it is tempting to put the camera away and head home. However, it can be possible simply to switch to subjects that are best shot in flat lighting. Woodlands in particular are best photographed in dull lighting, as sunlight usually causes a confusing mass of dark shadows and burned-out highlights that makes it hard to see the woodland view. Streams and dark green vegetation particularly benefit from flat light; the latter can look truly stunning in rain, the greens becoming quite vibrant, provided a polarizing filter is also used to remove reflections from the wet leaves.

Also photographable in dull light are rocks and cliffs – the kind of material where complex and subtle patterns may be broken up by the effects of sunlight.

Tip Do not be a slave to the automatic white balance setting. Experiment with different settings under different lighting conditions to see how they affect image colour and mood.

Silhouettes and outlines

Outline is everything in a silhouette image, a great outline creating the potential for a superb silhouette image. In landscapes this can be all manner of subjects, such as a gnarled old tree, jagged rocks, a mountain, a boat or an unusually shaped building. Do not expect any detail to be visible, and try to ensure that the image is not ruined by flare from the sun. Keep the sun out of the image frame, or hidden behind something, such as the main subject. Having the sun just slightly emerging from behind the subject can create a spectacular starburst effect that can make a good image great.

A view of a rugged escarpment in Stora Sjöfallet National Park, Swedish Lapland, has put a strong diagonal across the image, conveying the sense of the drama and raw energy of this wilderness.
Canon EOS 1Ds, Sigma 28–70mm lens, 1/800 sec at f/5.0, ISO 100.

and depressing effect a grey sky has on a landscape view. My usual solution is to choose subjects suited to low contrast and sunless lighting and frame the images to minimize (or preferably completely do away) with any sky.

Angles, perspective and lens choice

The use of lines at different angles in an image can be crucial in establishing mood. This is particularly true of landscape photography. Dynamic landscapes with plenty of movement, such as scenes with flowing water, or dramatic vistas such as mountain ranges, are likely to benefit from the presence of diagonal lines to enhance the sense of drama. These may be present in the form of mountain ridges or summits, a shoreline, or leaning tree trunks, and they can all be further accentuated by the use of a wide-angle lens.

related subjects

Diagonal lines and image mood: (page 79).

Lighting angles and image mood: (page 82).

The relaxing beauty of a quiet dawn, perhaps over calm water, is likely to be ruined by diagonal lines. Horizontal lines will help here, such as ripples on the water, a distant shoreline or horizon, misty clouds or gradations of colour in the sky. Soft pastel colours will also help, such as gentle pinks in the sky. Fiery colours tend to increase a sense of drama and energy, not calm relaxation.

When photographing many landscape views, it is tempting to use a wide-angle lens simply to ensure that as much of the scene as possible is fitted into the image frame, as well as to help maximize depth of field. Care needs to be exercised, however. Parallel vertical lines, for example in a cliff, that help to give a feeling of strength and permanence in an image taken using a standard or telephoto lens, can suddenly become converging diagonals if a wide-angle lens is used and the camera is tilted backwards a little. Suddenly, the image becomes quite dynamic, which may also be fine, but will result in a quite different image from the original with the parallel lines.

Furthermore, a wide-angle lens reduces the scale of anything included in the image frame. A mighty mountain range can suddenly be reduced to mere hills that look barely significant in the wide sweep of the image frame.

⋀

Diagonals formed by a mountain stream zig-zagging its way through forest, along with blurring of the flowing water, enhances the sense of movement and energy in this image, which was shot in Stora Sjöfallet National Park in Swedish Lapland.
Canon EOS 1Ds, Canon 16–35mm lens, tripod, 1/5 sec at f/22, ISO 100.

⋁

Soft colours and the more-or-less horizontal lines formed by the mountain outlines combine to make a peaceful dusk view, though some tension is added by small diagonal elements, particularly the triangular dip in the mountains on the right. Wulingshan Nature Reserve, Hebei Province, China.

Tip **Think about the mood you would like to create, given the subject and light available, and then choose lens, framing and perspective to match.**

Photographic Subjects

Architecture

Concentrating on a few details can say a lot about a building, whether modern or traditional, such as close-ups of columns at the base of the Lippo Centre, in Hong Kong, or the ornate roof of the Chinese Opera House in Taipei, Taiwan.

The Lied Children's Discovery Museum, in Las Vegas, Nevada, though an attractive building, did not easily lend itself to great architectural photography. However, homing in on some of its most interesting architectural features resulted in a few great images, showing the building off to its best.

Architectural photography is the photography of manmade landscapes, from entire city skylines to tiny building details. This genre is more popular than might be realized, and has a huge diversity of uses, from holiday snaps of the local resort to specialist commercial photography.

Much that was said about the control of light and colour temperature for landscape photography also applies to architecture; buildings frequently look most attractive in the reddish light of early morning or late afternoon, and rather unappealing under grey skies. An additional component is the stunning photography that can be carried out at dusk or at night, particularly of modern skylines, when buildings are illuminated by their interior lighting.

Converging parallels

A critical technical aspect of architectural photography that needs to be addressed is the issue of converging parallel lines. When photographing many kinds of buildings, you will find that it is often necessary to point the camera upwards to get the whole of the building in the image frame. In the final image, the walls will appear to be leaning backwards and what should be parallel lines tend to converge – a problem known as perspective distortion. This results from tipping the camera back so that the film or digital sensor is no longer parallel to the building's wall, with one end closer to the building than the other. This error is always corrected in good architectural photography, as described in the box opposite.

related subjects

Verticals and diagonals in image mood: (page 79).

In-computer steps to correct perspective distortion: (page 143).

Distilling architectural features

Whether shot on film or digitally, good architectural photography should aim to emphasize some of the building's main design features. Most buildings worth photographing were constructed for a specific purpose, and often have features announcing that purpose to the world. A church or temple aims to proclaim the glories of whatever god it is dedicated to; many office buildings shriek corporate pride or a sense of wealth and power; and a high-class hotel puts over a feeling of opulence and luxury. Capturing and emphasizing those features in a set of images should

concentrate on photographing the building from its most striking angle and under the most attractive light. It should also include images that home in on some of its most interesting details – points of interest that often say more about the building than an image of the whole building manages, and that you can be sure were a deliberate part of the architect's plan.

Correcting perspective distortion

Steps to overcome perspective errors help to ensure that in the final image all the walls are vertical and parallel lines remain parallel. Traditionally, this has entailed the use of cameras with complex movement facilities that allow the lens to be moved while keeping the film completely vertical and so parallel to the building's wall. Such facilities are expensive and have usually been limited to large-format and a few medium-format cameras. It is possible to buy what are called 'tilt-and-shift' lenses for 35mm cameras that usually solve the problem, although these are still quite expensive.

For the digital photographer, a cheaper solution is to let the computer do the correction. Provided the distortion caused by tipping the camera is not too great, it is possible to apply perspective correction during post-photography computer manipulation, producing results identical with those achievable with a shift lens (see page 143).

These images of the ruins of Concordia, in the Valley of Temples, Agrigento, Sicily, illustrate the problem of converging parallels in architectural photography (a), and how easily it can be rectified through work on the computer (b).

Tip When taking an image containing distortion that will need correction, leave plenty of space around the subject, as the in-computer steps will result in some cropping.

Photographic Subjects
Interiors

< The interior of the Hard Rock Café in Honolulu, Hawaii, shows not only a bizarre collection of details, but also the importance of ensuring a large depth of field to keep all of the view in focus.

> A detail of the ornate ceiling in the lobby of the Venetian Hotel in Las Vegas. Lit solely by tungsten lighting, the camera's white balance mechanism, left on automatic, produced a perfectly colour-balanced image, as shown by the whiteness of the lights themselves.
Canon EOS 1Ds, Sigma EX 28–70mm lens, tripod, 3 sec at f/16, ISO 100.

Often used as an adjunct to architectural photography, shooting interiors can cover a huge range of environments, from a vast cathedral nave to a tiny domestic or hotel bathroom. Typical requirements are a need to maximize depth of field, the management and manipulation of colour balance and artificial lighting, and an ability to overcome the problem of converging parallels also encountered in architectural photography.

Maximizing depth of field
Although interiors photography sometimes includes images of design details, usually it concentrates on relatively wide-angle views that show all or most of a room. In such a situation, the entire view is of interest and hence must all be in focus. This necessitates a large depth of field, and hence a narrow lens aperture and slow shutter speed. With the low light levels usually found indoors, a tripod is essential.

Controlling light and shadow
The human eye has a greater dynamic range than either film or the digital sensor, allowing us to see more detail in shadow and highlight areas. This is of particular importance to interiors photography because shadow areas, especially, can be quite significant. What looks reasonable to the eye can end up in a photograph as a huge, massively underexposed area. In film photography this is usually overcome by supplying some secondary lighting – usually flash – to fill in shadow areas, supporting but not replacing the main lighting (which may be natural or artificial light). In digital photography, if the shadows are deep it is common to take pretty much the same approach. However, for mild shadows it is often possible to dispense with the secondary lighting, relying wholly on post-photography processing in the computer to remove or lessen the effect of the shadows.

> This view of a domestic lounge illustrates the problem of converging parallels common in interiors photography when the camera is tilted downwards (a). Perspective correction applied in the computer (b) is perfectly straightforward and simple to apply.
Canon EOS 1Ds, Canon 17–40mm L lens, tripod, 1.6 sec at f/22, ISO 100.

related subjects | DSLR white balance settings for artificial lighting: (page 50). | In-computer correction of perspective distortion: (page 143).

the AWB setting can come up with a reasonable white balance compromise between the daylight and tungsten colour temperatures. If really accurate colour balance is needed, a twin exposure method can work (see Chapter 7), in which one image is taken balanced for daylight, and then a second balanced for tungsten, with the correctly colour-balanced parts of the two images being merged in the computer.

Perspective

It is common to use the camera close to eye-height so that the resulting images have more or less the perspective we are all familiar with. However, with the camera at this height, inclusion of lower points of interest such as chairs, low tables and flooring requires angling the lens downwards. This is not a problem for a camera with lens tilt and shift movements, as traditionally used by professional interiors photographers. However, for cameras without this facility we encounter the same problem as with architectural photography, only in reverse.

You will find that tipping the camera downwards results in the camera back being no longer parallel to the walls. The final images will show perspective distortion, the walls leaning outwards, and previously parallel lines converging towards a point below the floor. Provided that the camera is tilted by only a moderate amount, the solution is to correct the distortion during post-photography image optimization (see page 143).

In a room flooded with natural daylight, and with white walls that reflected a soft, flat light, photography was quite simple. This relatively narrow detail view is almost shadowless, with the colour perfectly balanced to daylight.

Colour balance in secondary lighting

The colour temperature of any secondary lighting used must match that of the main ambient lighting and the camera's white balance setting, otherwise the image's entire colour balance will be thrown off. Since flash normally has a colour temperature of 5500K, similar to that of sunny daylight, balancing it with tungsten lighting, for example, involves putting orange filters (called 85B colour-conversion filters) over the flash tubes.

Colour balance

If an interior's ambient lighting is of just one type, such as daylight, tungsten or fluorescent, then colour balance with a digital camera is quite straightforward: either set the white balance mechanism to automatic (AWB) or choose the appropriate 'cloudy daylight', 'tungsten', or 'fluorescent' settings. With mixed lighting situations – mixed daylight and tungsten is common in the domestic setting – achieving accurate colour balance can be less easy, although

Tip Try to keep interiors views simple: cluttered interiors make for messy images.

Photographic Subjects
Travel

One of the world's most famous vistas, Hong Kong's skyline and harbour seen at dusk, constitutes one of the world's great travel views.

Seizing the moment; an image grabbed in passing just as a customer was paying at a bagel stall creates a dynamic composition that makes a statement about daily life in Athens.

Distilling the essence of a place: this close-cropped image of a game of craps says just about everything you need to about the Las Vegas casino scene.
Canon EOS 1Ds, Sigma EX 28–70mm lens, tripod, flash, ¼ sec at f/11, ISO 100.

Travel and holidays probably constitute the biggest single reason why anyone buys a camera, whether compact or SLR. At the simplest level we want to capture the highlights of a holiday; at a more advanced level, we want to capture images of the stunningly beautiful world in which we live, whether that constitutes landscapes, people or famous buildings.

The skill of travel photography

Photographically speaking, there really is no such skill as travel photography. It is actually a composite of all the skills already described. A good travel photographer is a jack-of-all-trades, skilful at certain types of portrait photography, nature, landscapes, architecture and, to some extent, interiors. However, in my experience, all good travel photographers like to specialize in one of the main disciplines, whether it be people, wildlife, landscapes or something else.

In many senses, travel photography is documentary photography with a positive spin, depicting the beauty of our world rather than the awfulness of our daily news, in particular concentrating on places that people like to visit. In any photo shoot, whether close to home or on the other side of the world, the aim of the travel photographer is to come away with a set of images, magically composed and lit, that in some way distils the essence of a place, capturing how the people live, in what kind of environment and with what kinds of landscapes and wildlife, and generating what kinds of culture, architecture and art.

All the photographic techniques that have already been described for portraits,

related subjects

Image storage: (page 156).
The rules of composition: (page 77).

Downloading images from camera to computer: (page 130).

The skill of a travel photographer

One of the greatest skills of the travel photographer is the ability to chop and change quickly and effortlessly between different photographic disciplines, one moment photographing portraits of people in a market, minutes later engaged in architectural work at a famous temple, followed shortly by views of the surrounding landscape. In addition, they must be able to capture a subject at exactly the right moment in time, freezing movement in the street or a boat crossing a lake, for example, at exactly the right instant to create a perfectly composed, exposed and focused image.

nature, landscape, architecture and interiors apply to travel photography, whether the medium is film or digital. Learning how to use and combine them all and knowing the most appropriate times and places to use each are at the heart of successful travel photography.

Travel and the digital revolution

The advent of digital photography has been a great boon to the travel photographer. Anyone on a long visit to a distant place who was shooting on film could go a long time without seeing their results, particularly if they were in a country with no adequate film-processing facilities, making it impossible to know how well the photography was going and whether they were producing effective images.

Digital photography ensures that every image can be seen as soon as it is shot, making it possible to review the success or otherwise of a photo shoot as it happens. The fear

of airport X-ray damage to valuable film is a thing of the past, as is the need to carry a large amount of film when travelling to areas where it cannot be easily bought. That bag of film has been replaced with a laptop computer, smaller in bulk but at least as heavy as the film.

There is of course, the fear of corruption of digital files, destroying all or a large chunk of a visit's images, as well as the fear that a laptop computer carrying all the images could get stolen. The solution is duplication – an option never available with film. When I travel, the images I shoot are not stored on the laptop's hard drive at all, but on two external drives, ensuring that I have two copies of every image. One of the hard drives is a pocket-sized device that I can carry around everywhere with me, so that even if my hotel room is broken into I still have my precious images. The issue of image storage is covered in greater detail in Chapter 8.

Finding something unique: this wavy pattern of tiles in Sao Sebastian Square in Manaus, Brazil, is emblematic of the city, representing the nearby confluence of the Rios Solimoes and Negro to form the Amazon proper. Shot with no interfering background detail, this captures something unique about Manaus. Canon EOS 1Ds, Sigma EX 28–70mm lens, 1/100 sec at f/18, ISO 100.

Tip If travel photography is your thing, aim to hone a wide range of photographic skills that will enable you to grab great images in any kind of destination.

Some Digital Pitfalls
Avoiding Trouble

Digital SLRs are not perfect: like everything else, they have their pitfalls for the unwary. Some of these are an issue only for the digital novice, and fade away as experience increases. Others remain forever problematic, glitches that always have to be guarded against and overcome. Although a few of the problems may occasionally tempt you to return to film, the benefits of digital continue to outweigh those of film, and few people regret the switch.

<

Beach pebbles, beautifully lit by the red light of a low setting sun, with details in both shadow and highlight areas picked up perfectly by a digital SLR. Budleigh Salterton, Devon, UK.
Canon EOS 1Ds, Canon 17–40mm L lens, 1/50 sec at f/6.3, ISO 100.

M any of the DSLR's problems have been introduced in earlier chapters, but it seems worthwhile to group the most important in one chapter – both those already mentioned and a few more. Perhaps the most irritating problem is the ease with which the sensor gets dirty, and this is the first issue we discuss.

The Dirty Sensor

The problem with having interchangeable lenses is that every time one is removed there is an opportunity for dirt to get into the camera. Initially, it gets only as far as the mirror or perhaps the shutter curtain, but as soon as the shutter button is pressed, the dirt gains direct access to the sensor. In turn, being electrically charged during the exposure, the sensor attracts dust like a magnet, sucking any floating dust straight into it. What is more, the rapid movement of both mirror and shutter curtain creates a minor hurricane that stirs up any particles attached to the back of the lens or any part of the internal chamber, further helping to spread dust around.

The more often lenses are swapped around and the dustier the atmosphere, the faster the sensor becomes dirty. Make no mistake: even with limited lens swapping and in laboratory-clean air, the

>

The problem of dirt on a digital sensor: the detail image shows the shadows of bits of dirt, scattered across the sensor, before cleaning up on the computer. The complete image shows the finished result after cleaning. Floatplane moored in Anchorage, Alaska, USA.
Canon EOS 1Ds, Sigma EX 17–35mm lens, 1/60 sec at f/18, ISO 100.

In this image of trees silhouetted at dusk, the visibility of sensor dirt varied according to the lens aperture selected. In inset (a), with the aperture set at f/5.6 much of the dirt was visible only as vague grey patches. However, with a narrowing aperture, the dirt specks became sharper and more visible, as illustrated in inset (b) at f/20, and inset (c) at f/57.

sensor on any DSLR will become dirty. Dirt shows up on the images as black or grey blobs, usually blurred, normally visible only when viewed on a computer monitor, with the image blown up to or near 100% zoom. Only very large lumps of dirt will be visible on the image shown in the LCD screen, even when using the zoom feature.

A dirty sensor does not reveal itself on every image. Complex images containing lots of detail rarely show dirt, for example. Where the dirt does become visible is against plain backgrounds, particularly with pale colours, such as a blue or grey sky. Furthermore, lens focal length and aperture have a dramatic impact, due to depth of field. An image shot using a long telephoto lens with the aperture wide open

will probably reveal little dirt, the small amount that is found being large, faint and highly blurred discs that are easily removed by editing on the computer (see page 138). Conversely, an image containing lots of blue sky and taken using a very wide-angle lens shot with the aperture stopped right down is likely to reveal virtually every spot of dust that is anywhere near the sensor. Again, it can be erased on the computer, but it may take some time.

Prevention and cure

Efforts to minimize the amount of dirt that can get into the camera can include those listed in the box on the right. However, it has to be admitted that no amount of precaution will be completely

related
subjects

Cleaning images on the computer: (page 138).

The Healing and Cloning tools: (page 139).
Sensor design: (page 24).

effective, and your camera's sensor will eventually get dirty – dispiritingly quickly if you use the camera extensively. Cleaning a dirty sensor is an extremely difficult and nerve-wracking process. If not done carefully, it can end in the sensor becoming irreversibly, and expensively, damaged.

To obtain access to the sensor, you need to have the mirror up and the shutter curtain open. This can be managed by using the 'sensor cleaning' option, accessed via the menus in the LCD screen. This holds both mirror and shutter curtain open, with the sensor uncharged, for as long as the camera remains switched on and there is power in the battery. Make sure the battery is well charged before starting this, as loss of power will result in the mirror and shutter curtain snapping shut. If this happens while you are cleaning the sensor, with the stem of an air blower or swab inside the camera, it could result in damage to mirror, shutter curtain or sensor.

Under no circumstances should you be tempted to hold the mirror up and shutter curtain open by using the 'bulb' long exposure option. For one thing, if the shutter button is accidentally released the

mirror and shutter curtain will snap shut. Furthermore, since 'bulb' is a photographic exposure the sensor will be charged, not only making it impossible to clean existing dust away but actually sucking in more dust.

A first attempt to clean the sensor should consist of blowing air across it. Do not use your mouth, as this will result in moisture and droplets of saliva landing on the sensor. Instead, use a simple rubber bulb blower, one with a fairly long stem that will reach down towards the sensor. If greater force is needed, it is possible to use compressed carbon dioxide, available in handy miniature cylinders. Compressed air can also be used, but only with extreme caution: keep the cylinder upright at all times as tilting it could result in liquid propellant being sprayed onto the sensor. I would avoid this option, as in the process of struggling to blast air into some tight corner I would inevitably forget about the cylinder's angle, and would suddenly find a light mist of propellant across the sensor. Do not allow any nozzle – whether of a simple rubber blower or compressed gas cylinder – to touch the sensor, as it could scratch the surface.

Keeping the sensor clean

It is possible to slow down the speed with which the sensor gets dirty in several ways:

1 Try to plan the photography so you do not have to keep swapping between different lenses. Try to take a batch of shots with one lens, and then swap to another only when you feel you have finished with the one on the camera. This is a great idea in principle, but is easier said than done, especially when photographing a rapidly changing situation.

2 Keep the lens rear elements and the mirror as clean as possible, taking the opportunity to clean both whenever practicable.

3 Keep exposure of the camera's internal chamber to a minimum while lenses are swapped over by making the swap as fast as possible.

4 Point the camera body downwards while the lenses are being swapped over.

5 Keep out of the wind while changing lenses, using your body to shelter the camera if necessary.

6 Make sure that any cleaning you do is in a clean, windless environment.

Cleaning a dirty sensor

Patience and care are essential. Having to clean the sensor several times usually means the whole process takes more than an hour.

1 **Photograph a plain light-coloured or white surface such as the sky or a wall.** Preferably use a moderately wide-angle lens – with the aperture stopped down to at least f/11 – and a tripod.

2 **Download the image onto your computer.** Open it up on your image-editing software, and view at 100% zoom to check dirt distribution.

3 **Apply one drop of lens/sensor cleaning fluid to a sensor-cleaning swab.** Leave for a couple of minutes for the fluid to soak in. Do not let the swab touch anything.

4 **Remove the lens and use a blower to clean around the mirror. Put the camera cap in place.**

5 **Switch the camera on, activate the LCD screen menus and choose 'sensor' cleaning.**

6 **Press the shutter.** This will open the mirror and shutter curtain and keep them open as long as the camera remains switched on and there is sufficient charge in the battery (make sure the battery is well charged before starting this).

7 **Remove the camera cap. Use a hand-operated bulb blower to blow air around the sensor.** This will remove any large and/or loosely attached pieces of dust and hair.

8 **Lay the flat end of the swab in one corner of the sensor and drag or pull it all the way across.** Repeat for other parts of the sensor. Always drag the swab right the way across the sensor; do not stop halfway as this can deposit dirt in the middle. Apply moderate pressure to the swab – sweeping it lightly across the sensor will probably not remove any stuck-down dirt, whereas too much pressure could damage the sensor. Try to do this with the camera pointing downwards to decrease the likelihood of fresh dust falling into the camera. It can be very hard to remove dirt from the corners of the sensor, and at times it may seem that all you manage to do is remove particles from the centre of the sensor and pile them up in the corners. The only solution is practice and persistence.

9 **Be conscious of how much fluid is on the swab.** Too much will leave traces of fluid on the sensor; too little will cause the swab to make a squeaking sound as it moves across the sensor. If there is too much, remove the swab and wait a few minutes until some of the fluid evaporates. If too little, remove the swab, add one drop of cleaning fluid to it, wait a minute or two for the fluid to soak in and then start the cleaning process again. Excess fluid left behind on the sensor will show up in your test photos as clusters of perfect circles, mostly with thick black edges and clear centres. Some will evaporate within about 30 minutes, but most will have to be removed by wiping with a slightly drier swab.

10 **When you have finished cleaning, replace the camera cap and close the shutter curtain and drop the mirror simply by turning the camera off.**

11 **Put the lens back on the camera and take exactly the same image described in step 1.**

12 **View the image on the computer and compare the pre-cleaning image.** If you manage to clean the sensor at the first attempt, feel very pleased with yourself. It is more likely that there will still be dirt on the sensor and you will need to repeat the process several times.

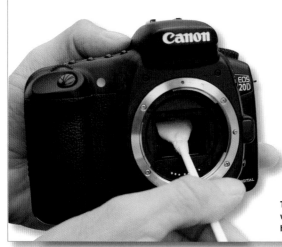

The process of cleaning a digital sensor: gently wiping with a swab on to which a drop of optical cleaning fluid has been placed.

related subjects

Variable ISO settings for every image: (page 62).

Checking images for dirt: (page 138).

Blowing in this way will dislodge loosely attached pieces of dust and hair, but it will not shift anything that has become firmly attached. To remove this there are only two options: send the camera to an approved service centre, or use a specially designed set of swabs and cleaning fluid. The first option is relatively expensive and leaves you without a camera for a period. The second is fiddly, not guaranteed to succeed and could be extremely expensive if the sensor becomes damaged.

If you opt to clean the sensor yourself, use only one of the specially designed swabs available on the market, along with the correct cleaning fluid. Do not be tempted to use your fingers, cotton buds or any other implements, and use only the recommended fluid, not CD-cleaning fluid or white spirit. The price of any damage to the sensor in doing this job is a whole new sensor. Even the purpose-designed swabs cannot be guaranteed completely safe, but they are the best presently available. Follow the method described in the box opposite, and you should eventually end up with a clean sensor. Take your time, stay relaxed and be methodical.

The issue of dirty sensors is something that camera manufacturers have played down in their rush to enthuse the photographic world with all things digital. Effective and safe methods of keeping them clean have yet to catch up with the sensors' own superb technological level.

Digital Noise

The problem of digital noise is in some ways analogous to that of film grain, although the causes are quite different. Both increase with increasing light sensitivity (and hence ISO setting) and also with longer exposure times, causing images to lose resolution, detail and colour qualities. While film grain occurs as the result of faster films consisting of larger

Causes of digital noise

Although most digital noise is overcome most of the time by in-camera processing, typical causes are as follows:

1 Tiny imperfections in sensor construction

2 Occasional failure in a few pixels to fully reset their charges to zero following the previous exposure

3 High sensitivity/ISO settings

4 Long exposures, from about two seconds upwards

5 High sensor temperature, caused for example by the camera being exposed to direct sunlight for a prolonged period

6 Random light, dark or coloured specks caused simply by the way light hits the sensor.

grains, in a digital camera noise is caused by electrostatic charges on the sensor.

Anyone using a digital camera is likely to encounter noise whenever they use long exposures and/or high ISO settings, and if they allow the camera to become hot, such as if left exposed to direct sunlight for any length of time. It is particularly noticeable in shadow areas of an image, especially in large uniform monochromatic areas.

There are essentially two broad types of digital noise: fixed pattern and random. The former is a product of tiny imperfections in sensor construction, and the latter is dependent on photographic conditions such as the selected ISO setting, exposure time, the presence of heat, and amount of light available. In general, much depends on the signal-to-noise ratio. The strength of the wanted image data is relative to the sensor's noise: the greater the former (and hence higher the ratio), the less noise will be visible in the final image.

CMOS sensors are innately more prone to noise than CCD sensors, but development has enabled on-sensor noise

Tip Sensor swabs can be expensive, so to reduce costs it is possible to use each up to three times during the same cleaning session.

This set of images shows the effect of increasing ISO setting on noise in an image. The dusk view of the British Meteorological Office, in Exeter, Devon, was shot with an ISO setting of 100. An inset of this image (a) reveals very little noise. The same inset taken from images shot at higher ISO settings reveals steadily increasing amounts of noise: (b) ISO 200; (c) ISO 400; (d) ISO 800; (e) ISO 1250.
Canon EOS 1Ds, Canon 17–40mm L lens, with tripod.

related subjects Variable ISO settings: (page 62). Photo-diode design: (page 24). Chromatic aberrations in inferior lenses: (page 45).

reduction to hugely improve their image quality. Firstly, micro-lenses over each pixel of a CMOS sensor amplifies the image light reaching the photo-diodes, greatly boosting the signal, while data processing is able to remove the predictable fixed-pattern noise.

The problem of random noise is tackled in most DSLRs during in-camera image processing. For long exposures – typically those of more than one second – an additional noise-reduction facility (which the photographer can usually switch on or off via the LCD screen menus) works by 'shooting' a second, blank frame after the initial image exposure. It uses exactly the same settings to produce a frame that contains no image but exactly the same noise pattern as the image exposure. This pattern can then be subtracted from the image frame to yield a final image with a considerably reduced noise level.

Image Aberrations

Apart from noise, a variety of problems not always solved by the in-camera image processing can arise. Some of these have already been mentioned, and the most important of these are described in more detail below.

Vignetting

As was described previously in Chapter 3, vignetting is not so much a problem with DSLRs as a case of what can happen when sub-optimal lenses are used with a DSLR. With so many different lens designs on the market, it is hard to predict which lenses will produce image vignetting and which will not, but generally wide-angle lenses optimized for use with film cameras are most prone. The vignetting results from less light reaching the pixels in the sensor's corners than those towards the middle. The cause is the acute angle at which the light can reach these furthest pixels (depending on the lens design), quite

literally shading the wells of the pixels' photo-diodes.

Chromatic aberrations

Again, this is normally a problem of lens rather than DSLR design. The main cause of chromatic aberrations is the inaccurate focusing of light of different wavelengths, resulting in bands of colour where there should be a sharply focused image. Normally only visible when viewed on a computer monitor at 100% zoom, a DSLR sensor will record banding only if the banding is more than one pixel wide. With cheaper lenses optimized for film photography, this is often the case.

The annoying Moiré effect. The square mesh of a sun-screen lowered across a huge sunroof has interacted with the square network of pixels in the camera to produce an interference pattern.

Moiré effect

This effect appears as a wavy pattern across an image that itself contains some sort of textured pattern, such as woven cloth. An effect that is unique to digital cameras, it is the result of an interaction between the grid pattern of the sensor's pixels and the image subject's sharply focused pattern, producing a secondary interference pattern. The solution is to change the camera's angle of view, its distance from the subject, the focal length of the lens being used, or the point of focus. These steps will either alter the relative angles of the image subject's pattern to that of the sensor's pixel grid,

Tip If the Moiré effect might be a problem with a subject, shoot it in a variety of ways, (different angles, distances, lens apertures), so at least one image is free of the effect.

or will decrease the sharpness of the former in the final image, thereby decreasing the tendency to generate a Moiré effect.

Image Capture and Processing Issues

More pitfalls that the DSLR photographer needs to be conversant with lie in the arena of image capture and processing. The main problems are outlined in this section.

Sensor size

Most DSLRs have a sensor that is smaller than the 35mm film dimensions that were the norm for so many years. Whilst smaller sensors greatly reduce cost, the need to squeeze ever-larger numbers of smaller pixels into the limited space in order to drive digital image file sizes up has major implications for image resolution and quality. Furthermore, reduced sensor size results in a smaller image capture area from the lens's image circle, reducing the field of view in the final image and resulting in an increase in effective focal length for the lenses. For any given sensor size, then, a focal length magnification factor needs to be applied to all lenses – usually between 1.3x and 1.6x – greatly improving telephoto ability but reducing wide-angle coverage. The introduction of a new breed of very wide-angle lenses helps to overcome this problem, but increases issues of image quality due to image distortion.

Sensor sensitivity

Digital sensors show a sensitivity to light that is not quite the same as film. Both show a linear relationship under average lighting conditions. However, in very dim and very bright lighting, film shows reduced sensitivity, helping to maintain detail even in image highlight and shadow areas. Digital sensors, on the other hand, continue to show a linear light sensitivity right the way

A comparison of the image area size, as revealed by the mirror dimensions, in full-frame (Canon EOS 1Ds – inset a) and small sensor (Canon EOS 350D/Rebel – inset b) cameras.

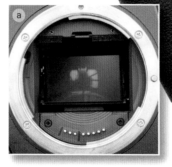
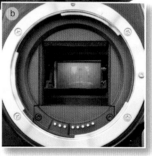

through dim and bright lighting conditions, in the latter rapidly causing burn-out and hence total loss of detail in image highlights far sooner than would occur with film.

Unless overcome, a typical DSLR sensor would quite likely have a much narrower dynamic range – the range from dim through to bright light in which image detail can be seen – than is possible with film. As described in Chapter 2, this can be partly overcome by using large pixels, which should be able to 'soak up' more light than is possible for smaller pixels, greatly increasing dynamic range. However, it is also standard practice for digital photographers to have to take great care not to allow image highlights to burn out. This can only be managed by carefully monitoring the image histogram accompanying every image, detailing its tonal ranges. Exposures need to be set as

related subjects — Sensor size and pixel count: (page 27). Buffers in image processing: (page 28). The effect of focal length multiplication on wide-angle photography: (page 42).

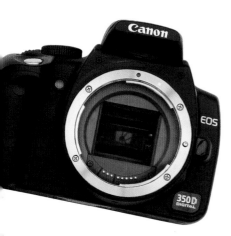

Other issues with DSLRs

far as is possible to prevent burn-out at the white end of the histogram, even at the expense of underexposing the image. Overall image brightness then has to be corrected during image editing on the computer.

Continuous shooting speed and burst rate

Rapid continuous shooting is a problem for digital cameras, as it is usually impossible for them to process the images quickly enough to allow the camera to keep going for more than a few seconds at a time. A host of limiting factors create this problem, starting with the speed with which the electrical charge can be cleared off the sensor after each image, leaving it ready for you to take the next exposure. After that comes the size of whatever buffer the camera's processor has for temporary image storage while it processes other images, coupled with the speed of the processing itself, and finally the speed with which new images can be written to the memory card. There have been rapid improvements in all these capacities in the past few years, but the majority of DSLRs are still significantly inferior in this respect to many film SLRs.

In addition to the main DSLR problems covered, a few minor issues remain:

1 Start-up and shutter lag times

When a digital camera is switched on, it may take a couple of seconds for all its systems to 'wake up' and get the camera ready for action. This may seem like a tiny amount of time, but when things are happening fast and you have foolishly switched the camera off (in the name of wisely saving battery power!) those couple of seconds can make the difference between capturing an image and missing it. Similarly, with early DSLRs there was an annoying lag time between the shutter being pressed and the image being taken; this was usually considerably less than a second, but sufficient to miss action shots. This problem has all but disappeared with the latest generation of DSLRs, although it remains an issue with many compact camera models.

2 LCD screen visibility

The LCD screen and the facility to see images as soon as they have been captured is an absolute godsend. However, the screen can also be infuriating at times, and it is likely that future camera models will see improvements here. The main problem is simply being able to see anything in the screen when outdoors and especially in

sunlight. Although screen brightness can be altered, it is not sufficient to overcome sunshine. Under these conditions, seeing anything depends on being able to shield the screen in some shade, often through cupped hands.

Furthermore, the tiny size of the image limits its usefulness to allowing the photographer to check only for general composition. However, the zoom facility does help, allowing for some check – though not wholly accurate – on focusing, and for such issues as whether subjects have their eyes closed.

3 Cold weather

Digital cameras, DSLRs included, do not like cold weather. As soon as the temperature drops to near freezing point, batteries lose their charge worryingly quickly, while general camera functions can become unreliable, often resulting in the whole camera locking up. If this happens, the quick solution is to turn it off for a few seconds and then back on again, although this is hardly an ideal solution. Keeping the camera switched off and wrapped up until it is actually needed is the only reliable way of reducing these problems when you are working in very cold weather. However, if you are shooting action this is not very practical, due to the 'wake-up' time lag inherent each time the camera is switched on.

Photography with the Computer in Mind

The advent of the digital era has not significantly changed photographic techniques: the capturing of great images, whether they be portraits, landscapes or architecture, still relies on the photographer's eye for composition, aesthetics, lighting and the right moment. The change in technology has, however, opened up many new possibilities for controlling the way that process is executed, and how to handle the images once they have been captured.

A dusk shot of a modern office building, its triangular roof shape creating a stunningly dynamic image. Canon EOS 1Ds, Canon 17–40mm L lens, 6 sec at f/5.6, tripod, ISO 100.

The development of the digital darkroom and the resultant ease with which images can be altered, improved, rescued and combined to create whole new composite images has revolutionized photographic creativity. It might be tempting to think that the processes of capturing the images, and then later altering them on the computer are two quite separate events. For many kinds of images, where the computer will be used only to optimize the images (cleaning up dust marks and improving contrast and saturation levels, for example), this may well be the case. However, there are many instances when the photography should be carried out with a specific view to how the resulting images might be manipulated on the computer, when the final image may actually be created on the computer, with the camera merely the starting point to gather together the component materials. The simplest example of this type of situation is where photographic conditions at the time of capturing the images are so bad that only extensive post-capture computer work will generate a useable image. At the other end of the scale lie composite images, consisting of parts from numerous quite different images. These are not so much a photograph, in the sense of being a record of the world, as a piece of digital art.

There is potentially an almost endless list of scenarios for when you might build in plans for post-capture image manipulation while still shooting. It is not possible to list them all here, but a few of the most common are described below.

Exposure Bracketed Multiple images

As described in Chapter 4, an image containing an excessive contrast range will lose detail in both its shadow and highlight areas, illustrated by clipping at both ends of the image histogram. Whilst clipping at one end or other of the histogram can usually be overcome by altering the exposure, clipping at both ends can rarely be fully overcome during photographic capture itself. In this situation, the twin-exposure method (see Chapter 4) comes into its own.

After metering the subject and obtaining an overall exposure reading, use the camera's exposure compensation facility to overexpose on this meter reading by either lengthening exposure time or opening up the aperture. The aim is to produce an image that correctly exposes the subject's dark areas, showing no clipping at the histogram's shadow end. Inevitably, overall this image will be grossly overexposed, with large amounts of burn-out in the highlight

A modern office building at night is a typically high-contrast scene, resulting in an image with strong highlights and deep shadows. Inevitably, this generates a histogram showing clipping at both ends – the contrast range is simply too great for all tones to be captured.
Canon EOS 1Ds, Canon 17–40mm L lens, 1.3 sec at f/8, tripod, ISO 100.

dark and show extensive clipping at the histogram's shadow end.

The correctly exposed parts of the two images can be combined in the computer to generate a well-exposed image whose histogram lies within both the highlight and shadow limits. This process becomes much simpler if the two images are identically aligned, so the images should be shot with the camera on a tripod if at all possible. Moreover, if several attempts are needed to obtain the two images needed, delete the unsuccessful images so that only the two correct ones remain, thus avoiding later confusion when sitting in front of the computer. Remember, however, that if shooting in Raw format some adjustment of the exposures will also be possible on the computer (see Chapter 8).

Selectively Focused Multiple Images

As outlined in Chapter 5, there are times when it is simply not possible to obtain a depth of field sufficient to bring an entire image in focus. On many occasions this will not be a problem – in fact it may be desirable to leave, say, the background blurred. However, for those times when it is critical to make everything as sharp as possible, a twin exposure (or even triple) can be highly effective.

The method is very much as described for the exposure bracketed images. The image to be captured is framed, the camera focused first on the nearest part of the image that needs to be sharp, and an image exposed. The camera is then refocused on the background and a second image taken, using the same exposure as for the first. Registration of the two images in the computer is of course helped if the camera is locked onto a tripod, ensuring identical framing of the two images, but this method is still one that works with handheld photography.

areas, and hence massive clipping at the highlight end of the histogram. The second image should be underexposed using the exposure compensation facility to either shorten shutter time or narrow the aperture. The aim is to correctly expose the highlight areas, producing an image with little or no clipping at the histogram's highlight end. This image will be very underexposed; the shadow areas in particular will be very

Exposing for specular highlights

A photograph that contains specular highlights – pinpoint spots of very bright light such as the glare from the heart of a lamp, or the sparkle of sunlight reflecting strongly off rippled water or from any other reflective surface – constitutes an exceptional situation in which you may not want to bother bringing all highlight exposure down to within the histogram's limits.

It can be extremely difficult to shorten an exposure sufficiently in order to bring such highlights into the histogram, and ultimately you may decide that it is not worth the effort for what are probably only tiny parts of the image. In any case, it may not always be appropriate to excessively reduce a sparkle that could in fact be among an image's strongest features.

related subjects | LCD screen settings: (page 48). | Histogram clipping: (page 64).

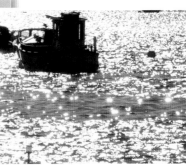

Specular highlights, such as when sunlight glints off rippled water, inevitably result in burned-out hotspots that cannot be overcome, and that actually constitute a vital part of an image's atmosphere. The inset shows the burned-out areas most clearly.

Canon EOS 1Ds, Sigma EX 70–200mm lens, 1/320 sec at f/18, ISO 100.

In this backlit view of a Cornish clifftop, it was impossible to produce an image that had a histogram showing no clipping. Exposing the grass correctly, for example, resulted in the sky and parts of the sea being badly burned-out. As a result, twin exposures were taken, the first (a) correctly exposing the grass and leaving the sky to burn out, and the second (b) correctly exposing the sky and greatly underexposing the grass. In the computer, the correctly exposed parts of the two images were combined to create a single image that is well exposed throughout (c).

Different types of fine-weather sky that would work well as backdrops inserted into images perhaps spoiled by grey or pale sky. Since this will generally only involve the upper half of an image, the inclusion of some land at the bottom of two of the images is not a problem. The natural gradation of the blue sky from pale to darker in the second image, with increasing height, can be an important factor when selecting a backdrop.

Blue sky gradation

When shooting a blue sky, remember that, since there is a natural tendency for it to become paler towards the horizon, do not be tempted to miss out this part of the sky. For a blue sky background to look natural when slotted into an image it must include this gradation. If necessary, include some of the land, so try to shoot a view with a simple horizon that if necessary can be easily erased later.

Backgrounds

Perhaps the simplest form of shooting with later computer manipulation work in mind is the collection of images consisting of plain, often monochromatic, views that can later be used as backdrops in composite images.

The sky

The most obvious example of such a type of background is the blue sky. It is amazing how a rather dull landscape, photographed on an overcast day, can be enlivened by slotting in a blue sky. It is also notable just how common a practice this is among advertising agencies struggling to promote new products and holiday destinations. Purists might consider this cheating, but it certainly can save many less than successful shots.

Stormy skies can often be used as backdrops to add drama to landscape or urban scenes that otherwise lack vitality or interest.

related subjects | In-computer steps to merge foregrounds with backgrounds: (page 148). | Landscape photography: (page 94).

Whilst blue sky is the most popular sky backdrop, another that should not be overlooked is the stormy setting, with threatening black clouds scudding across the sky, perhaps even with a lightning bolt thrown in if you are really lucky. Perhaps rather easier to add to a poorly lit landscape than a sunny blue sky, this can turn a dull image into something quite dramatic and exciting.

You can improve a grey-sky image (left) by insertion of a blue-sky backdrop, as with this view of the Potala Palace in Tibet (below). Although the building itself is sunlit, the grey sky behind badly brings this image down. Inserting the blue sky shown on the far left (page 118) greatly enhances the image.

Tip To combine a foreground with a blue-sky background convincingly, the foreground must be shot in at least reasonably bright light so that some shadows are generated.

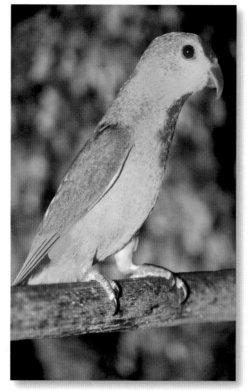

A backdrop of vegetation can be used to improve the naturalistic setting of an image of a captive bird. In this image of a caged Colasisi, the parrot was cut out and then pasted onto a previously shot deliberately out-of-focus vegetation backdrop. The deliberate blurring of the backdrop ensures that the vegetation does not compete with the parrot for attention. At the same time, it mimics what would be seen if the parrot really were photographed using a telephoto lens with vegetation in the distance behind. This method does not replace the need to photograph wildlife in its natural environment whenever possible, but can suffice when all else fails.

Vegetation

Another set of backgrounds that I find very useful consists of blurred vegetation. These can be used as backdrops to animal images, particularly animal portraits, rescuing pictures of animals photographed in unsightly conditions and restoring them to a more attractive and naturalistic setting. Keeping the vegetation backdrop out of focus and preferably lit only with a soft, even light ensures good subject separation from its background in the final backdrop–animal composite. As a result, even well-camouflaged animals will 'pop out' of the image, mimicking the result obtained when using a telephoto lens to photograph an animal in front of distant vegetation. A further benefit of having the backdrop blurred is that there is no danger of mixing inappropriate species – a background of temperate vegetation with a tropical animal, for example.

Subject Components

The opposite of shooting for backgrounds is shooting for the main subjects of a composite image. Of great use when it is just too complicated to take your subject to the desired actual setting, this photography can vary from simply shooting a small still-life for later insertion into an image scene or combination with a backdrop, to a car or people. Obviously, the larger and more complex the main subject, the more difficult both the photography and the later computer work become. However, the basic techniques remain essentially the same.

Before you start shooting, it is important to have a clear idea of what sort of background image your subject will later be pasted onto: a simple backdrop such as a plain blue sky, or something more complex such as a beach or garden scene, for example. It is critical to match the lighting of your subject with that present in the background image, while at the same time conveying the right kind of image.

If the background is going to be a simple blue sky, this implies the subject should be lit with a high white light to mimic daytime sunlight, or lit with something much lower and redder if the backdrop is of a sunset-coloured sky. If the background image contains objects, such as palm trees or buildings, lit by a sun shining from a particular angle, then your subject must also be lit from that angle. Bright light in the background image requires identical bright lighting on the subject. Soft light in the background image dictates soft lighting on the subject.

Of course, the background image will not be present in the background when you photograph the subject: the two will later be combined in the computer, not in-camera during your photo shoot. Instead, the subject will have to be photographed against a plain backdrop – some kind of plain sheet or board. The backdrop should

related subjects

In-computer steps to merging foregrounds with backgrounds: (page 148).

Nature photography: (page 90).

Here we see studio photography of elements that are to be pasted onto location images. In this example, a laptop computer and a bottle of champagne are to go onto an image of a Hawaiian beach. The aim is to produce a composite image that suggests the concept of being able to work away from the office in any kind of exotic location, while still being able to celebrate and have a good time. The computer, bottle and glasses were shot against a blue background using quite a simple tabletop set-up, and were then pasted separately onto the Hawaiian beach image to produce an effective composite. A crucial element to the image's success is the inclusion of shadows, one of the hardest parts of the project.

offer a high contrast to the subject, making it as simple as possible during subsequent computer work to cut the subject out and then paste it onto the desired background.

The backdrop can be illuminated to increase the subject–backdrop contrast, but make sure that this has no influence on the subject lighting. Furthermore, if the backdrop is white, excessive lighting can cause image burn-out that can start to affect the edges of the subject. For this reason, it is common practice to use a plain coloured backdrop: blue is a colour that seems to give good contrast without running the risk of burn-out.

Photographing a subject to be merged with a background

1 Know what the background looks like and where in it the subject will be placed.

2 Ensure that the subject is lit in a way that is compatible with the background.

Check this in terms of lighting, height, angle, colour and luminosity.

3 Photograph the subject against a plain background from which it will be easy to cut the subject on the computer.

4 Make sure no shadows from the subject fall on the backdrop.

If it does, make sure it is not in any way that will interfere with the later computer work.

5 Use a backdrop with a soft, neutral colour, such as blue.

This will be easy on the eye during prolonged computer work and will not interfere with the quality of the subject image. The backdrop should not be white if it is going to be lit.

6 When working out exposures for the subject and backdrop, it is better to use incident light readings, not reflected.

The former will not be influenced by the colours and tones of either.

Tiled and Panoramic Images

Brent Tor, a church-topped hill on the western edge of Dartmoor National Park, in Devon, Great Britain, has stunning all-round views that no standard-format photograph can really do justice to. One solution is to create a panoramic, fusing together a number of consecutive images (a–c). In this example, three images have been brought together and lined up in (d) to show how the panoramic will look when they are fused together (see Chapter 8 for the final version).

Panoramic images – pictures that are very long and narrow – have long had a certain interest, but the arrival of the digital era has seen an explosion in their popularity. Shot mostly in horizontal format and mainly for wide landscapes, they nevertheless can be used for a wide variety of subjects, shot vertically or horizontally.

At its simplest, digital panoramic photography can consist of using a very wide-angle lens and then in the computer cropping out large parts of the image to leave a long, narrow and apparently panoramic view. However, it is more usual to shoot a series of overlapping images (usually two to four) that cover quite a wide angle of view, and then later to 'stitch' them together in a computer.

The creation of tiled images basically consists of the same process of photographing a series of overlapping frames. However, instead of shooting to create a long and narrow panorama, the aim is to generate a rectangular or square image, often with similar overall proportions to the single frame but with a hugely increased final file size. The benefit is that it allows for the eventual output of a vastly larger reproduction than would be possible if shot as a single frame.

The basic photographic steps are the same for both panoramic and tiled images. They involve collecting a set of shots that will keep the computer work to the minimum. Although the process is not

related subjects

In-computer steps to stitching images into a panoramic: (page 150).

Landscape photography: (page 94).

difficult, a methodical and careful approach will help to avoid any mistakes that may later make in-computer stitching harder or even impossible. A list of steps is shown in the box right.

A little-realized point about making a sweeping movement with the camera is that as the camera rotates so nearby components of the view will change their relative positions slightly. If they are in a part of the image that overlaps with the next frame, this can make alignment during the stitching quite difficult, resulting in 'ghosting', a very slight double image of that component being produced. Technically, it is possible to overcome this while doing the photography, but it can be difficult to spot, and even harder to work out how much correction (through a little camera movement) is needed. It may be better to overcome this at the stitching process.

Panoramas or tiled images that contain movement are the most challenging of all to shoot. If you intend to create images containing scudding clouds or rolling waves, for example, it may be best to pick a moment when the pattern of movement is likely to be least disruptive and then go through the photographic sweep as

quickly as possible. Even with this, it will probably be necessary to do some careful touching up and blending of elements in the final panorama.

Once the images have been collected, there then follows the process of stitching them together in the computer, a process that is described in the next chapter (see page 150).

Panoramic and tiled image photography
A step-by-step guide

1 Use a tripod if at all possible.
> This will make it easier to maintain correct alignment of the successive images, and to keep the horizon level. It will also help with concentration on such issues as correct exposure, framing and focusing of the view.

2 Do not use a very wide-angle lens.
> The distortion they usually cause at image edges makes it very difficult to match up adjacent images during the stitching process. Mildly wide-angle, standard or even mildly telephoto lenses will help to overcome this problem, though of course it will become necessary to shoot more frames to cover the intended view.

3 Make sure each successive image overlaps by 20–30 per cent.
> This makes it easier to match up images during the stitching process.

4 Use the same exposure for every photograph.
> Take an exposure reading on a suitable midtone somewhere in the view, then switch the camera to manual, enter the aperture and shutter speed values just obtained and use those throughout. This will help to maintain similar tones and colours across the view, easing the matching and stitching process.

5 Focus on the main subject(s) in the view and then switch the autofocus off.
> This ensures that the camera will not refocus on other subjects in successive frames.

6 Go through a number of practice sweeps with the camera before actually taking any pictures.
> Check that alignments and overlaps are correct, and be sure of exactly how many frames will be needed to cover the view. Check to see that the horizon remains level throughout the sweep. If it does not, this may mean that the tripod is not set up evenly.

7 When you are sure everything is ready and checked, take the images in succession, working in a logical order – evenly left to right, for example.
> When finished, review each image in the LCD screen and repeat the process if necessary. If several attempts are needed, delete the unsuccessful images in order to avoid confusion later when sitting in front of the computer.

Multiple Portraits

One annoying feature of portrait photography is the propensity people have to look away, close their eyes or pull a strange facial expression just as you press the shutter. Inevitably, this gets worse with group portraits: the more people there are in shot, the more likely it becomes that someone will be wrecking the composition!

With film photography, the only way to overcome this is to just keep firing away on the assumption that a reasonable proportion of the images will be all right. In digital photography, even a bad situation can be rescued. Imagine a situation where you have an image where composition and subject posture are just perfect, but the subject(s) has their eyes closed. In a following image, something is remiss with the composition or posture, but at least the subject has their eyes open and is even looking at the camera. Neither image is great on their own, but it will be possible to create a good one by copying the eyes from the latter image and pasting them onto the former. Suddenly, the closed eyes are open and you have a great image.

To reduce the risk of having unusable portrait shots, especially for group portraits, take multiple shots that can later be cut and pasted in the computer to put together perfect compositions.

Multiple Exposures for Colour Balance

Although the DSLR is superb at giving images the correct colour balance, problems can still arise when mixed lighting sources are present – a problem that applies mainly to indoor photography.

One common scenario is a room that is lit mainly by natural daylight coming in through windows, but which also contains localized areas of tungsten lighting. Photographing with the camera set to automatic white balance (AWB) will lead the camera to balance the image close to the colour temperature of the reflected daylight, at about 6000–7000K. Most of the resultant image will have the correct colour balance, but certain parts, close to the tungsten lights, will be quite orange. This may impart a pleasantly warm atmosphere, but if desired it can be removed by a simple twin-exposure technique, shooting first with the camera's white balance mechanism set on AWB, and then with it set to tungsten (see box right). The second image will come out mostly very blue, but those areas close to the tungsten lights should be correctly balanced. The correctly colour-balanced parts of the two images can then be combined in the computer to produce one entirely correctly colour-balanced image.

In taking this publicity shot I had trouble getting all three men to look at the camera simultaneously, as they were being constantly distracted by goings-on behind me (images a and b). In the end I gave up and resorted to digital manipulation, copying the head of the man on the right from image (a) and pasting it onto his shoulders in image (b). The resulting composite, after a little rescaling of his head to suit the slightly different aspect, is shown in image (c).

related subjects

Multiple images for correct exposure: (page 146).

Multiple images for differential focus: (page 147).

Balancing differing colour temperatures in the same view. This lounge was lit primarily by diffused daylight coming through a large window to the left, though several tungsten lamps also provided some lighting. In image (a), the camera's white balance was set to 5000K, and the exposure set for the room as a whole. As a result, the room was correctly exposed and colour balanced, but the tungsten lamps – with a colour temperature well below the 5000K for which the camera was balanced – have come out characteristically yellow-orange.

The tungsten lamps were also badly overexposed, so this image also became an exercise in balancing exposures as well as colour temperatures. In image (b) the camera's white balance was set to 2800K to balance with the tungsten lights, and the exposure was set to correctly expose the foreground lamp. As a result, while the foreground lamp is correctly exposed and well colour balanced, the room as a whole is both too dark and quite blue.

To produce a single well-balanced image (image c), the foreground lamp was copied from image (b) and pasted into image (a). The background lampshade was also copied over, but the other tungsten lamps were left unchanged in order to retain the warm sense they gave out.

Twin exposures for colour balance

In a room lit by both daylight and tungsten but in which the daylight is dominant, follow these steps to obtain twin exposures that can be combined in computer to generate a fully colour-balanced image.

1 Set the camera on a tripod.
This will ensure that the images are exactly aligned and so can be more easily merged in the computer.

2 Focus the camera on the required view then switch off the autofocus.
You do not want the camera to refocus during the process.

3 If the daylight is much stronger than the tungsten lighting, take the first image with the camera's white balance mechanism set to AWB.
If the daylight is less dominant and is highly diffused and/or reflected, set the white balance to either shade or, more likely, cloudy conditions. These settings will come close to accurately balancing the indirect nature of the daylight coming into the room.

4 Change the camera's white balance mechanism to tungsten and take a second picture.
Use exactly the same aperture, shutter speed, ISO and focusing settings as for the first image.

5 When accurate exposures for both images have been obtained, with no clipping at either end of the histogram, download the images onto a computer.
Merge the correctly colour-balanced parts of each to create a single fully colour-balanced image.

Tip When taking multiple images for in-computer merging, set the camera on a tripod, align the framing and lock the tripod to ensure registration of successive images.

8 The Finishing Touch
Editing Images on the Computer

A computer is an essential companion to any digital camera, loaded with appropriate image-editing software and with sufficient power and memory to handle and store the increasingly large files that the latest generation of digital SLRs produce. Fortunately, today's computers are more than up to the task. Virtually any desktop computer can handle photographs adequately, although the lowest-powered computers may struggle with large files.

◄

With a little work on the computer, the giant conservatory domes of the Eden Project, originally photographed in quite flat light, have been turned into something a little surreal; Cornwall, Great Britain.
Canon EOS 1Ds, Sigma EX70–200mm lens, tripod, 1/90 sec at f/16, ISO 100.

►

This erotic image is backlit and has extensive shadow areas – a situation in which in-computer image optimization is often important to prevent loss of image detail.
Canon EOS 1Ds, Canon 24–105mm lens, tripod, 1/20 sec at f/4, ISO 400. Image courtesy of Bjorn Thomassen.

In the past, it was said that a photographer would need an Apple Macintosh (Mac) computer for high-quality image editing due to this brand's superior image-handling capabilities compared to a Windows-based PC. That superiority has all but disappeared today. Macs still hold sway in publishing and in many areas of professional imaging, but many people involved in image editing now use a PC. For that reason, this chapter assumes PC usage.

Another point concerns the use of laptop or notebook computers. Although such a computer is important for photographers on the road, no serious image editing is possible with one, as the appearance of any image on the screen can change quite radically with even just a small change in viewing angle. Such variation makes it impossible to accurately set image contrast, brightness, saturation and colour balance. Captioning and cleaning up can be carried out on a laptop, but much of the serious work needs to be done on a desktop computer.

Before becoming involved in editing images, the computer and the monitor have to be set up correctly, suitable image-editing software installed, and images copied onto the computer's hard drive. It is not possible to address such a wide range of issues in detail here, but we will give an overview of the major considerations.

Colour Management

Colour management is crucial, as it allows us to be sure that colours assigned to an image are not only accurate but also remain stable and reproducible across a host of computers, printers and other output devices. Several colour-management systems, organized under the banner of the International Color Consortium (ICC), are available to the photographer. Called colour spaces, each of these systems has a slightly different but overlapping gamut, or range of possible colours, that it can express and control. Linking one of these colour spaces to an image will create what is called an ICC colour profile that becomes embedded in the image file. This enables the image to be moved from computer to computer with a guarantee that it will be possible to reproduce its colours accurately.

Colour spaces

The most important colour spaces for a photographer are sRGB, and Adobe RGB (1998). The former, which comes as the default setting for many digital cameras, standardizes colours for viewing on computer monitors. Unfortunately, its colour gamut is relatively limited, and for this reason the wider-ranging Adobe RGB (1998) has become the colour space of choice for photographers. Always tick this as the colour space in a camera's options menu, ensuring that your images receive an embedded colour profile from the moment they are captured.

Monitor Calibration

Linked to the issue of colour management is monitor calibration. The computer monitor is the principal means by which the world is able to see any digital images, so we need to be sure that what the monitor displays are actually an image's true colours. This helps not only if an image is to be moved among several computers but

Two top-quality LCD monitors presently on the market.

also when making prints. If the monitor is not displaying colours as it should, then there will be a mismatch between what is seen on that monitor and how the images will appear when printed out.

Both Macintosh and Windows operating systems contain software that goes some way to calibrating the monitor, but this is generally insufficient to guarantee accurate profiling. Not only do individual monitors vary one from another, even among those of the same model, but also their output changes with age. Furthermore, our perception of their appearance will vary according to ambient light intensity and colour in the room containing the computer.

The colour channel controls for monitor calibration available with Adobe Gamma.

Calibrating the monitor can be done in two ways. The first, available only to those using Windows and who have Adobe Photoshop installed, is to use Adobe's own calibration software, called Adobe Gamma. Accessed via Control Panel, it is a fairly simple tool with the drawback that it relies on human eyes to assess when colours are balanced. A more accurate means is to use a colorimeter that attaches to the front of the monitor. Software that comes with the colorimeter automatically calibrates and establishes a profile for the monitor.

In addition to setting the brightness and neutral tones for black, white and midtones, calibration also determines the correct gamma and colour temperature

CRT versus LCD monitors

Over the past few years, photographers have had a choice between cathode ray tube (CRT) and liquid crystal display (LCD, also called TFT) monitors. The former represent 'traditional' computer technology; the latter are much newer, but rapidly taking over altogether as the standard monitor type. When LCD monitors first became available, CRT retained a clear advantage for the photographer in that they had the better contrast, colours and resolution, as well as being viewable from any angle. However, that advantage has all but disappeared, at least with the top-end LCD monitors. All the main issues – including the restricted viewing angle of early LCD screens – have more or less been resolved. Now, despite the LCD's continuing higher price, the disadvantages of the CRT, namely its greater weight and size, eye-hurting flicker, and higher power consumption, are pushing people towards the LCD.

related subjects

Printer calibration: (page 154).

settings. The chosen setting for the last of these will vary according to ambient room lighting, but for a room in daylight it is generally about 6500K. Gamma is a measure of the intensity of a monitor's output relative to the input (a setting of 1 would mean that output equalled input), and has default values of 2.2 for PCs and 1.8 for Macs.

Image-Editing Software

A wide variety of fairly simple editing programs are available, such as Paint Shop Photo Album, Paint Shop Pro, Microsoft Office Document Imaging, Microsoft Picture It! Digital Image Pro, and ArcSoft PhotoStudio. The last two are probably the best among these options, allowing image optimization and simple manipulation procedures.

However, standing head and shoulders above all image-editing software programs is Adobe Photoshop, the industry's professional standard. Its huge array of features is quite mind-boggling, covering everything you might ever want to do to an image and much more besides. It is quite expensive, so if budget is an issue, there is a cut-down version: Adobe Photoshop Elements. This is still a very advanced piece of software containing most of the features found in the full version, though sadly lacking a few rather important tools. All image editing described in this book will assume use of the full version of Photoshop, though most steps will also be applicable to Elements.

Adobe Photoshop

This is the all-encompassing image-editing software, used not just for photographs but also graphic images. As a result, many of its controls are not entirely appropriate for photographic images. This chapter concentrates only on those processes a photographer is likely to need.

Photoshop presets

Before starting any work with Photoshop, it is important to set up a number of presets that you will probably stick with for all image editing. Follow Edit > Color Settings on the menu bar. In the resulting dialog box under Working Spaces, the most important components to ensure are that for RGB 'Adobe (1998)' and for Gray 'Gray Gamma 2.2' (or Gray Gamma 1.8 for Macs) are selected. Under Color Management Policies, ensure that in all boxes 'Preserve embedded profiles' are selected.

To ensure that you spot any images loaded with the wrong or no colour profile, tick all three boxes.

A typical view of Adobe Photoshop with an image open.

The typical view of Photoshop after launching shows a menu bar across the top, with headings for drop-down menus that list a host of options. Down the left side is a tool bar containing groups of editing tools, and down the right are clusters of panes that record a variety of image data, such as histogram, colours, layers and history (a list of actions so far carried out). The tool bar and panes can somewhat clutter the screen; they can either be all removed simultaneously by pressing the Tab key (which acts as a toggle between viewing and hiding tool bar and panes), or switched on and off individually via the Window option on the menu bar. In addition to the main Photoshop program, an array of plug-ins (that is, third-party software that is available separately but that work within Photoshop) provide even more image-editing features. This chapter will concentrate on what Photoshop itself can do without the help of these add-ons.

Tip If the full version of Photoshop is too expensive, start with the much-cheaper Elements, upgrading later if you need the extra facilities of the full version.

Downloading images onto a laptop computer: (a) directly from the camera; (b) via a card-reader.

>

Views of two Raw image converters:
(a) Canon ZoomBrowser EX; (b) Pixmantec's RawShooter Essentials. The former is bundled as standard with Canon's digital SLRs; the latter is third-party software.

Even without the plug-ins, Photoshop consists of a plethora of tools, and there are often several ways to achieve the same ends. Any book describing all routes for all solutions would be huge, so much of what follows aims to cover just one or two methods that achieve some of image editing's main goals.

Downloading Images from Camera to Computer

Before image editing can begin, the images need to be copied from the camera's memory card to the computer's hard drive. To do this, either link the camera to the computer, or remove the memory card from the camera and slot this into a card reader that in turn is linked to the computer. Both card readers and most cameras can be linked to a computer via a USB cable, while a few of the top-end professional cameras use a FireWire connection.

If a card reader is used, or once the camera is plugged into the computer and switched on, one simple way to copy the images over is to open the computer's file-management software (in a PC running Windows, this is Windows Explorer), create a new folder in which to drop the images, locate the camera icon or folder, select the images and then copy them into the newly created destination folder.

Alternatively, since the camera's dedicated computer software will probably launch automatically once the camera is plugged in and switched on, it is easy to download images via this route. The software will give prompts for a destination folder on the computer and will manage all the copying steps. Similarly, a card-reader may also launch dedicated software that can manage the downloading process.

If the images were shot as Jpeg files, they will be visible as thumbnails as soon as they have been downloaded, and will be immediately editable in any image-editing

software. Raw files, on the other hand, are likely to be visible only when viewed in the camera's dedicated software, and must be converted to either Tiff or Jpeg formats before they can be edited.

Using and Converting Raw Files

The beauty of shooting in Raw mode is that all the exposure data is stored separately from the image itself, making possible a wide range of changes to improve an image's colour balance, contrast and exposure without damaging overall quality, before locking it all into a Jpeg or Tiff image format.

The drawback is that Raw images can usually only be viewed and altered in specialized software, known as a Raw converter, either the camera manufacturer's own dedicated software or a third-party Raw converter. The widely accepted best

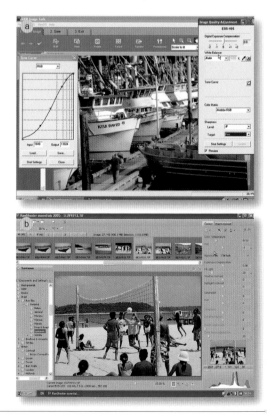

Comparison of Jpeg, Tiff and Raw formats: (page 53).

Memory cards: (page 53).

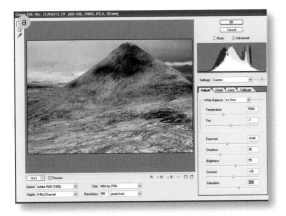

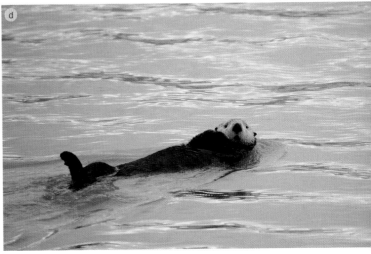

Views of Adobe Raw Converter, showing (a) a mountain landscape in sunlight with a wide range of tonal values that were easily optimized to spread the histogram across the full range available; and (b) a wildlife image, quite monochromatic in view and shot in poor light, showing a very narrow histogram.

Even spreading the histogram by moving exposure and shadow settings in the Raw Converter to the right leaves a sub-optimal image (c). Further work in Photoshop after conversion to Tiff format yielded a much more attractive image (d).

and most convenient Raw converter is that provided with Photoshop. Unfortunately, the third-party Raw converters, including Adobe's, have one major drawback. Raw files are unique not just to one camera manufacturer but to each camera model, making it essential that Raw converter software be continuously updated as new cameras come onto the market. While the camera manufacturers are able to do this, the third-party software manufacturers may find it harder to keep up with developments. It is perfectly possible for someone to buy a new camera, shoot in Raw format, download the images onto their computer and then find it impossible to open them in the Adobe Raw converter. This is solvable, since Adobe Raw converter updates can be downloaded from the Adobe website (www.adobe.com).

The Adobe Raw converter is often the software of choice, since it works seamlessly with Photoshop. Attempt to open a Raw file in Photoshop and it will automatically launch the converter, and once converted the file will automatically open as a Tiff file in Photoshop.

The Adobe Raw converter displays not only the image but also its three-channel histogram, while options enable changes to exposure, colour temperature, brightness, contrast and saturation, making it possible to carry out the most important steps in image optimization before even entering Photoshop. If used in Advanced mode it is also possible to remove vignetting/corner-shading, and to reduce noise and lens-induced chromatic aberrations. Other options include choice of colour profile, bit depth and output resolution.

Once all the appropriate settings have been chosen, image conversion can be carried out, and further editing done in Photoshop.

Tip If you are not sure which Raw converter to use, do some experiments initially to compare a couple and see which one works best for you.

8-bit or 16-bit?

8-bit-per-channel processing generates 16.7 million colours, more than either the eye or a computer monitor can resolve. And yet, it is still recommended that image editing be carried out in 16-bit-per-channel mode, which is able to generate a staggering 300 trillion colours! In 16-bit processing very subtle tonal variations, such as are common in sky or skin tones, can be very accurately reproduced – something that is not always the case with 8-bit processing.

Raw files can be set up in 16-bit mode during conversion, but even if 8-bit files are opened in Photoshop they can still be converted to 16-bit simply by following Image > Mode and altering the colour bit setting.

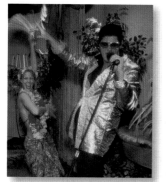

There are many occasions when the impact of the main subject can be greatly increased by cropping out unimportant or distracting parts of an image. Photoshop's Crop tool makes this a very simple job, as with this shot of an Elvis impersonator presiding at a 'Blue Hawaii'-themed wedding in Las Vegas.

Image Optimization

Even with all this help, and especially if an image is shot in Jpeg format and therefore not open to changes in a Raw converter, there may still be plenty of work to be done in Photoshop before an image is fully optimized.

Cropping

Sometimes an image's impact can be greatly improved by selectively cropping part of it, increasing the dominance and size of the main subject in the frame.

This is easily done using the Crop tool on the tool bar. Place the tool in a part of the image that will form one corner of the final image, click and hold down the mouse's left button, and then drag the tool diagonally across to the furthest point that is to be included in the image. Release the mouse button. Everything inside the resulting box will be in the cropped image; everything outside (which will now appear dark) will be lost. If necessary, the box can be adjusted by pulling or pushing on the tabs using the mouse. Once the crop is set correctly, hit 'Enter' and the image will be cropped. If you do not like what you see, follow Edit > Undo Crop and start again.

Levelling horizons

It is remarkable how frequently a horizon is at a distinct slope in an image. It is a problem we all encounter, and thankfully in digital photography it is easily remedied, as described in the box on the right.

Adjusting brightness and contrast

This is a critical and highly subjective part of image optimization. The aim, apart from simply making the image look 'right', is to ensure optimum use of the available tonal ranges. A high-contrast image's histogram will already take up the entire range and will tolerate no further broadening. For a low-contrast picture, on the other hand, such as a more or less monochromatic view taken in dull, flat light, the histogram will probably occupy only a limited band of the available range. Widening this band will bring out more detail in the image, increasing its three-dimensional feel. It can be overdone, however, resulting in an image with strong contrast, sometimes inappropriate for the soft feeling it should have. This is where subjective judgment comes in: you need to set the tonal range according to the mood an image is meant to evoke, while at the same time bringing out the right amount of tonal range and detail. This is most easily set using Levels (Image > Adjustments > Levels), which enables adjustments to the histogram. To spread a narrow histogram and so increase the image's tonal range, slide the end-points along the horizontal axis and then hit Enter.

Brightness and contrast can be altered in several ways. Though not essential, it is better if all these changes (including Levels) are carried out initially in an adjustment layer – essentially a set of instructions that sits separately from the image itself. This overcomes the risk of image degradation that can occur when repeated tonal alterations are made to an image's pixels. Carry out changes initially in adjustment layers and then, when finished, apply them

related subjects

Framing the subject in the viewfinder: (page 78).

The principle of colour bit depth: (page 28).

Levelling the horizon

To level a horizon, follow these steps:

1 Left-click the mouse on the Eyedropper tool and hold the mouse button down. Three options will appear. Click on the lowest one, the Measure tool. A cross-shaped cursor with a tiny ruler icon will appear.

2 Place the cross on the horizon and draw it along the horizon as far as possible, holding the mouse's left button down. A line will be drawn along the horizon. Release the button when you have finished.

3 Follow Image > Rotate Canvas > Arbitrary. A dialog box will show the amount the image needs to be rotated and in which direction. Click 'OK'. The image will be rotated.

4 You now have a crooked image set on a white canvas. The image needs to be cropped. Select the Crop tool, place it close to one corner of the image, press and hold the left mouse button, and drag it diagonally across the image to the far corner. Readjust the cropping points as needed to exclude any of the white canvas areas. Strike 'Enter', and the image will be automatically cropped.

5 The resulting image will be a little smaller than the original. If needed, interpolate the file back up to the original size by following Image > Image Size, and then entering new values in either Pixel Dimensions or Document Size. Image resizing is covered in greater detail below.

Crooked horizons can be difficult to avoid, especially when shooting a fast-moving subject – and in this instance when your own platform is bouncing around. This problem is easily fixed in Photoshop, using the Measure, Rotate image (a and b) and Crop tools (c). The final result is shown in (d).

Tip If intending to crop an image and level its horizon, do the levelling first. Then do just one crop to simultaneously straighten up the crooked image and crop in closer on the subject.

to the image itself in one go by flattening the layer(s) into the image.

The most common method of brightness and contrast alteration for beginners is to use the slide bars found either under the image adjustments layers list or from the menu bar under Image > Adjustments > Brightness/Contrast. Simply moving the settings on the bars is effective, but when it comes to altering contrast there are problems: increasing contrast in this way can push the image histogram beyond its shadow and highlight outer limits, resulting in clipping.

Creating adjustment layers

To create adjustment layers in which to carry out changes to brightness, contrast, saturation and colour balance, follow Layer > New Adjustment Layer followed by selection of the appropriate type of layer for the planned change. Click OK on the dialog box that opens. Create a new adjustment layer for each different type of change (i.e. whether for levels, brightness, contrast, saturation or colour balance), and carry out all the needed changes in those layers. When finished, flatten the layers into the image (Layer > Flatten Image).

Setting up an adjustment layer, in this case a Curves layer, is a straightforward four-step process: Layer > New Adjustment Layer > Curves > OK.

| related subjects | **Photography in flat light: (page 62).** | **Exposing an image to avoid histogram clipping: (page 64).** |

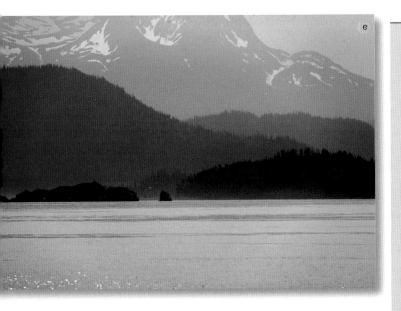

e

Curves

Follow Image > Adjustments > Curves, or Layer > New Adjustment Layer > Curves, and what comes up is a diagonal straight line graph with axes that measure the tones from black to white expressed as the pixels' original settings along the horizontal axis versus the changes you make along the vertical. Changes can be made by clicking on any part of the curve (which then places a locking point on it) and then pushing or pulling. As shown in the attached graphs, raising the curve lightens the image, while lowering it results in darkening. Contrast can be increased by giving the graph a slight S-shape, raising it towards the white end and lowering it towards the dark end. Do the opposite to lower contrast.

◄ ∧

Although Raw images with poor tonal range can be greatly improved before conversion, similar steps can be taken in Photoshop using Levels. A very flat view of the Kachemak Mountains, Alaska (a), was hugely improved by extending the image histogram, by moving the shadow and highlight endpoints to the outer points of the original histogram (b and c). The resulting image (e) has a much broader histogram (d).

The Curves option

In the full version of Photoshop, a much better and more versatile method is to use the Curves option (Image > Adjustments > Curves), which allows simultaneous alteration of brightness and contrast without the danger of clipping the histogram. As described in the box on the right, this method offers the possibility of hugely varied, extensive and yet also very subtle alterations to brightness and contrast.

Shadow/Highlight

A third method mainly used for altering contrast, and for which no adjustment layer can be set up, is to use the Shadow/Highlight option (Image > Adjustments > Shadow/Highlight). Activating this choice brings up a large dialog box and automatically lifts all the image's shadow areas to a midtone – which can look dreadful. This should then be turned down using the sliders. Overall, the tool can be very useful in setting shadow and highlight levels, and is especially good in picking up details in previously overly dark shadows. This can be overdone, however, as really dark areas when lightened tend to contain

The Curves dialog box, and the effects of changing the graph:

(a) (left) The initial graph seen upon opening the Curves option.

(b) Darkening an image by pulling on the middle of the graph.

(c) Lightening an image by pushing on the middle of the graph.

(d) Increasing contrast by creating an S-curve.

(e) Decreasing contrast by creating a reverse S-curve.

Tip Be careful about excessive lightening of very dark areas of an image: they are likely to contain a good deal of noise.

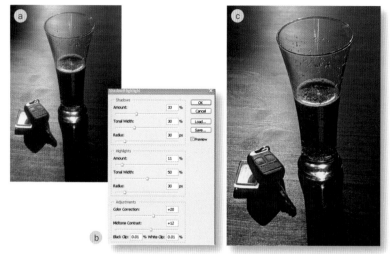

Using the Shadow/Highlight option to improve the balance between shadow and highlight areas in two very different images, with (a) the original image, (b) the process of alteration, and (c) the final image.

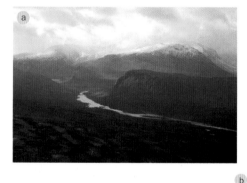

a considerable amount of noise. A third control under Shadow/Highlight is midtone contrast. This useful tool adjusts the contrasts of the image's midtones without affecting the highlights or shadows.

Saturation and colour balance

Today's digital SLRs usually produce images with good colour saturation, and more often than not only a small increase is needed on images needing extra impact. However, images that have had their contrast range significantly reduced (usually through use of Curves or Shadow/Highlight) also suffer a massive reduction in colour saturation, and this needs to be corrected. This is achieved through either Image > Adjustments > Hue/Saturation, or by Layer > New Adjustment Layer > Hue/Saturation, and then by moving the middle of the three sliders to the right. In the options box, keeping the selection on the default 'Master' alters the saturation of all three primary colour channels. To change the saturation of just one, select the appropriate colour from the drop-down menu.

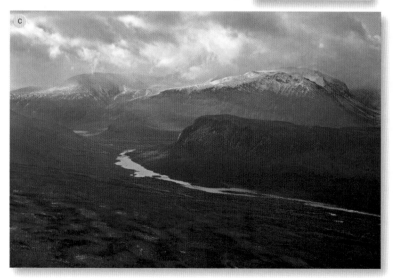

‹
Altering image saturation is a simple process, achieved using a slide bar.

related subjects **Controlling colour balance with white balance settings: (page 70).**

A misty sunrise view of farmland in Somerset, UK, (a) is enlivened by changing the colour balance, increasing the apparent warmth of the light (b) by increasing both the yellow and red content via the slide bars.
Canon EOS 1Ds, Sigma EX 70–200mm lens with 2x teleconverter, 1/1000 sec at f/5.6, ISO 100.

and it is important to bring the histogram back within limits, setting the shadow and highlight end-points just within the histogram's scales. This can be achieved using Curves, moving the upper and lower ends of the graph. This will not rescue any image data lost at the time of exposure, but it will minimize the amount of image reproducing as featureless black or white as a result of image optimization steps.

Making alterations to parts of an image

Everything described so far has been applied to an entire image. However, there will be many occasions when you will want to change contrast, brightness, saturation and colour balance in just restricted parts.

A simple way to do this is to select the image area to be worked on using the Lasso tool. This has three options: Lasso, Polygonal Lasso and Magnetic Lasso. The first of these is useful for throwing a quick loop around something; the second is good for selecting areas bounded by straight, well-defined lines; and the third is unbeatable for selecting quite complex shapes. The selection drawn by a Magnetic Lasso will automatically lock onto the edges of a subject you want to select, particularly if it has a fairly high-contrast separation from surrounding elements.

Feathered edges

The general Lasso tool is very good for selecting areas with an ill-defined shape or boundary, particularly if it is used with a large feather setting. All three Lasso tools have a variable feather, which can change the degree of cut-off between selected and unselected areas, but I find it of most use with the general lasso. A low feather of 1 to 10 causes a sharp distinction, whereas a high feather setting of, say, over 40 blurs the edges of the selected area, resulting in a gradation of any effect that is applied to the selection (see page 138).

Colour balance

As with brightness and contrast, for images shot in Raw format colour balance can be altered during conversion. However, if any further changes are needed, or if colour balance is incorrect in an image shot as a Jpeg, corrections can be made via either Image > Adjustments > Color Balance or via Layer > New Adjustment Layer > Color Balance. Any of the three primary colours and their complementaries can be altered using the sliding bars, with the midtones, highlights and shadows alterable independently.

Changes to either saturation or colour balance can affect the spread of the image histogram, frequently causing clipping. If this happens be sure to correct them, as described below.

Setting histogram end-points

With even the greatest care when exposing an image, when it comes to converting a Raw file or optimizing an image on the computer it is sometimes hard to stop the image histogram clipping. This may happen at any time during image optimization,

Tip An image can be greatly improved by altering colour balance or saturation, though take care not to overdo it, particularly if the image is meant to be realistic.

∧ > The Magnetic Lasso is extremely useful for highlighting objects with distinct edges. The lasso tends to snap onto the edge quite efficiently, as shown in this dome and spire view of St Michael's Russian Orthodox Cathedral in Sitka, Alaska, USA.
Canon EOS 1Ds, Sigma EX 70–200mm lens, 1/160 sec at f/10, ISO 100.

Using layers

Lassoes can be used to copy sections of an image to create layers that float above the main image, making it possible to work on the copied section without affecting the rest of the image. Parts of the layer can be erased if necessary, and when finished the layer can be flattened back into the main image, either exactly where it came from or in some other part of the image.

Cleaning up

Because sensors get dirty so easily (see page 105), many images will show the shadows cast by this dirt. Every image must be scoured at 100% magnification and any visible dirt marks removed. Be methodical: start in an image's top-right corner, work down to the bottom right and then zig-zag across the image.

Any dirt can be removed with either the Clone or Healing Brush tools, as described in the box opposite. The Healing Brush is often best used in areas of low detail or low focus or other parts with subtle gradations of tone, such as skin or sky. Highly detailed parts can best be managed using the Clone tool.

Making adjustments to one small area of an image can be achieved by putting a highly feathered lasso around the area to be worked on (a and b). The lasso isolates this part of the image, ensuring that changes made affect only that area (b). In this backlit image, the overexposed branches and water can then be darkened to a level that fits with the rest of the image (c and d).
Canon EOS 1Ds, Sigma EX 28–70mm lens, 1/160 sec at f/5.0, ISO 100.

related subjects

The problems of a dirty sensor: (page 105).
Cleaning a dirty sensor: (page 108).

Understanding how to use Curves: (page 135).

Healing and Cloning tools compared

The two tools act by copying one very small part of the image onto the area selected using the tool's brush, thus replacing the pixels showing the sensor dirt with pixels showing a slightly different part of the image. The copied part must be a good match for the spot it is being copied into, especially in the case of the Clone tool as it transfers an exact copy (see page 140). The Healing Brush, however, copies the pattern across but then matches its colour to the surrounding pixels in the area where it is being placed. This is superb for cleaning up areas of subtle tonal changes, such as skin or sky, where making a perfect match using the Clone tool is almost impossible. When working on skin, the Healing Brush is also great for removing any blemishes.

The Healing Brush encounters problems when used close to details and other high-contrast edges that have a different colour from the area you want to work on. The colour from these adjacent areas will bleed across into the treated part. This can be solved by putting a lasso around the area you are working on, limiting the Healing Brush's pixel-sampling area to within the lasso. It can, however, be quicker to use the Clone tool.

The Patch tool

Second of three options under the Healing Brush tool, the Patch tool is useful for replacing large blemishes. Throw a lasso around the affected area, move to an adjacent 'clean' area, copy and

The Cloning and Healing Brushes

The controls for both tools are pretty much the same, so are described together, as follows:

1 To access, left-click with the mouse on the appropriate tool bar icon. The active area, or brush, is by default a circle, and is the simplest to stick with.

2 Brush size can be altered using the slide bar, most easily accessed by right-clicking the mouse. Below the brush size slide bar is another for altering 'Hardness'. This controls the size of the brush's feathered edge. A hard edge will result in any changes made showing up as distinct circles, whereas an excessively soft feather (i.e. a hardness setting at or near 0) results in softening and blurring of the image, especially in areas with texture and/or grain. A hardness setting of 20–30 is useful in most situations. Once the right brush size and hardness have been selected, hit Enter twice. Other adjustments, visible below the menu bar, should usually be left on their default settings.

3 After finding an area that needs changing, identify a nearby area that has a similar pattern, colour and texture but no faults, place the tool's brush over the latter and hit Alt and left-click simultaneously. This puts a cross over this area, marking it as the spot to be copied from.

4 Move the brush to the area being changed, hold the mouse's left button down and carefully rub away. The area under the cross will be copied over. This action is difficult to start with, but becomes easier with practice. Mistakes can be undone easily, using either Edit > Undo or the History pane.

The Healing Brush being used to remove marks left by sensor dirt, and showing the dialog box for altering brush size and hardness.

Tip If using the Cloning Tool or Healing Brush extensively on a small area, keep changing the point being copied from, or the result will be a pattern continually repeating that point.

Images (a) and (b) show how the Cloning tool reproduces an exact copy, necessitating care in its use. Image (c) shows how using a Healing Brush close to another colour will cause that colour to bleed across into the healed area.

Pixels per inch vs dots per inch

Image resolution is often expressed as dots per inch (dpi), though this is a misnomer and should be used only for the resolution of ink dots on a print, whether inkjet or off-set lithographic. Image resolution should be expressed as pixels per inch (ppi), and yet using dpi to express both image and print resolution has become almost universal. This is something that can be quite confusing for the beginner, but once the issue becomes clear the two are easily differentiated.

then paste over the blemish. The patch's pixels are automatically adjusted to match the surrounding area for colour and tone.

Changing image size and resolution

In principle, changing image size or resolution is a simple matter of following Image > Image Size, entering new values in the image dimensions or resolution boxes and pressing Enter. However, there are a number of issues to be aware of.

The resolution, the number of pixels per inch (ppi, often mistakenly called dpi – dots per inch; see box) can be set at different levels for different uses. For making prints, a commonly used resolution is 240ppi, whereas for most forms of publication it needs to be 300ppi. For images destined for a website, resolution is usually set at either 72 or 96ppi, the generally accepted standard screen resolutions for Macs and PCs. Digital cameras have a default resolution setting that varies from one model to another, but it should be set at 300ppi, as it is better to later have to lower resolution than raise it.

As for changing image dimensions, reducing size is less of a problem than increasing it. However, in downsizing, image pixels – in other words, data – are dumped. For large steps in size reduction, be aware that this can cause some loss of image quality, especially sharpness.

The big question comes with increasing file sizes. Usually called interpolation, increases are enabled by the software's ability to guess what new pixels should

surround each already existing pixel, creating a smooth increase in size. Clearly there can be no increase in image detail when interpolating since no new data is being introduced, but the process does enable larger reproduction with little or no loss of image quality.

How much interpolation is possible is a subject of considerable debate. To some extent, it depends on the image-manipulation software and how it is used. Various Photoshop plug-ins have been favourites among some photographers at various times, but recent tests have suggested that Photoshop's own interpolation process was among the best provided that the 'Bicubic' setting was used (selected in the Image Size dialog box).

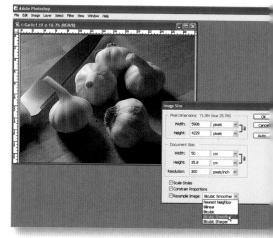

A still-life shot of garlic used to illustrate the process of changing image size. The image size dialog box is used to alter image resolution, dimensions and interpolation method; here, Bicubic Smoother is selected to increase file size.

related subjects

Image sizes needed for different end uses: (page 37).

Working in 16- or 8-bit colour depth: (page 132).

From frequent experience of interpolating file size, it can be said that since doubling an image's dimensions only causes a 50% increase in the pixel count (a 20MB file, for example, becomes 30MB), this does not seem to be a problem. Interpolation to actually double the pixel count, however, may be starting to push the boundaries a little, though a six-fold increase in dimensions has been claimed to be possible.

If altering both resolution and file size simultaneously, take note of the total file size. When increasing dimensions but reducing resolution it is still possible to come out with a total file size lower than the original, meaning that there has been no interpolation.

A final note is to warn that repeated image size and resolution changes will quickly cause serious deterioration in image quality. Always keep a copy of the original image in reserve and use this each time a new image size is needed.

An image of a seagull illustrates the use of Unsharp Mask to sharpen images. Image (a) and its inset (b) show the original image, with (c) illustrating the process of applying Unsharp Mask. Image (d) is the sharpened image, with its inset (e) showing how much sharper it is than the original image (compare b and e).
Canon EOS 1Ds, Sigma EX 70–200mm lens with 2x converter, 1/400 sec at f/9, ISO 100.

Sharpening

Whether or not to sharpen images is a fraught question, and must to some extent depend on how good your digital camera and lenses are in the first place.

The sharpening tool to use is Unsharp Mask, so named after an old darkroom trick to sharpen up reproduction from slightly blurred negatives. Do not bother with the other sharpening tools. Found under Filter > Sharpen > Unsharp Mask, careful sharpening can add an extra crispness to an image, but is easy to overdo. Oversharpened images can often look terrible, and it can take practice to tell when an image has been oversharpened.

16-bit to 8-bit conversion

For those working on images in 16-bits-per-channel colour depth, virtually the final step in image optimization is conversion of the file to 8-bit. This is important to photographers who are likely to send their images out to a wide variety of people, since not all computer programs and few printers are able to use 16-bit images. Do this by following Image > Mode and then ticking 8 Bits/Channel instead of 16.

Tip While very useful in sharpening slightly soft images, Unsharp Mask can cause unpleasant edge artefacts. Use it sparingly, if you must use it at all.

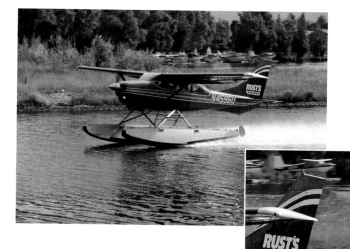

There are times when you need to remove unwanted elements from an image – in this case, the company name from the airplane's tail fin. Removal was managed by careful use mainly of the Cloning tool and with a little work with the Healing Brush at the end.
Canon EOS 1Ds, Sigma EX 70–200mm lens, 1/320 sec at f/8, ISO 100.

Further Image Manipulation

The line dividing standard image optimization and further image manipulation is blurred, and some of the steps described here may be standard procedures for some photographers. Nevertheless, they are likely to be less routine for the majority, and require more advanced working procedures.

Removal of distracting components

Overhead wires, a badly placed rubbish bin, litter, obtrusive people and advertising can often mar an otherwise great image. Removing such items can be simple or complex depending on the background against which they are standing and their relative size in the image. The process consists mainly of a judicious combination of the Healing Brush and Clone tools, along with either the Patch tool, or copying and pasting whole sections of image to cover over the distractions.

Correction of perspective distortion

As described in Chapter 5, this is of great importance to architectural and interiors photography. A step-by-step guide is given in the box, but there are a few extra points to note. Perspective correction normally involves stretching part of an image, which means interpolation of the pixels in that area. For this reason, only moderate distortions can be corrected with this technique before image quality starts to decline. To remove extreme distortions, it is important to have the correct lens-shift facilities during the actual photography.

Furthermore, perspective correction tends to compress the image vertically, so it is essential to follow up with a rescaling to stretch the image back into its original relative proportions. Both steps will crop the image. Ensure when taking the original photograph that plenty of space is left around the subject – space that can be readily lost during the processing.

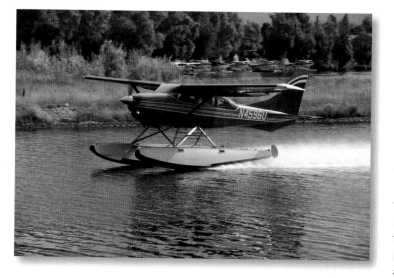

related subjects | Architectural photography: (page 98). | Interiors photography: (page 100).

Perspective correction

1 To activate the Perspective Correction tool, first follow Select > All, and then Edit > Transform > Perspective.

2 To correct parallels that are converging towards the top, point the cursor at either of the image's top corners, left-click and hold down the mouse button, and then draw the perspective box outwards until the parallels are once again parallel with one another. Release the mouse button. Further adjustments can be made in the same way if necessary. Hit Enter.

3 Although the perspective will now be corrected, the image will probably have been compressed vertically. To correct this, make sure the image is still selected, and then follow Edit > Transform > Scale. Using the mouse as before but pointing at either the image's bottom or top edge, restretch the image. Once correct, hit Enter.

Correcting converging parallels using perspective correction. In the original image (a) the cathedral walls show significant distortion. Using perspective correction overcomes this but shortens the verticals (b), making it important to stretch the image vertically a little (c) to correct this. The final corrected image is shown in d.

Tip When correcting vertical compression, stretch the side of the image containing material that can be lost (the process will crop it out), such as empty sky or (as above) grass.

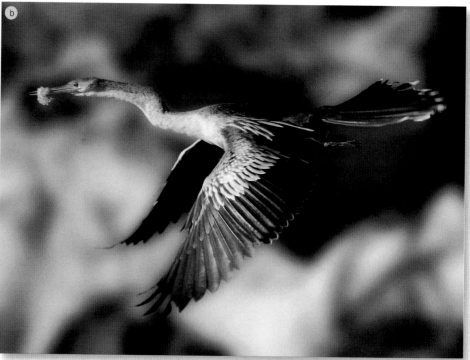

Use of Extract (see box on page 145), in this case to blur the background. In the original image (a) the background is almost as sharp as the bird (an Anhinga, seen on the Amazon, Brazil), creating little distinction between the two. Applying Gaussian Blur to the background only (image b) makes the bird much more clearly visible.

Canon EOS 1Ds, Sigma EX 70–200mm lens plus 2x converter, 1/500 sec at f/5.6, ISO 100.

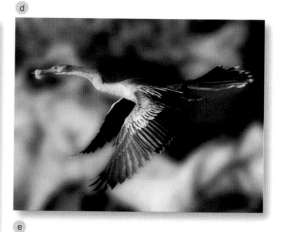

The bird was first carefully selected by drawing around it (c) and then using the fill selection (d).

The background was then knocked out to the leave the image on its own with a transparent background (e). The image was copied (Select all > Copy) and the original file closed without saving it. The file was then reopened and the extracted bird pasted from the clipboard onto it. Gaussian Blur (Filter > Blur > Gaussian Blur) was applied to the background only, and the layer containing the still-sharp bird flattened onto it.

related subjects

Shooting with motion blur: (page 145).

Shutter speed and the lens focal length reciprocal rule: (page 87).

Selective blurring

There are occasions when at least part of an image needs to be blurred, often to achieve a clear separation between the main subject and its background. A range of options is available under Filter > Blur. The most commonly used include Blur, Gaussian Blur and Motion Blur. The simple Blur tool can be useful in reducing the sharpness of an oversharp image or of reducing the impact of excessive noise.

Gaussian Blur is used to throw an image out of focus by an amount controlled by a slide bar, such as when trying to mimic the effect a powerful telephoto lens has on a background. Lens Blur can also be useful here, giving a more natural impression of the background going gradually out of focus behind the main subject.

Motion Blur can be used to blur an image to give the feeling of motion, and is useful in bringing dynamism to an image of a moving subject that has come out appearing rather static. Regardless of the type of blur to be applied, highlight

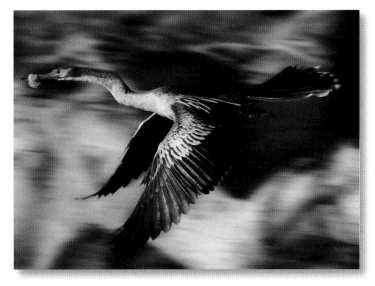

and then copy the main subject that is to remain sharp, paste it back onto the image to create a new layer, make the background main image the active layer, blur this, and then once satisfied with the blurring, flatten the still-sharp subject into the image. The result is a sharp subject, showing clear separation from its blurred background.

This shows exactly the same process applied as in the image opposite, except that Motion Blur (Filter > Blur > Motion Blur), angled from left to right, was applied instead of Gaussian Blur.

Lasso or Extract?

The usefulness and versatility of the Lasso tools has been covered, but an additional and very powerful tool to consider is Extract, which is accessed via the Filter option on the menu bar (Filter > Extract).

The Extract tool is not used simply to select or highlight a particular part of the image; it also deletes all the non-highlighted areas. This is extremely useful for cutting components out of an image, for example to paste onto a new background, or to incorporate into another image.

In addition, Extract's cutting-out process copes more readily with

such irregular surfaces as feathers, hair and fur than any of the Lasso tools, making it invaluable when dealing with wildlife images or portraits of people.

Using the example of the Anhinga bird shown above, follow Filter > Extract to open the extraction window containing the image. To highlight the wanted area(s), draw around it with Extract's pen tool (the thickness of which can be altered with the Brush Size option). Once the selection has been completed, highlight the area to be retained using the Fill tool, make any necessary adjustments, and click OK

to carry out the extraction. If necessary, the edge of the selection can be softened using the Smooth option prior to extraction – this can be important with photographs where excessively sharp edges would look unnatural.

After the extraction, you will be left with an image containing only the selected component; the remainder of the image will consist only of a transparent background. To transfer to another image, simply select the entire image, including the transparent background, and copy it (Select > All, followed by Edit > Copy).

Tip If you need to highlight an image that has indistinct edges, such as feathers or fur, use Extract. Varying the thickness of its pen can help to take into account such edges.

Making composite images

The techniques here cover a series of scenarios described in Chapters 5 and 7, including the combination of exposure bracketed multiple images, differentially focused multiple images, insertion of a new image background behind the main subject, and the combination of various components into a single image. The techniques for all these are quite similar, though have some differences.

Exposure bracketed composites

The simplest and most likely combination is of two images with different exposures, brought together to lower an otherwise excessive contrast range across a single image. The technique is relatively simple in principle, though merging the two images' meeting points can be made complex by trees or tall buildings.

Combining exposure bracketed images. In this image of a domestic lounge, it was impossible to correctly expose both the indoor space and the view of the garden outside in the same image. To overcome this, the twin-exposure method was used (a and b).

The window area of the darker image (containing the correctly exposed view of the garden) was highlighted using the Polygonal Lasso (c), copied and pasted onto the lighter image (d, with the background invisible).

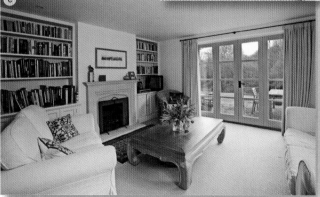

After further work to balance the exposure of the two layers, the image was flattened to produce the final result, shown in (e). Canon EOS 1Ds, Canon 17–40mm L lens, tripod, 0.5 sec at f/16, ISO 100. Exposure data correct for the interior view.

Combining exposure bracketed images

To combine the correctly exposed parts of each image, follow these steps:

1 Open both images, select and copy the correctly exposed area(s) of one of the images.

2 Paste the copied selection on top of the other image and moving it into the correct position above the lower image. The pasted image now sits as a layer above the other.

3 Working on this top layer, trim away any remaining incorrectly exposed areas using the Eraser tool.

4 There will usually be a transition zone that is correctly exposed in both layers. Continue to erase a little into this zone in the top layer, using the Eraser tool with a feathered edge. This will help any blending and gradation of exposure that might need to occur between the two layers.

5 Finely adjust the curves for each layer until contrast and lightness for the two match.

6 Flatten the top layer down onto the background to create the final image.

related subjects | Differentially focused multiple images for in-computer merging: (page 116). | Exposure bracketed multiple images for in-computer merging: (page 115).

An image shot three times with a very narrow depth of field and focused on three different planes through the image (a, b and c). The sharply focused parts of each image were combined to generate an image in focus throughout every level (h).
Canon EOS 1Ds, Sigma EX 28–70mm lens, 1/60 sec at f/4, ISO 200.

Intermediate images show: (d) the middle of the three images (i.e., b) with a lasso around the part in focus, ready to be copied and pasted onto the base image (a), shown on the left; (e) the selection from the middle image pasted onto the base image, with the background made temporarily invisible; (f) the sharp area of the top image (i.e., image c), lassoed, copied and pasted onto the base image, with other layers temporarily invisible (g).

Differentially focused images

Combining two or more images with different planes of focus in order to create a single image with a large depth of field follows much the same steps as described for exposure bracketed images. Be sure to have the in-focus nearer object(s) as the top layer, so that after deletion of the blurred background it can be flattened down onto the sharp background. Also note that, since an out-of-focus object may be larger than when it is sharp due to the blurring effect, it may be necessary to resize the sharp subject slightly to make sure it completely obscures the blurred version below.

Tip When combining images in which one will form the bulk of the composite, use this image as the background, and paste the smaller parts from the other image on top of it.

Inserting a background

1 Open both the image containing the new background and that containing the main subject.

2 Working in the latter image, follow Filter > Extract and in the extraction box draw round the outline of the subject to be preserved.

3 Once the outline is complete, select the enclosed area using Extract's fill tool. This is the area that will be preserved.

4 Make any necessary adjustments to the outline, hit Preview to check that the right areas will be lost, and then OK to carry out the extraction. Everything outside the selection will be lost.

5 Select and copy the entire image (Select > All, followed by Edit > Copy).

6 Paste (Edit > Paste) this into the image containing the new background.

7 The result will be an image with two layers – the background and the main subject. Work on each separately to alter contrast, brightness, etc to make the apparent lighting in the two layers match as closely as possible.

8 When satisfied, flatten the layers (Layer > Flatten Image) to create the final image.

A *new background*

Slipping a new background behind a subject can be quite straightforward, though it is important to select a background with lighting suitable for that present in the subject/foreground. Although alterations to contrast and brightness to both background and subject layers can help bring the two together in this respect, there is only so much that can be done, so appropriate choices are the key. The merging technique is described in the box left.

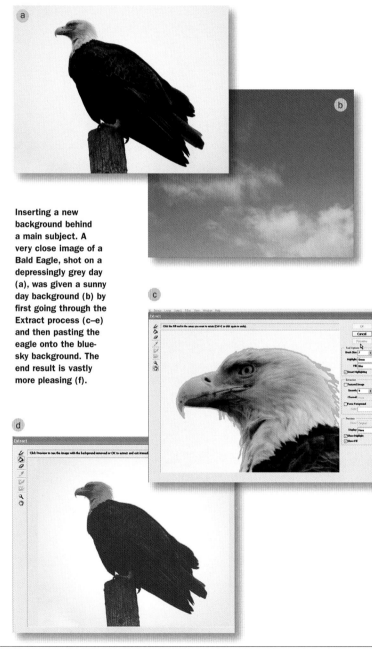

Inserting a new background behind a main subject. A very close image of a Bald Eagle, shot on a depressingly grey day (a), was given a sunny day background (b) by first going through the Extract process (c–e) and then pasting the eagle onto the blue-sky background. The end result is vastly more pleasing (f).

related subjects

Nature photography: (page 90).

Shooting images specifically as backgrounds: (page 118).

Combining components

Merging individual elements into a larger image can be difficult to manage realistically. If not done carefully, the additions will appear to sit artificially on top of the background. Ensuring that the pasted object(s) is rotated to sit at the right angle relative to the background is an important first step, often combined with selectively erasing small parts of its edges to give the impression of the object sinking into the background. The addition of shadows is usually crucial. To carry this out, follow the steps in the box on the right.

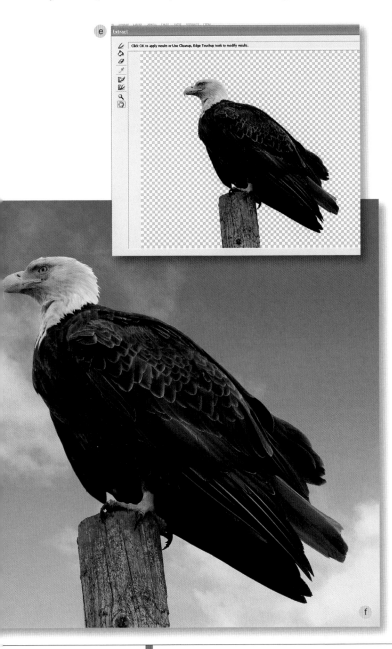

Merging components

1 To copy an image component into a main image, first select that component using one of the Lasso tools or Extract. Copy the selection or extraction (Edit > Copy).

2 Paste the copied selection into the main image (Edit > Paste).

3 The image component will now be sitting as a layer on the main image in an unnatural way. The first step to make it fit in is to alter its size to a suitable scale. Follow Edit > Transform > Scale, and then push or pull the tabs on the surrounding box until the component is the right size. Hit Enter.

4 Rotate the component to the right angle, by following Edit > Transform > Rotate, and then using the mouse to rotate the component. Hit Enter.

5 To help the component appear to sink into the main image, gently erase a few of the component's edges so that the background seems to wrap itself around and blend with the component, particularly to reveal any elements of the background that should actually be in front of the pasted object.

6 Draw in shadows on the background. Select the appropriate area using one of the Lasso tools, then darken the selection using Curves.

7 When finished, flatten the layer down (Layer > Flatten Image) and save.

Tip Make sure when making a composite image that all its separate parts received similar lighting when photographed.

Making panoramics

To make a panoramic from three images using Photoshop's Photomerge option, follow these steps:

1 Follow File > Automate > Photomerge. This opens the Photomerge dialog box. Choose the images to be merged by pressing Browse and then finding and selecting the relevant files. Click Open.

2 The selected files will be displayed in the dialog box. Click OK, and after a few seconds the Photomerge window will open, with thumbnails of the selected images visible at the top.

3 Drag each of the images down in turn into the main window, roughly arranging them. The software will snap them into alignment. When satisfied, click OK.

4 Photomerge will automatically make the panoramic image, which will then be displayed in Photoshop.

5 The outer edges may be quite crooked, the result of slight misalignment of the camera as the three successive photographs were taken. Remove this either by cropping the image or by copying appropriate pieces of the image into the missing spaces – particularly appropriate when only a simple pattern or tonal range is needed, such as with sky, water or grass.

6 If the tones and colours are not quite matched in the transition areas between images, use a combination of the Clone and Healing Brush tools to manually correct the imbalance.

7 When finished, flatten the image (Layer > Flatten Image) and save.

Making panoramic images

The first choice to make when you are creating a panoramic from two or more images is whether to do it manually or to use automated software. Doing it manually offers greater control and fine-tuning, but it can be difficult and time-consuming. It is generally better to use dedicated software to automate as much of the process as possible, finishing off manually if necessary.

Several image-stitching programs are available, either stand-alone or as Photoshop plug-ins, though the quality varies immensely. An accurate process is available in Photoshop, called Photomerge. This is accessible via File > Automate > Photomerge. The steps needed to create the panoramic image introduced in Chapter 7 used Photomerge, and are described in the box on the left.

Select the files you want using Browse, then click OK.

When the Photomerge box opens, arrange the images as needed. They should snap together in the correct alignment. Clicking OK activates the stitching process.

related subjects | Photographing a subject with in-computer panoramic creation in mind: (page 122). | Landscape photography: (page 94).

The image preview
before the panoramic
is stitched.

The image immediately after
stitching. Note how the images
are not quite perfectly aligned.

One way to remove the blank areas, especially
those adjacent to a plain area such as sky, is to
fill them in using a combination of the Clone and
Healing tools. Initially, the colouring may not
match, but working with the Healing Brush will
eventually solve this.

The final panoramic first shown in Chapter 7
(see page 122) was created in the computer
using Photoshop's Photomerge software, as
shown in these stepwise images.

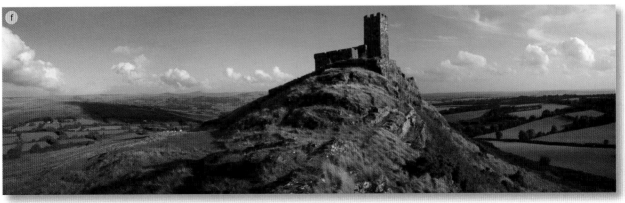

Tip Try to ensure that large areas such as sky, which may have slightly different colour
properties in consecutive images, match each other closely before stitching takes place.

Converting colour to black and white

There are at least three ways to convert a colour image to black and white in Photoshop; some are better than others. The simplest and perhaps most obvious is to change the image's mode (Image > Mode), ticking 'Grayscale' instead of 'RGB'. The problem with this method is that the loss of colour combined with no alteration in tones may lead areas of radically different colour but similar tone to appear almost indistinguishable in black and white.

Converting this image of the giant guitar outside Las Vegas's Hard Rock Café into a black and white image was as simple as selecting the 'Desaturate' option.
Canon EOS 1Ds, Sigma EX 17–35mm lens, with polarizing filter, 1/90 sec at f/16, ISO 100.

A second method is to desaturate the colour image (Image > Adjustments > Desaturate or Hue/Saturation), though this can lead to even less tonal variation than is present after switching mode.

A third, and much better, route is to make the colour channels visible (Window > Channels) and then view each of the three channels in turn. Each selection will provide a black and white image, the tones of which will vary according to the way the colours are rendered in that channel. For example, in the red channel blue will appear almost black, a step that mimics the use of a red filter in black and white film photography and a frequent ploy to increase the contrast among sky, clouds and green foliage.

After viewing all three channels, decide which one does the best job of rendering the colour image into black and white. Copy that channel (right-click the mouse while pointing at the channel) and paste into a new file. Name and save your new black and white image.

related subjects Colour channels in RGB images: (page 30). Principles of colour bit depth: (page 28).

Three different black and white images created from each of the colour channels of the original RGB colour image: (a) the original RGB image, showing the colour channels on the right; (b) a black and white image created from the blue channel; (c) from the green channel; (d) from the red channel. With the original colour image rich in red and blue, not surprisingly image d has the greatest tonal range, the sky almost black and the guitar a pale grey (as also in the final image, e).

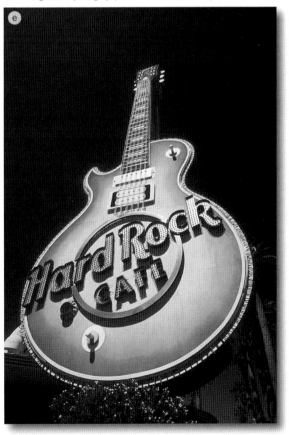

Tip Think ahead about how different colours are likely to be rendered in a black and white image created from an RGB colour image.

Priorities in printer selection

The main factors to weigh up when deciding what printer to buy are:

1 **Photographic quality output.** To have the best image quality, a photo-optimized printer is needed. These usually use six inks (black, yellow, cyan, light cyan, magenta and light magenta), as opposed to the four inks (lacking light cyan and light magenta) of standard printers.

2 **Maximum printable size.** Mainly a choice between A4 (8¼ x 11¾in) and A3 (11¾ x 16½in); if you intend to make saleable prints you will probably opt for an A3 machine. A4 will be suitable if printing is actually only a secondary need, or if it is not an issue to send files to an outside printer whenever larger prints are needed.

3 **Choice of papers useable.** Each printer model is designed to take only a certain range of paper types and weights. Make sure that any chosen printer is designed for the types of paper likely to be used. Some printers can now also print on specially coated CDs and DVDs.

4 **Longevity of prints.** In the past there has been a question mark over the longevity of inkjet prints, but this seems to have been largely overcome. Nevertheless, there are two broad types of inks: dye and pigment. The latter produces prints with a much longer lifetime, claimed to be as much as 200 years. If this is important, look for the type of ink each printer uses.

5 **Running costs.** The printers may be cheap, but manufacturers compensate with high ink prices. Pay careful attention to the manufacturer's claims for how many pages can be printed per cartridge, as well as to prices for replacement ink cartridges.

6 **Direct printing.** To be able to print without going through the computer, look for facilities to plug in and directly print from a memory card.

Printing

When it comes to printing out your digital images, inkjet printers are king. These printers are able to produce at a reasonable price stunningly high-quality prints that are virtually indistinguishable from photographic prints.

Inkjet printers work by spraying extremely fine droplets of ink across specially treated paper. Their prints differ from photographic prints in being made up of a series of discontinuous dots, whereas in photographic prints the colouring is continuous.

Another kind of desktop digital printer works by a process of dye-sublimation, which transfers inks from a heated ribbon to the paper, producing a continuous print. Though a few years ago serious contenders for dominance of the printing market, they are now rather more expensive than inkjet printers and are less common.

Choosing a printer

Most photographers use an inkjet printer. The choices that need to be made when deciding which printer to use are outlined in the box on the left.

Individual priorities will vary; someone who intends to produce top-quality archival prints for sale will need to invest in the best printer that they can afford, but anyone who wants to produce prints only for home use, or for whom printing is only a secondary need, will want something that is smaller and cheaper.

Standardizing print output

A printer needs calibrating just as a computer monitor does. It is not just the printer model that needs to be considered, but also the inks and the type(s) of paper being used. In general, only one type of ink is ever used with a single printer, so the main variable comes in the types of paper. The software provided with the printer goes

related subjects

Monitor calibration: (page 128).
Image colour profiles: (page 128).

Image size and their end uses: (page 37).

a long way towards setting up the needed profiles. Once installed, ensure that the printer is using the colour-management profile provided, and when preparing to print always be sure to select the options in the printer dialog boxes relevant to both the print quality needed and the type of paper being used.

Provided you use only paper for which the printer software has the right profiles (and hence options within the dialog box), this will often be sufficient to produce good-quality prints. However, it is not uncommon for there to be a mismatch between the colours seen on the monitor and what the print shows. If the monitor is calibrated correctly, then alterations can be made in the printer colour, contrast and brightness settings that will, after trial and error, produce prints that match the monitor. These alterations can be saved as a custom setting unique to the type of paper being used.

Two inkjet printers available, one (above) showing a facility to print on CDs and DVDs.

Profiles

Profiles can also be built up by use of specially designed images, available from services specializing in profiling, that are rich in neutral tones and what are called 'memory' colours. These are colours associated with particular objects with which we are all familiar: the yellow of a banana, green vegetation, skin and sky tones, for example. Even though these will have some cultural variation, in general we instinctively know when any of these colours is right or wrong. Printing out a digital reference image designed to contain all these elements can be useful in assessing and altering print output quality, as well as in matching printer to monitor. Though not needed for any general use, it is possible to go still further, paying for a profiling service that analyzes your prints with a spectrophotometer and then makes a custom profile that is specific to your printer and paper combination.

Making full use of the printer dialog box, including the most advanced of options, can go a long way to calibrating the printer correctly for the paper being used and the image on the monitor.

Tip Try to use only papers and inks that match the options in a printer's dialog box, and be sure to choose the appropriate settings each time you print.

A view of Windows Explorer on my computer, showing the Philippines folder within my Travel section of My Pictures. Grouping images carefully in folders by subject and/or location can help you keep track of images on the hard drive, and is therefore useful in organizing your workflow.

Long-Term Image Storage and Archiving

In an ideal world, the solution to storage of images would be to simply leave them on the computer hard drive, where they are at their most accessible. However, in the real world, computer hard drives can become quickly choked with a growing image bank, and there is the constant fear of a computer crash or virus wiping out the files. For the long term, images must be backed up, preferably removed altogether from the computer's main hard drive, and stored in a permanent format in a safe place.

Images on the computer's hard drive

In the short- and medium-term, it is fine to leave images on the computer, particularly if they are also backed up on an external hard drive programmed to replicate everything on the computer. To make it possible to find any image in the growing mountain of pictures, make sure they are arranged in folders and sub-folders that have some logical order. For example, all my travel images are in a folder labelled 'Travel', which then contains sub-folders for each country. Within these country folders may be further sub-folders dividing the images into regions. In this way, you end up with a folder tree that neatly divides up the image library.

Photoshop's Browse feature (File > Browse) is very useful here, allowing thumbnails in any folder to be viewed directly in Photoshop, along with all the camera and exposure metadata gathered at the time the image was shot. Keywords can be entered here. The full-sized image can be launched in Photoshop by double-clicking on the thumbnail.

This organization of your images can be taken a stage further by using specialist cataloguing software such as Portfolio or Fotostation. Portfolio, for example, allows images to be listed into catalogues, which in turn can be further divided into galleries that give subsets of images within a catalogue. A thumbnail plus an enlarged view, directly linked to the image on the hard drive, is created for each image within a catalogue. Captions, keywords and information as to where the file can be found on the computer can all be listed along with each image.

Photoshop Browse can capitalize on folder arrangements in Windows Explorer. This is not only useful in showing image thumbnails as in Explorer, but also in making embedded image metadata visible (see bottom left).

related subjects File sizes: (page 37). Screen resolution: (page 140).

Two more ways of keeping track of images on your computer hard drive. (a) shows Canon ZoomBrowser EX, which comes packaged as standard with Canon's digital SLRs. This allows images and folders to be viewed in a way similar to Photoshop Browse, and also contains a Raw converter. (b) shows Extensis Portfolio, which works independently of the folders system, allowing the photographer to generate catalogues of images that in Explorer may be stored in very different folders. Within each catalogue, subsets of images can be created that can be viewed as a gallery separate from the rest of the catalogue. The view here shows my catalogue of British photographs, with the galleries I have for different parts of the country.

Long-term storage

For the long term, it is essential that you remove your images from the computer and store them separately. This is possible using digital storage on a succession of external hard drives, though optical storage on CDs or DVDs is a cheaper and possibly less bulky alternative.

Before writing images to a DVD, I normally create a low-resolution thumbnail version of each image, to keep on my computer hard drive as a record, stored in my system of folders and viewable in both Windows Explorer and Portfolio. This helps to remind me of what digital images I have without having to refer to the DVDs or any printed records I keep. The full-size images are then copied to DVDs, divided up in the same way that they are on my computer. Contact sheets are made of the images on each DVD, using Photoshop (File > Automate > Contact Sheet II), with one hard copy being kept with each disk and a further hard copy going into a file that I keep within easy reach. The DVDs are stored in a filing cabinet, which again is divided up into

sections just as the original images are on the computer.

Not only are my Tiff and Jpeg images stored long-term in this way, but also the original Raw files. This greatly increases the storage space that is needed, but it gives me the flexibility to go back to an original image if necessary, and it serves as an additional safeguard against corruption of any of the files.

Tip **Always keep image archiving up to date; it is easy to fall behind and then any system for tracking images can start to break down.**

A Digital Glossary

Sometimes it feels as though half the struggle with digital photography lies simply in understanding the jargon. Hopefully, this glossary will help to demystify the subject.

Analogue Refers to film photography, which is able to generate an infinite number of colours and tones.

Artefact A false colour or object in the image, resulting from lens inadequacies, sensor problems or dirt on the sensor.

Bit Binary digit; the smallest amount of binary digital information possible, either 0 or 1, equating to that supplied from a single pixel.

Bit-depth The number of bits used to make up one byte of data, usually either 8 or 16, for each channel of a colour image.

Buffer Temporary in-camera image data storage.

Burst rate The number of images a DSLR can shoot in rapid continuous firing before the buffer is full.

Byte A unit of digital information resulting from the combination of data from a fixed number of bits, or pixels, usually either 8 or 16.

CCD Charge-coupled device; the most common of two types of digital camera sensor.

Channel The information for each of the three primary colours (red, green and blue) used in a colour digital image.

Clipping Loss of image detail as expressed by an image's tonal histogram going beyond its highlight and shadow limits, causing burn-out at the highlight end and blackness at the shadow end.

CMOS Complementary Metal Oxide Semiconductor; the second of the two most common digital sensor designs.

CMYK The colour space applied to images printed on lithographic off-set printers, representing the ink colours cyan, magenta, yellow and black.

Colour profile A set of instructions on how to reproduce an image's colours and tones embedded in the image file, which will vary according to the colour space selected to determine the profile.

Colour space A model for the way colours and tones can be reproduced. There are several models, including sRGB, Adobe RGB, CMYK and Lab.

CompactFlash One of the most common types of solid-state memory cards.

Compression Reduction of an image file down to a much smaller size.

Dpi Dots per inch; strictly speaking, meaning the density of dots of ink applied by a printer in making a print, but often used to mean pixels per inch – the resolution of a digital image.

Dynamic range The maximum range of tones, from black to white, in which image detail can be resolved.

File format The way a digital image is written and stored. The main formats for photography are Tiff and Jpeg.

Full-frame A digital image sensor with the same dimensions as a frame of 35mm film (24 x 36mm).

Gamma In a computer, this is the ratio of the strength of the output signal relative to the input signal.

Gamut The extent of the range of colours and tones that can be reproduced by a colour space.

Giga- A prefix meaning 'thousand million'; e.g., gigabyte.

Histogram A bar chart or graph of tones from black through grey to white represented in a digital image. The black or shadow end lies to the left, the white or highlight end to the right.

ICC International Color Consortium; the international body charged with coordinating image colour spaces.

Interpolation The process of changing image size in the computer, usually applied to increases in file size.

Jpeg Joint Photographic Experts Group; one of the two most commonly used image file formats.

Kilo- a prefix meaning 'thousand'; e.g., kilobyte.

Lab A wide-ranging colour space, designed to mimic the way the human brain interprets colour.

LCD Liquid Crystal Display; the type of screens used on cameras and increasingly in computer monitors.

LZW Lempel-Ziv-Welch; a compression system used with Tiff images.

Mega- A prefix meaning 'million'; e.g., megapixel.

Metadata Information about an image file, such as exposure settings, lens used, dimensions, resolution and date.

Microdrive A common type of memory card that contains a miniature spinning hard drive.

Midtone A middle-level tone that is halfway between black and white.

Noise Graininess in a digital image, often resulting from a high ISO setting, long exposure, or excessive in-computer lightening of a very underexposed image.

Photo-diode A device that captures light and converts it into an electrical charge. This is the very basis of digital photography, and one of the main components of every pixel.

Photosite A single light-sensitive site on a digital sensor, equivalent to a pixel.

Pixel PICture Element; the smallest unit of a digital sensor – a single, square, light-sensitive site consisting of a photo-diode and associated electronics.

Ppi Pixels per inch; the resolution of a digital image as expressed by the number of pixels and hence data fitted into one inch of an image.

Raw Image data stored as a file with the minimum amount of processing, and offering the opportunity to greatly alter exposure settings after the image has been copied to a computer.

RGB Red, green, blue; the three primary colours and a standard nomenclature for a full-colour image.

SD card Secure digital card; a common form of solid-state memory card suitable for use in digital SLRs.

Sensor A semiconductor sheet that captures light to create a digital image. Divided into millions of pixels, individual light-sensitive sites.

Tiff Tagged Image File Format; one of the most commonly used digital image file formats.

Tonal range The spread of tonal values in a photograph, in a digital image expressable as the tonal histogram.

White balance A mechanism to balance colour capture with the colour temperature of the lighting, ensuring correct representation of colour.

Index